THE HIDDEN
TREASURES OF
TIMBUKTU

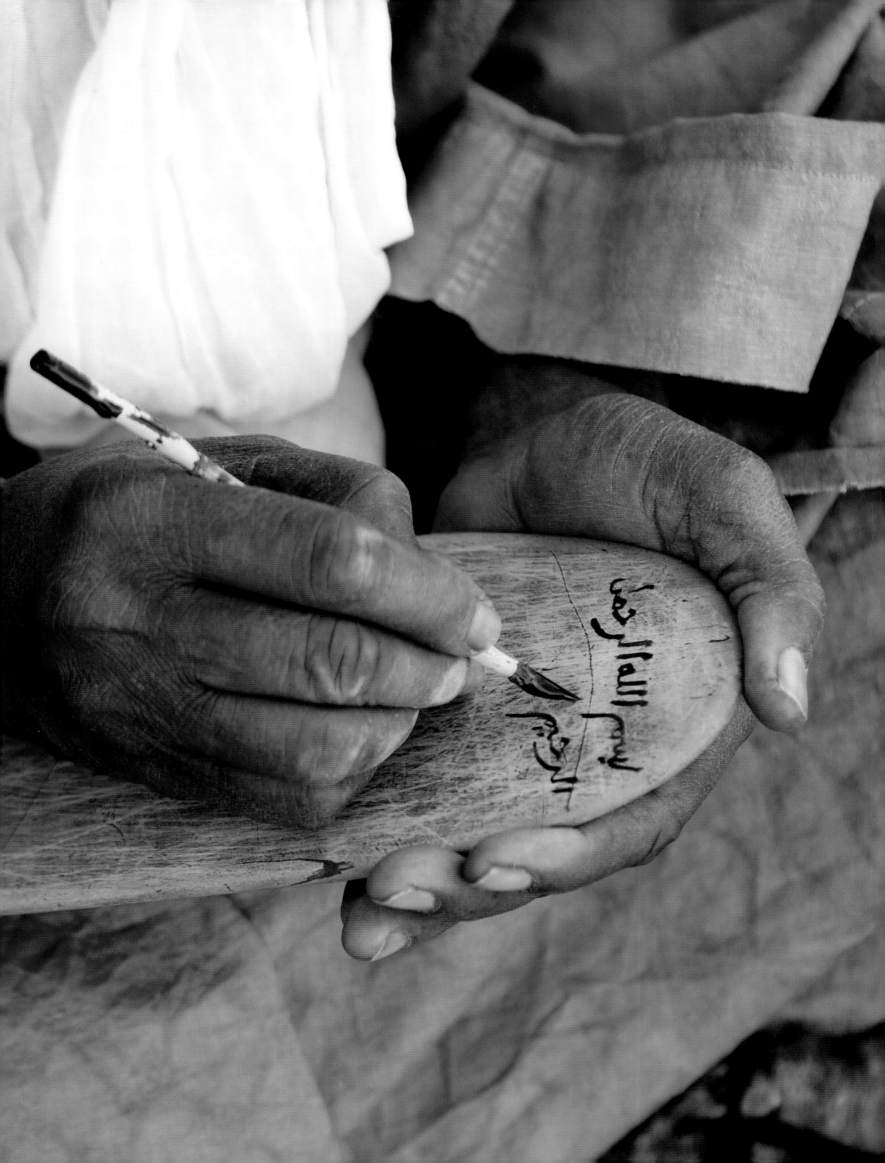

John O. Hunwick and Alida Jay Boye
Photography by Joseph Hunwick

THE HIDDEN TREASURES OF
TIMBUKTU

Historic City of Islamic Africa

With 193 colour illustrations

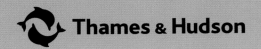
Thames & Hudson

PAGE 1 Before the era of European colonization, political correspondence between the Islamic rulers of the Middle Niger region and beyond was typically conducted in Arabic. This letter written in the mid-19th century was from the emir of Timbuktu, Abdu al-Qadir b. Muhammad al-Sanusi al-Tinbukti, to the 'emir of the believers', Ahmadu Ahmadu, ruler of the Islamic state of Hamdallahi in Masina, southeast of Timbuktu. From the Mamma Haïdara Library.

PAGE 2 A Kounta calligrapher in Timbuktu inscribes the opening verse of the Koran on a wooden writing board.

FOLLOWING PAGES Abdoul Wahid Haïdara, Director of the Mohamed Tahar Library in Timbuktu, opens up a trunkful of manuscripts recently inherited from his father. There are doubtless many more such private collections still to come to light across the region.

Edited in collaboration with Abdelaziz Abid, Clover Jebsen Afokpa, Gunnvor Berge, Albrecht Hofheinz, Mohamed Maghraoui, Bernard Salvaing, Charles Stewart, Knut Vikør and Amanda Vinnicombe

First published in the United Kingdom in 2008 by
Thames & Hudson Ltd, 181A High Holborn, London WC1V 7QX

www.thamesandhudson.com

British Library Cataloguing-in-Publication Data
A catalogue record for this book is available from the British Library

ISBN 978-0-500-51421-4

Printed and bound in Singapore by CS Graphics Pte Ltd

CONTENTS

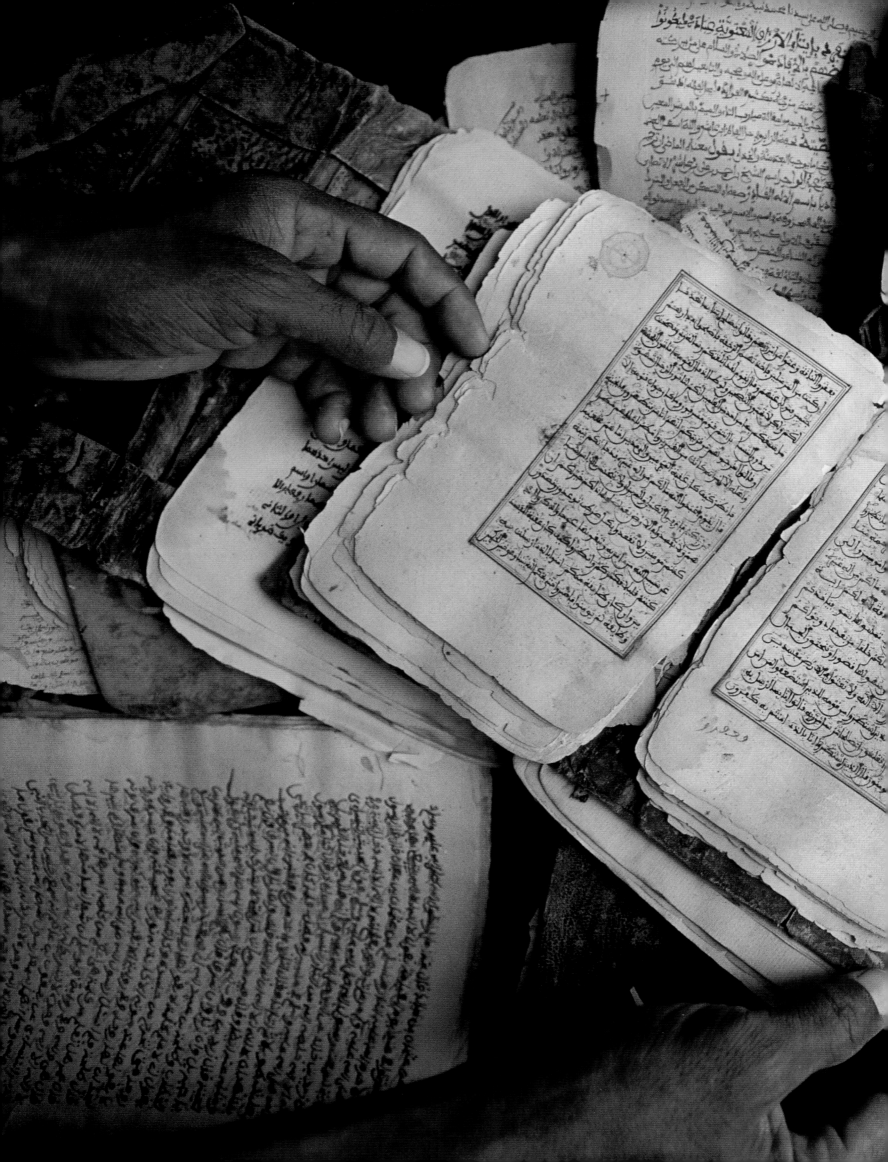

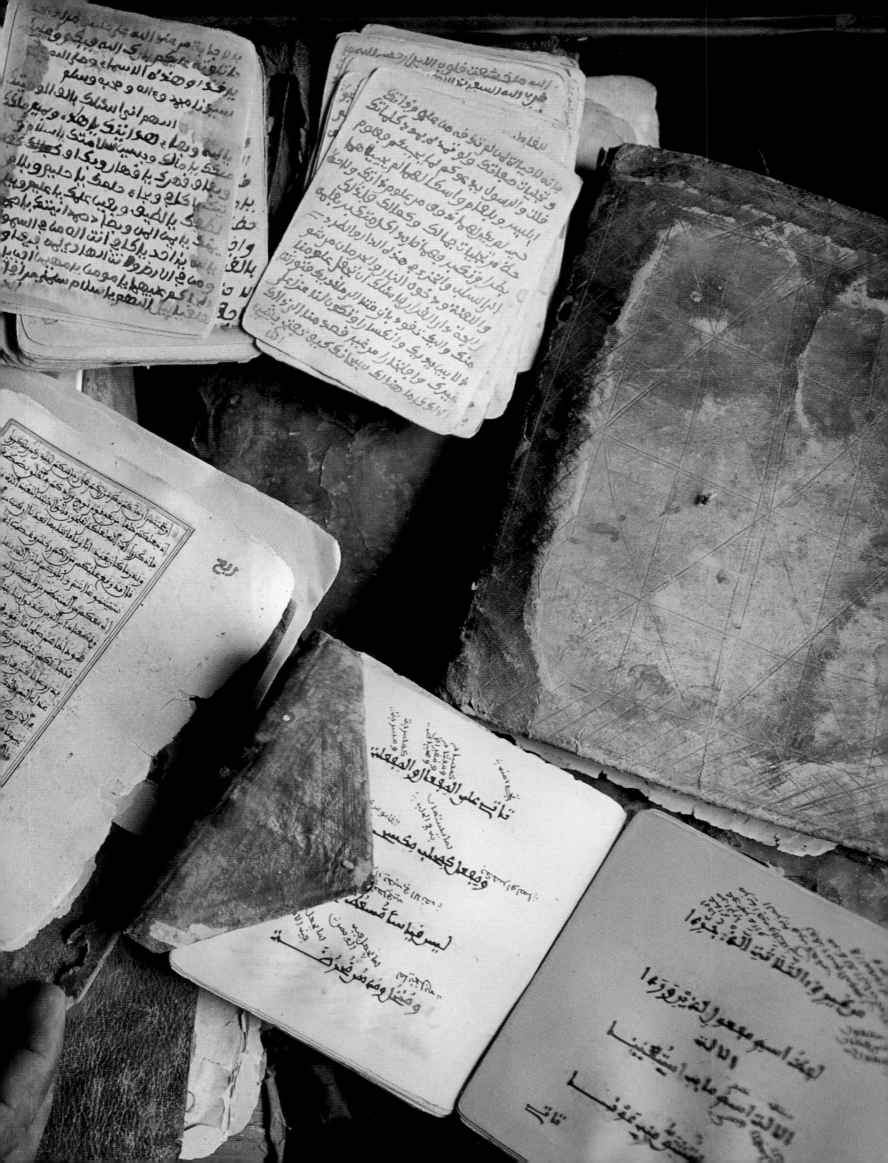

TOLEDO

AL-ANDALUS

QAYRAWAN

TLEMCEN

CEUTA

FEZ

RABAT

ATLAS MOUNTAINS

MARRAKESH

SIJILMASA

GHADAMES

ZAGORA

WADI DAR'A

TUWAT

TAGHAZA

HOGGAR MASSIF

TAOUDENITE

AZAWAD

ADRAR-N-IFORAS
MASSIF

ARAWAN BOUJEBEHA

AWDAGHAST WALATA TADMEKKA *AÏR MASSIF*

TIMBUKTU TAKEDDA

KABARA GAO

Niger Bend

Inland Delta *Lake Chad*

MOPTI *BORNO*

MASINA HAMDALLAHI

Senegal River DJENNE *DOGON* *Niger River* SOKOTO KATSINA

COUNTRY *HAUSALAND*

FUTA TORO SEGU KANO

BAMBUK BAMAKO *Niger River*

Gambia River

FUTA JALLON

AKAN FOREST *Niger Delta*

INTRODUCTION

The historic manuscripts of Timbuktu are revolutionizing our understanding of Africa, increasing our knowledge of African history and unveiling the mysteries of this paradoxically famous yet almost unknown city. Historically, Timbuktu was one of the great centres of Islamic learning. Today it is home to the highest concentration of manuscript collections, public and private, in West Africa – there are as many as sixty private libraries in the city alone. These family collections have been preserved from generation to generation for hundreds of years through climatic fluctuations and political turbulence. Although many manuscripts have been displaced through pillaging and plunder, or destroyed by fire, floods or insects, as many as one million may have survived, dispersed throughout the region from the shores of the Mediterranean to the northern fringes of the forest regions of Guinea and Ghana.

The manuscripts range from small fragments of paper to books and treatises running to several hundred pages. Manuscript books were imported from the Middle East and North Africa from the 14th to 19th centuries, as well as written and copied in the region. Many are the primary texts of Islam – Korans and collections of *Hadith* (the sayings and deeds of the Prophet Muhammad), as well as devotional texts and Sufi writings. There are the canonical works of the Maliki school of Islamic law and the Islamic sciences, including astronomy, mathematics and grammar. And there are also numerous original works written in the region: poetry, commentaries and historical chronicles as well as correspondences, contracts, and marginal notes and jottings – often a surprisingly rich source of historical information.

This trove of literary treasures is testimony to the great intellectual achievements of the scholars of the region. It is changing our notion of sub-Saharan Africa from being the lands of 'song and dance' to a continent with a rich literary heritage.[1] Families are now reassembling collections that have been dispersed among different branches, and building libraries to shelter them or putting them in the hands of expert caretakers. Meanwhile African history is being written and rewritten as new manuscripts and manuscript collections are brought to light.

For too long Timbuktu has been a place everyone has heard of but cannot find on the map; a place which has been described as more a myth or a word than a living city. Through conservation, cataloguing and study of its manuscripts, Timbuktu is now being revealed as a city with a rich written history. In the process, our notion of Timbuktu is shifting from it being the 'end of the world' to an important historic centre of Islamic scholarship and culture.

There remains a great need for serious study across disciplinary and national boundaries to discover the richness of these sometimes still unidentified pieces of paper. This book does not itself represent new scholarship, although it is based on original academic research, primarily that of Professor John

Hunwick. Rather it is a homage to the scholars of Timbuktu and an attempt to bring these written sources of African history to a wider public, as well as to enlighten the many who have grown up to believe that Africa had no written history. The hope is that this book will serve as an inspiration to further study and research; and above all that it will raise awareness of a magnificent heritage which is transforming our understanding of the history and culture of this part of the world.

A THOUSAND YEARS OF HISTORY

'Timbuktu had no equal among the cities of the blacks...and was known for its solid institutions, political liberties, purity of morals, security of its people and their goods, compassion towards the poor and strangers, as well as courtesy and generosity towards students and scholars.'
Tarikh al-fattash, completed 1665[2]

Founded around 1100 CE as a seasonal camp for desert nomads, Timbuktu was to develop over the next couple of centuries into a thriving commercial city that was a key crossroads for the intellectual, social and economic development of West Africa. Situated on the northernmost bend of the great Niger River, between the gold mines in the southern reaches of West Africa and the salt mines of the Sahara desert, it became a major centre of inter-regional and transsaharan trade. An estimated two-thirds of the world's gold came from West Africa in the 14th century, the period in which the Malian Empire reached its zenith.[3] A substantial proportion of that gold passed through Timbuktu, an important hub in the transportation of goods, people, ideas and books.

Timbuktu was an Islamic city from its foundation. Muslim Arabs had extended their control across the whole of North Africa by the end of the 7th century CE. In the following centuries Islam and the Arabic language were spread deeper into the African continent not by conquest but by Muslim traders who ventured across the Sahara primarily in search of gold. Thus Arabic became the written language first of tradesmen and travellers and then of scholars and

kings. Diplomatic and commercial relations between North Africa and the Niger Bend and between the Niger Bend and territories further south required communication over great distances. The written word was used to regulate commercial transactions (including the slave trade), to legitimize authority and even to instigate war.[4] Scholarship was thus not only an intellectual and spiritual pursuit, but a means of social and political influence, even at times a matter of life and death. The renowned scholars of the region often came from wealthy trading families; trade created an affluent ruling elite whose scholars had the means to purchase books and the time to read and write.

Through trade, conquest and intermarriage, the peoples of black Africa and the Mediterranean mixed, making the Niger Bend one of the most ethnically diverse areas of Africa. Timbuktu has at one time or another been under the political control of almost every ethnic group in the region, each power determined to maintain the security and profits of West African trade routes. But through this succession of foreign overlords the scholarly class in Timbuktu exercised a considerable autonomy. Its learned men or *ulama* constituted the city's ruling elite, serving as imams and teachers, scribes, lawyers and judges.

Over the course of the 15th and early 16th centuries, Timbuktu gradually lost its prominence as a centre of long-distance trade as the transsaharan trade routes were diverted by the arrival of Portuguese ships along the coast of West Africa and then by the discovery of gold in the Americas. The city has also endured the vicissitudes of climate and politics throughout its existence: repeated pillaging and sacking as described by the Timbuktu chronicler al-Sadi in the *Tarikh al-sudan*; fires as described by Leo Africanus, who visited in the early 16th century; conquest by a succession of West African peoples, as well as by the Moroccans and the French; and recently the Tuareg uprising in the last decade of the 20th century and the floods of 1999. All have taken their toll through the centuries. But the independence and civic pride of Timbuktu's citizens has ensured the preservation of the city's culture and libraries into the 21st century.

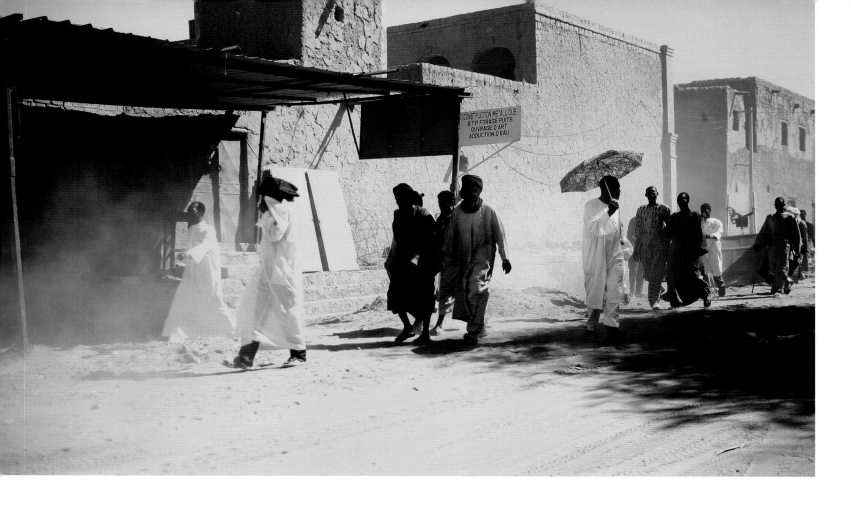

TIMBUKTU'S LITERARY PATRIMONY

Until recently the significance of this region's literary heritage has been difficult to appreciate because of its dispersal. Ironically this may also have assisted its survival: the colonial conquest resulted in manuscript collections being hidden away, sometimes literally buried in the desert sand, for fear of them being seized. It is only during the past twenty-five years that the wealth of the region's past intellectual life has been unearthed again.

New evidence of all kinds continues to feed into the corpus of our knowledge of the Niger Bend region; however, there remain many obstacles. In the recent past, scholars able to study these manuscripts seriously have been few. Not only have the manuscripts themselves been at risk, but so has the expertise necessary to read and interpret their content. Under colonial rule, education and literacy in Arabic was largely supplanted by French, and hence many of the families owning manuscripts lost the ability to read and appreciate them. Arabic has only recently been reintroduced at university level in Mali, so that while there are numerous highly qualified Malian historians, only exceptionally have they mastered Arabic and been able to exploit these written documents in their research.

ABOVE The men of Timbuktu return from Friday prayers. Mali remains an overwhelmingly Muslim country. Under colonial rule, however, education and literacy in Arabic were largely supplanted by French, so that many families inheriting manuscripts lost the ability to read and appreciate them.

In Western academic institutions a major reason for neglect in the study of the Arabic literature of Africa is the unfortunate divide between Middle Eastern Studies and African Studies. The consequent compartmentalization of the African continent into zones that are classed as 'Middle Eastern' and 'African' is a legacy of orientalism and colonialism. North Africa, including Egypt, is usually seen as forming part of the Middle East, though in fact Middle East experts are not generally keen to venture further west than Egypt. Northwestern Africa – the Maghreb – is generally regarded as peripheral to Middle Eastern studies and extraneous to African studies. Even the Sahara has generally been viewed as something of a no-go area, while the modern countries of Sudan and Mauritania lie in a kind of academic no-man's-land. Northwestern Africa, despite the area's close and enduring relationship with West Africa, has been excluded from the concerns of most Africanists. Although several scholars have made valiant attempts to integrate the

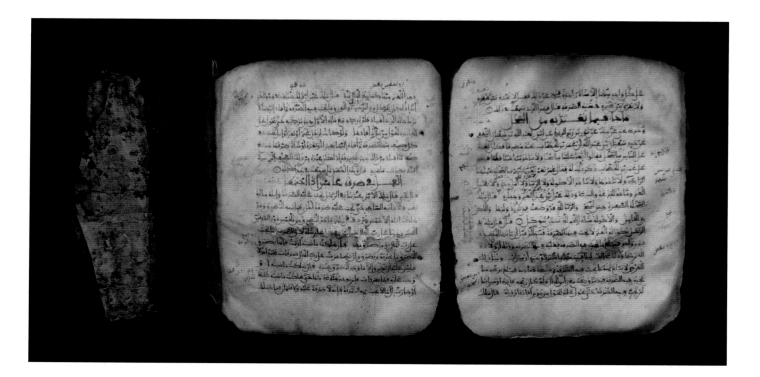

ABOVE Pages from a two-volume work on Islamic law of the Maliki school, from Timbuktu's Mamma Haïdara Library. This work is on parchment made from gazelle skin.

whole of northern Africa into continental history,[5] most works on Africa still focus on the lands south of the Sahara. The scholarship that underpins this book has endeavoured to bridge this gap, but there remains much work to be done.

This is a book about manuscript traditions and the written word. It does not attempt to exploit the rich oral traditions[6] of the Niger Bend area or the intensive archaeological research that has been carried out,[7] detailed study of which is necessary to gain a more comprehensive picture of the region. Archaeologists, anthropologists and historians are still debating questions concerning the historical movements of many of the ethnic groups in the Niger Bend,[8] the whereabouts of the capital cities of the great empires,[9] as well as their succession of kings. Their work has been greatly hampered by the disgraceful pillaging of archaeological sites and private libraries over the centuries.

This book is dedicated to the protectors of Timbuktu, its scholarly traditions and its manuscripts. The villains of its story are those who in one way or another threatened the autonomy of the Timbuktu scholarly elite. Of course the military powers which besieged Timbuktu might well have presented an

entirely different picture, as would the illiterate classes of the Niger Bend. No single type of historical evidence can ever be conclusive, and reliance on the written sources alone risks perpetuating the bias of the scholarly ruling class and their socio-political-economic networks, as well as their attempt to justify their privileged place in society. What's more, the history of Timbuktu cannot be understood in isolation of events in Hausaland, Futa Jallon, Masina and further afield in West Africa. Fluctuations in the European gold market, the abolition of the transatlantic slave trade, as well as religious movements elsewhere in the Islamic world have all had their effect on the city.

Nonetheless, the literary sources upon which our story is based are an important resource whose potential has only begun to be tapped. Before the 1950s, little was known in the West about the Arabic writings of Africa south of Egypt and the Maghreb, even though one or two collections of such manuscripts were held in European institutions; most notably, the library of Umar Tall and his descendants, which was seized by

OPPOSITE Commercial document on the salt trade from the Maigala/Almoustapha Konaté Library in Timbuktu. Commercial transactions and contracts were traditionally documented in Arabic according to the principles of the Maliki school of Islamic law. Proficiency in Arabic and in Islamic law thus gave considerable influence to clerics and scholars in this highly mercantile society.

French colonial forces in Segu in 1890 and transferred to the Bibliothèque Nationale in Paris. The celebrated multi-volume work in German on the history of Arabic literature by the scholar Carl Brockelmann published between 1898 and 1902 covers Arabic writings from Andalusia to India, with a total of 4,706 pages, yet devotes only four pages to Arabic writings in sub-Saharan Africa.

Given the evident richness of the sub-Saharan Arabic literary tradition, and the lack of scholarly attention it has received, John Hunwick and Sean O'Fahey decided to create a guide to its authors and their work. When they initiated the project in 1965 they could not have imagined how much Arabic writing they would uncover and the huge number of manuscripts that remained hidden. Their efforts led to the compilation of a multi-volume series called *Arabic Literature of Africa* covering writings from Senegal to Tanzania.[10]

BELOW AND OPPOSITE Students of a *madrasa* in Djenne. From a very young age, boys are sent to centres of learning such as Djenne and Timbuktu to study the Koran. But very few Malians have had the opportunity to study Arabic to an advanced level in recent times.

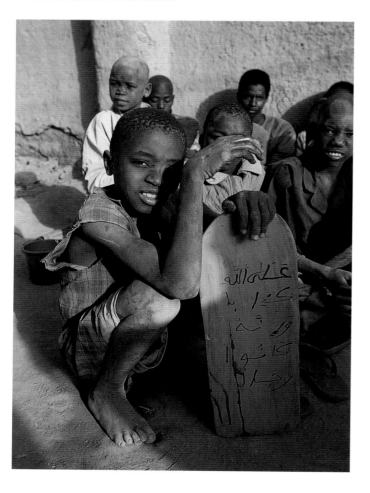

One of the most important ways to preserve a literary heritage is through cataloguing. In the case of manuscripts, cataloguing not only facilitates access to the various works but also records what existed in case manuscripts are destroyed. For unlike books, each manuscript is unique and each copy needs to be recorded. Several catalogues and databases now exist across the region. The dispersed libraries of what was once a hub of cutting-edge intellectual activity on the fringes of the Islamic world are being reunited by cutting-edge computer technologies, capable of pulling together the contents of diverse collections which are now spread across three continents and, in Africa, in at least half a dozen national repositories.[11] We now are beginning to know what the scholars of the region certainly knew two hundred years ago about the most authoritative books in the region and where they were to be found.

TIMBUKTU TODAY

The modern Republic of Mali, founded in 1960, took its name from the ancient Malian Empire, though its territories and wealth are significantly less. Indeed Mali is today listed as one of the poorest nations of the world, yet is one of the richest in culture. Timbuktu is still known as the 'End of the World' and 'Mysterious City of 333 Saints', but it has also recently been acclaimed as the 'Islamic Cultural Capital of Africa' and has become a symbol of the 'African Renaissance' spearheaded by the South African government of President Thabo Mbeki. Both Mbeki and President Muammar Gaddafi of Libya have claimed Timbuktu within their strategic political sphere. The mosques of Timbuktu, like that of Djenne, are protected through UNESCO's Registry of World Heritage Sites.

Timbuktu's economy is primarily maintained today by adventurous tourists who make the journey in order to say they have been there, and to see the doors, dunes, mosques and, recently, manuscripts. Although salt is now mostly transported by trucks, Mali is one of the only places where you can still see the great salt caravans, and it is a tremendous event when a camel caravan comes to a village or to Timbuktu. Slavery was abolished with French colonization, although reminders remain: in the

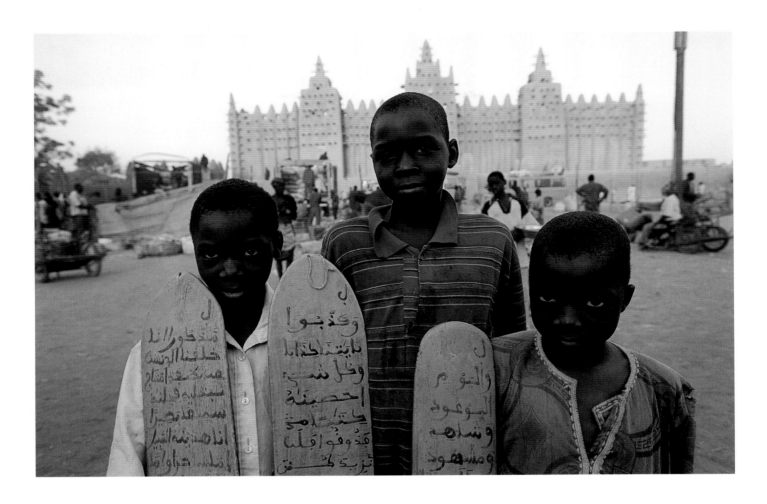

middle of the medina in Timbuktu there stands a hundred-year-old wild date tree to which slaves were once attached by their feet (see page 46). Gold remains a major export item for Mali; however it is now flown over Timbuktu and the Sahara. Cloth is still a very precious commodity and high priority is given to how to dress, the materials to use and how to tie a turban, as can be witnessed on the street after Friday prayers or during gatherings at festivals. Modern Timbuktu retains something of the playfulness Leo Africanus witnessed during his visit in 1506: 'The people of Timbuktu have a light-hearted nature. It is their habit to wander in the town at night between 10pm and 1am, playing instruments and dancing.'[12]

THE AHMED BABA INSTITUTE

The Ahmed Baba Institute (IHERIAB) in Timbuktu was established through a UNESCO initiative in 1970 as a national repository and conservation centre for the manuscripts of the region. Today its collection of nearly 30,000 manuscripts is in the process of being conserved, catalogued and studied by a trained team of national and international experts.

MALI'S MANUSCRIPT TRADITIONS

By Dr Mohamed Gallah Dicko, Director of the Ahmed Baba Institute

Colonization dealt a hard blow to this cultural heritage. Many manuscript collections were burned, stolen or seized. In addition, the droughts in the period which followed led many guardians of manuscripts to leave their patrimony behind – entrusting their manuscripts to their neighbours or even burying them in the sand, before departing into exile.

West Africa in general and Mali in particular still conceal many manuscripts which have neither been inventoried nor catalogued. In Timbuktu and throughout the country, many families still jealously hide their libraries, refusing access to researchers for fear that the requisitions and pillaging of the colonial period will be repeated. Our culture is usually considered to be largely based on oral traditions. However, this literary tradition has played a great part in Mali and the wider region throughout its history. It is a key part of our culture.

Aside from those of the Ahmed Baba Institute, manuscript collections are generally in private

ownership, since they have been passed down to their present proprietors from father to son through generations, often over several centuries. Such collections nevertheless also form part of our national documentary heritage.

The significance of the manuscripts lies in their quantity, the quality of their content, and also their owners' attachment to them both as a body of knowledge and a patrimony passed down by their ancestors to which they attach a great moral and spiritual value. For them, the manuscripts are a sacred legacy and a source of great family pride.

There is, however, a difficulty inherent in the nature and content of some of these manuscripts. They treat all subjects and report on all facets of life, including historical, political, social and private events. Such events, though they occurred a long time ago, can sometimes have grave repercussions for the present. For example there are commercial contracts which relate the sale at a particular price of a person whose descendants today claim him as one of the great nobles of his time. It is the nature of history that one remembers only its glories, never its defeats. Some of these manuscripts could make or unmake the fabric of our current society. Certain manuscripts compromise men who are well placed in today's social hierarchy by reporting unfortunate events or servility imposed on their ancestors. There are manuscripts showing the debt of one family towards another, or that an asset (a piece of land or a house) was unjustly acquired. Thus while the manuscripts are a source of legitimate pride for Timbuktu and Mali, they are often also a jealously guarded treasure.

BELOW Girls in Timbuktu play music and sing in celebration of a wedding.

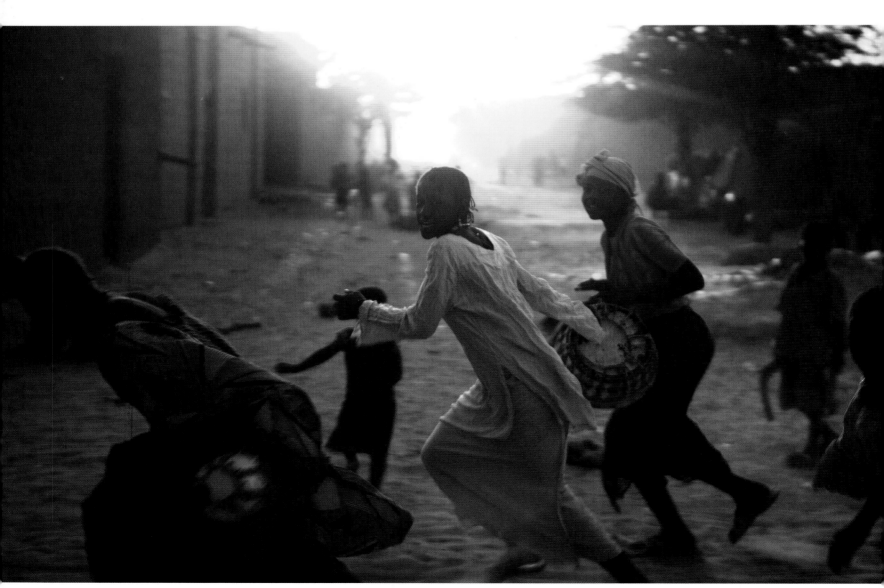

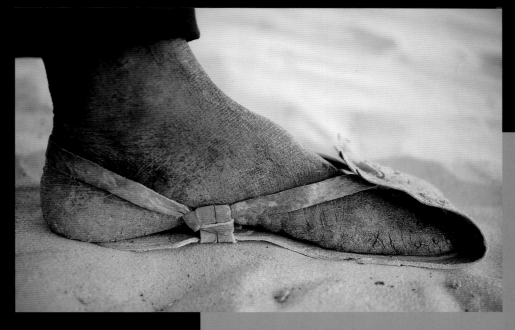

Plates I: The Setting

PREVIOUS PAGE A simple leather sandal worn on the baking-hot desert sand – a reminder of the hardships of the traditional desert crossing undertaken on foot and camelback. According to a signpost in Zagora in northern Morocco, the journey to Timbuktu took 52 days. A pilgrimage to Mecca required months or years, and demanded considerable stamina and financial means.

RIGHT Nomad with his flock on the outskirts of Timbuktu. The first settlement on this site was established in *c*. 1100 CE by nomads who would camp here in summer to graze their herds on the banks of the river.

OVERLEAF The exposed roots of the tree on the left testify to the vicissitudes of the desert climate and the constant shifting of the Niger River. Such fluctuations have affected the Timbuktu region for centuries.

PAGES 22–23 Boys play on the outskirts of Timbuktu. Desert dunes surround the town.

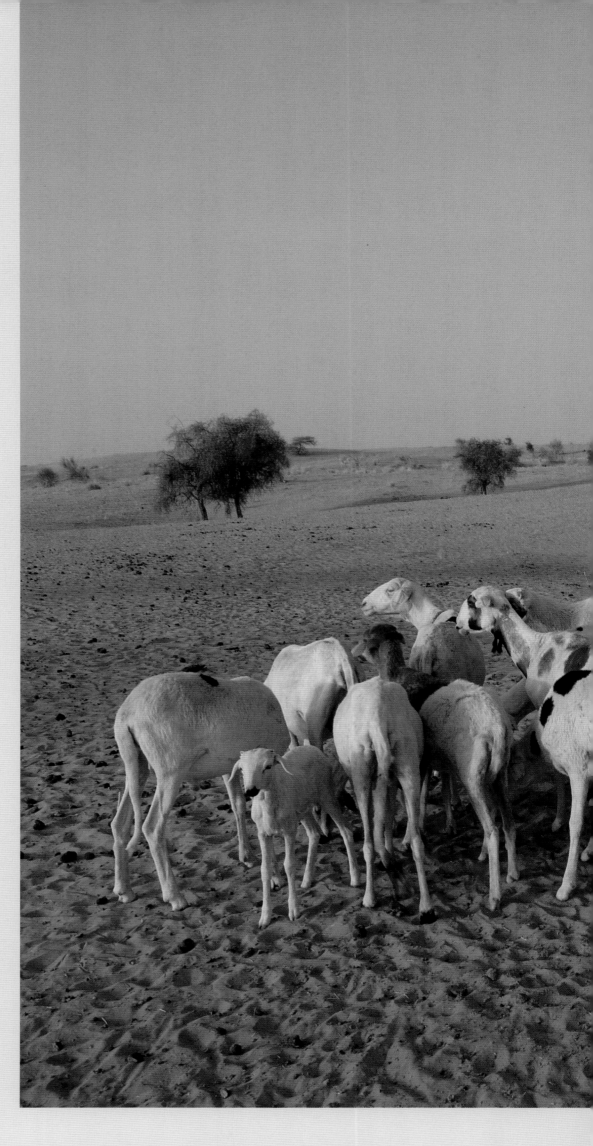

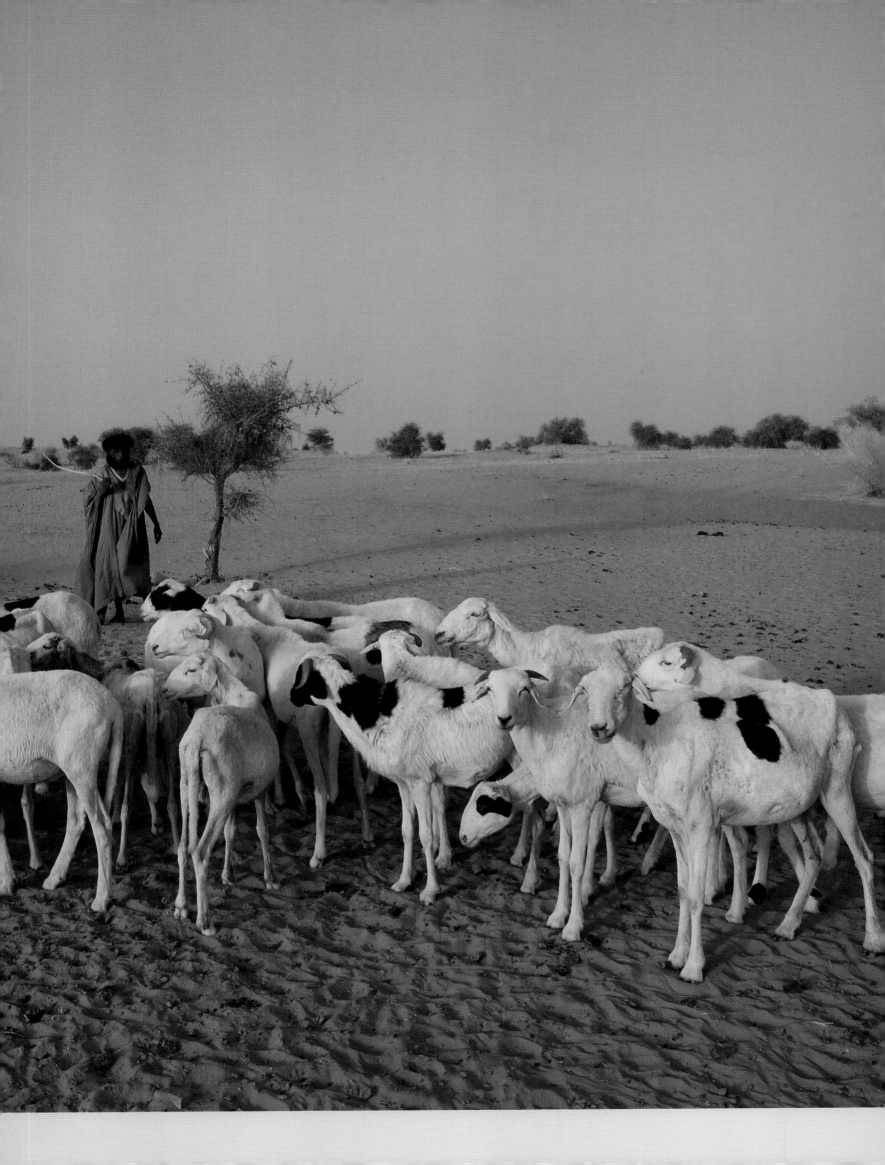

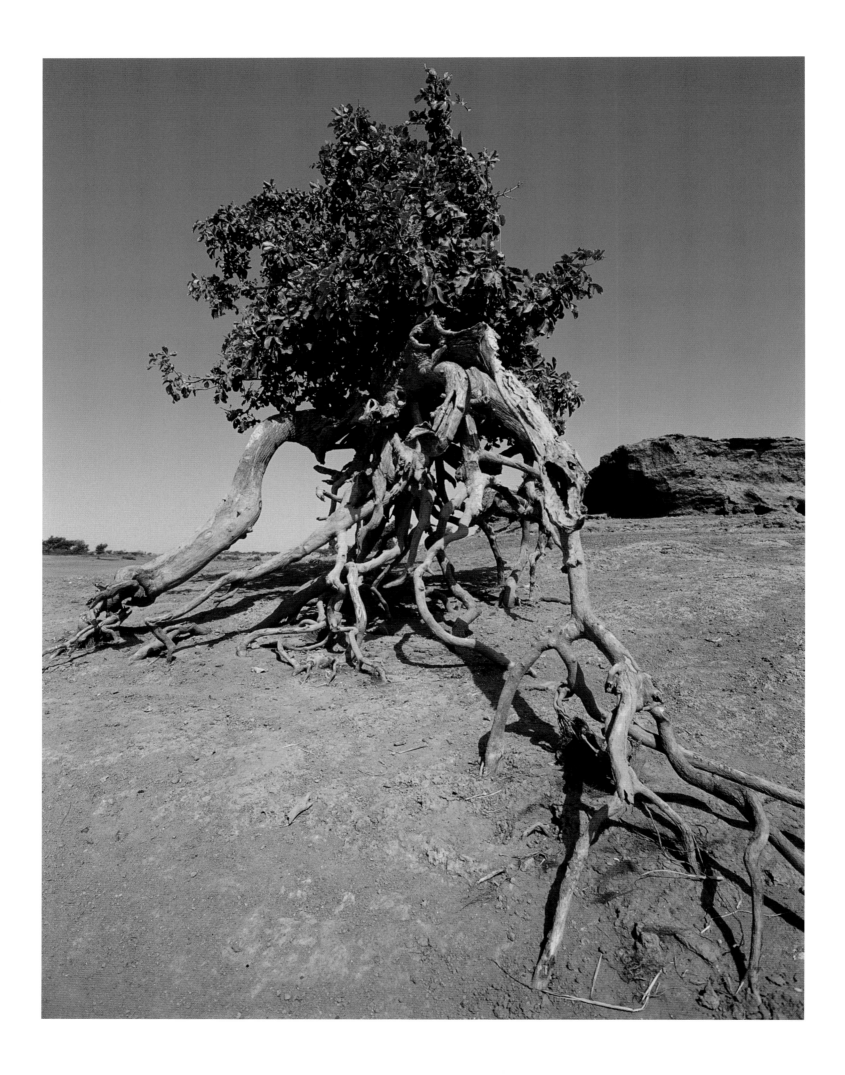

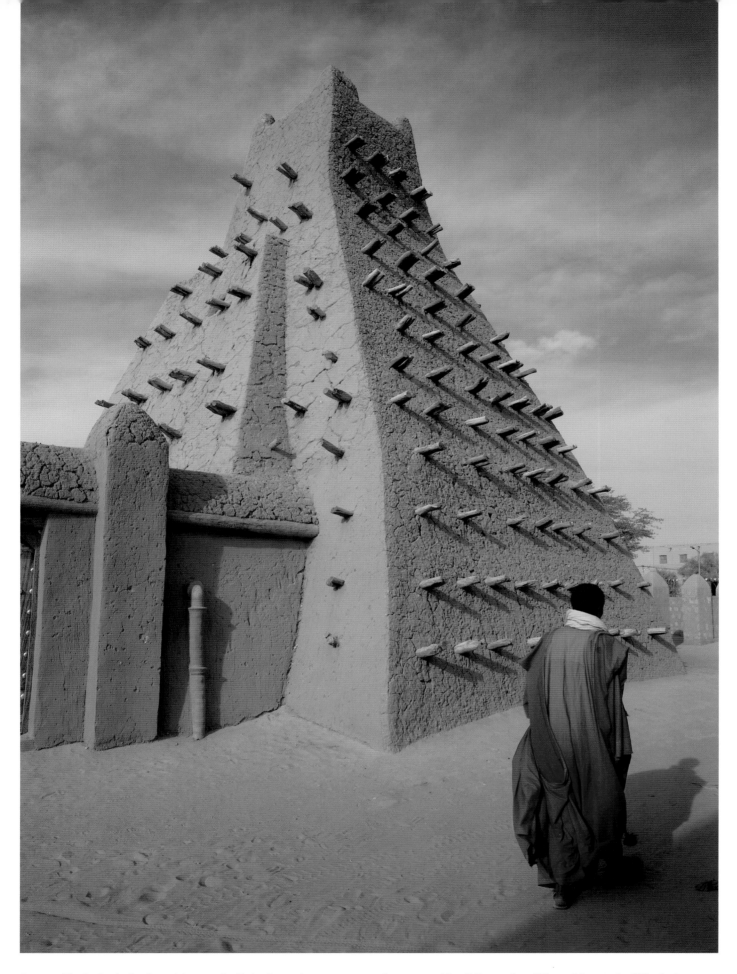

ABOVE Timbuktu's Sankore Mosque, built in the 14th century with funding from a woman of the Aghlal, a religious Tuareg tribe. The Sankore quarter in the northeast of the city became a dwelling place for scholars and teachers. It was in the homes of these scholars that the city's libraries were first created.

OPPOSITE The Djingereber ('Great Mosque') of Timbuktu was constructed in 1335 under the supervision of the Andalusian poet-architect Abu Ishaq Ibrahim al-Sahili, who accompanied the Malian Emperor Mansa Musa on his return from Mecca.

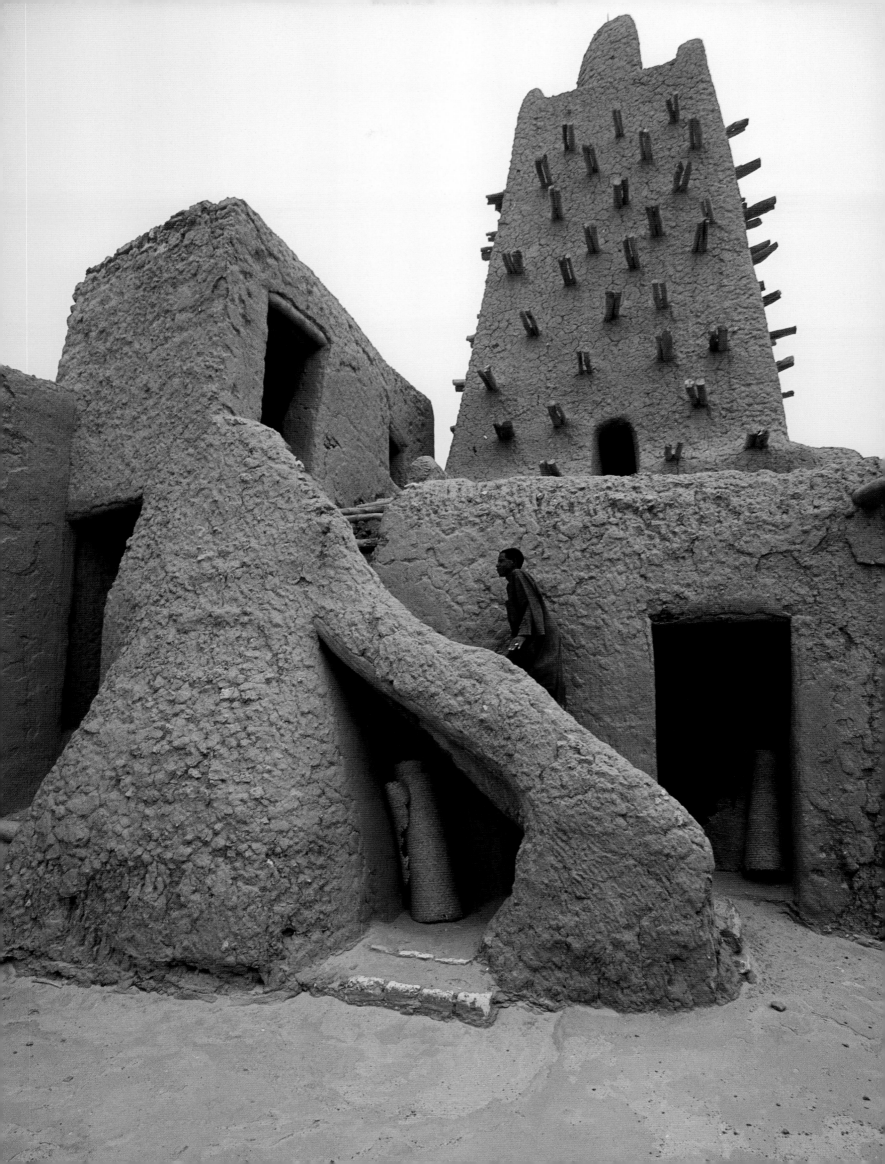

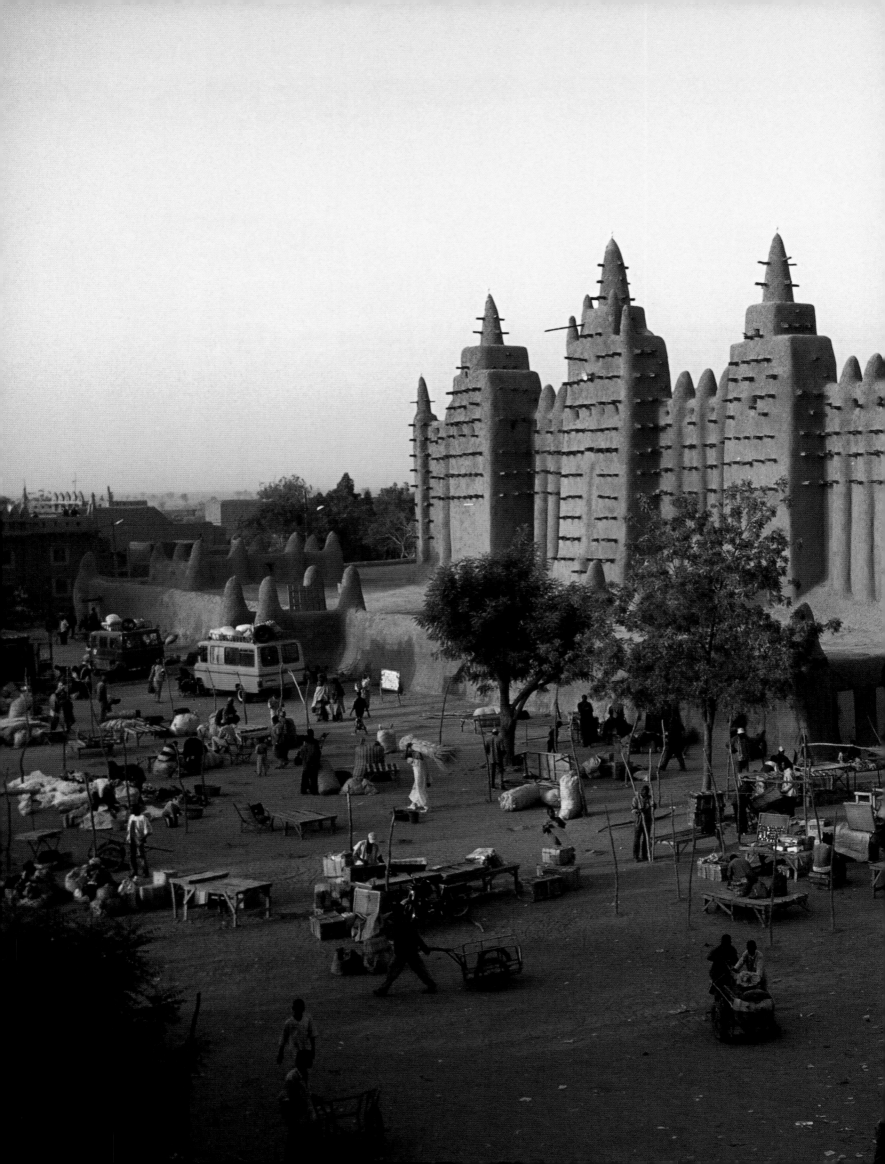

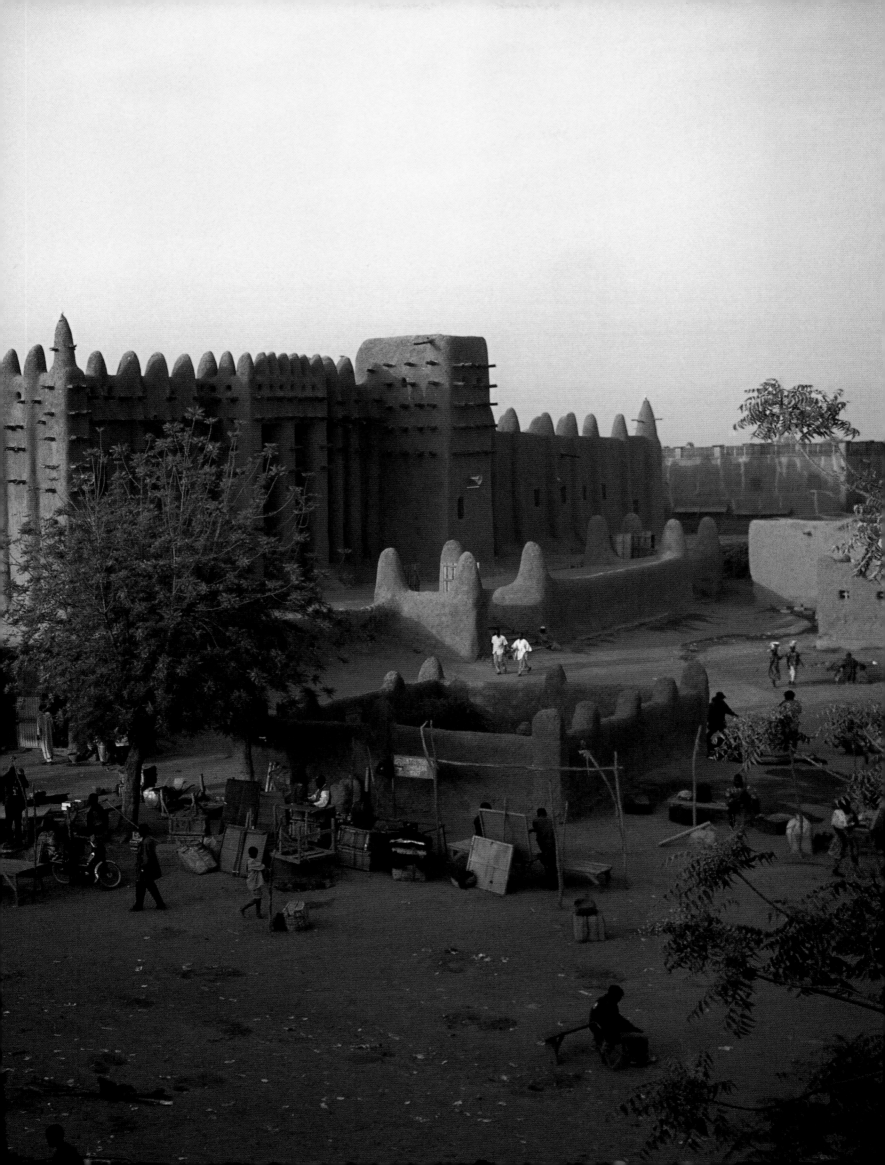

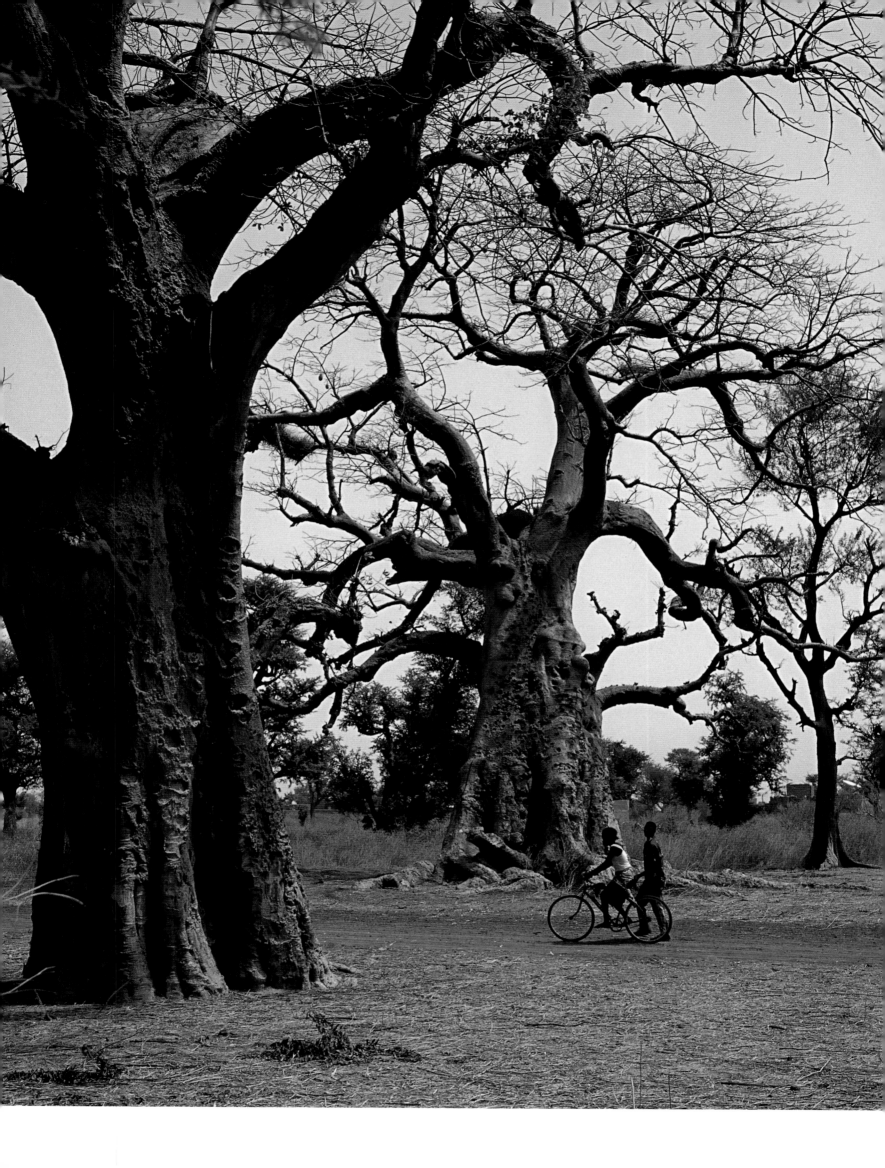

PREVIOUS PAGES The Great Mosque of Djenne is said to be the largest adobe structure in the world. It was built in 1907 during the period of French colonial rule, after the original mosque on the site was destroyed in 1834 on the orders of Ahmadu Lobbo. Djenne and Timbuktu are sister cities, rivalling each other as centres of commerce and Islamic learning for a thousand years.

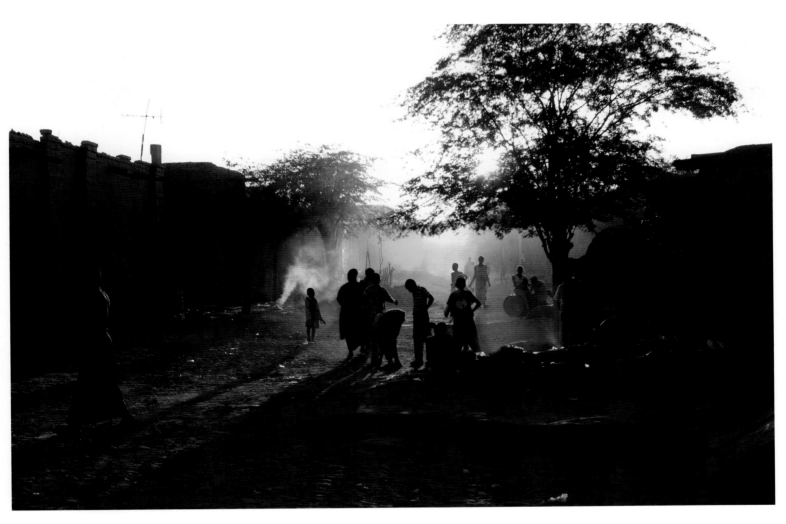

OPPOSITE Baobab trees, typical of the area around Segu, which lies southwest of Timbuktu, upstream on the River Niger. Segu was the capital of the kingdom of the Bambara, one of the various peoples who have levied tribute upon Timbuktu through its history.

ABOVE A Timbuktu street at sunset. The town's population today is around 30,000, though this fluctuates annually and seasonally according to events: the arrival of the caravan, a religious festival, the tourist season, conflict or drought.

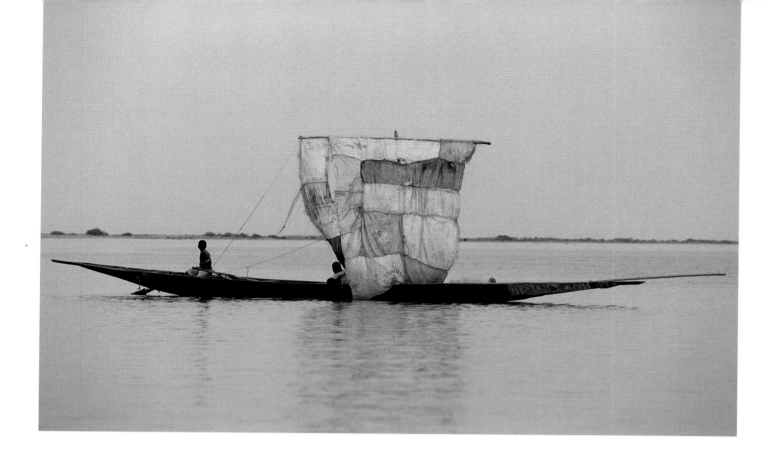

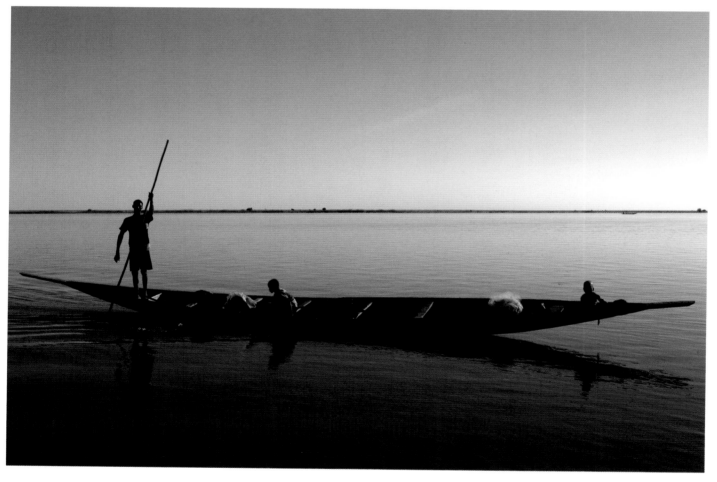

ABOVE AND OPPOSITE Pirogues on the River Niger. A pirogue
is a shallow, canoe-like boat which can be paddled or punted,
sometimes with sail or even motor added. It is used chiefly
for transportation, fishing and – historically – hippopotamus
hunting. Securing and maintaining control over the boatmen
and their pirogues was essential to empire-building in the
region in centuries past.

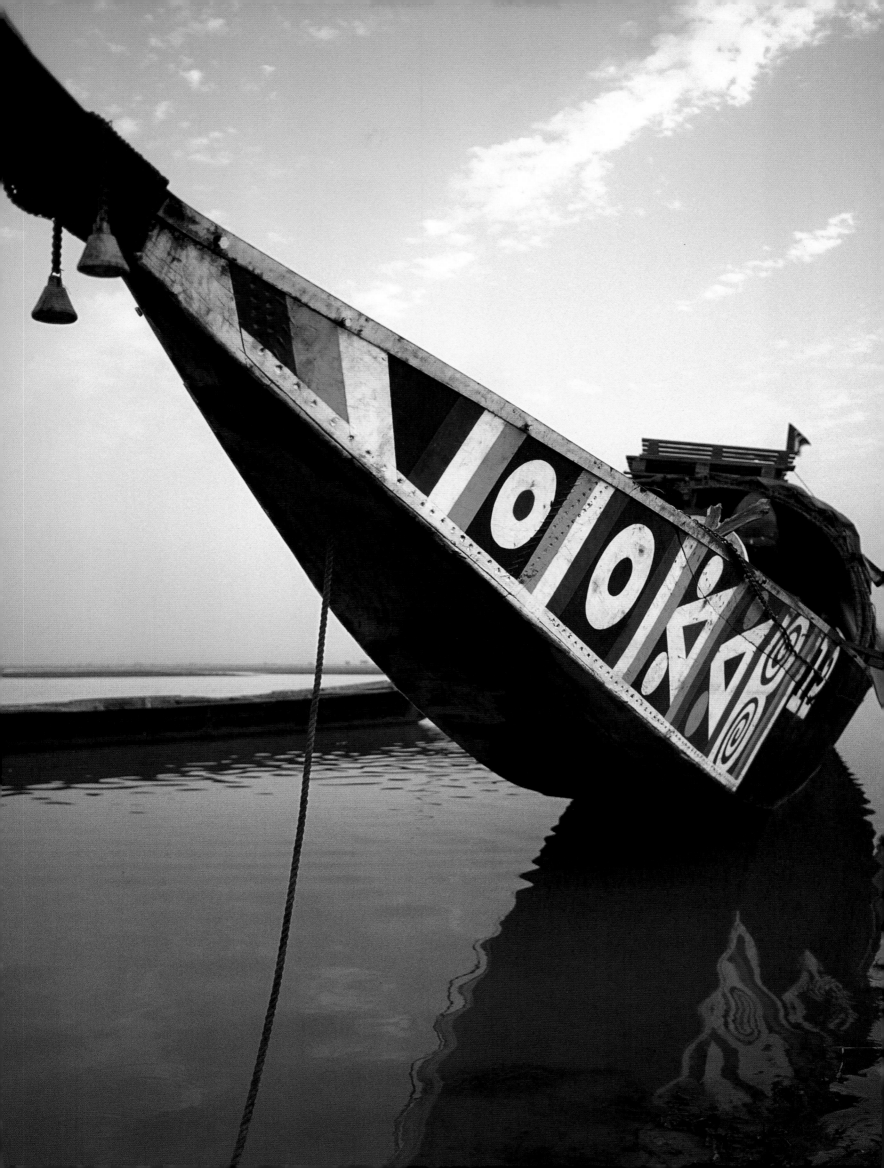

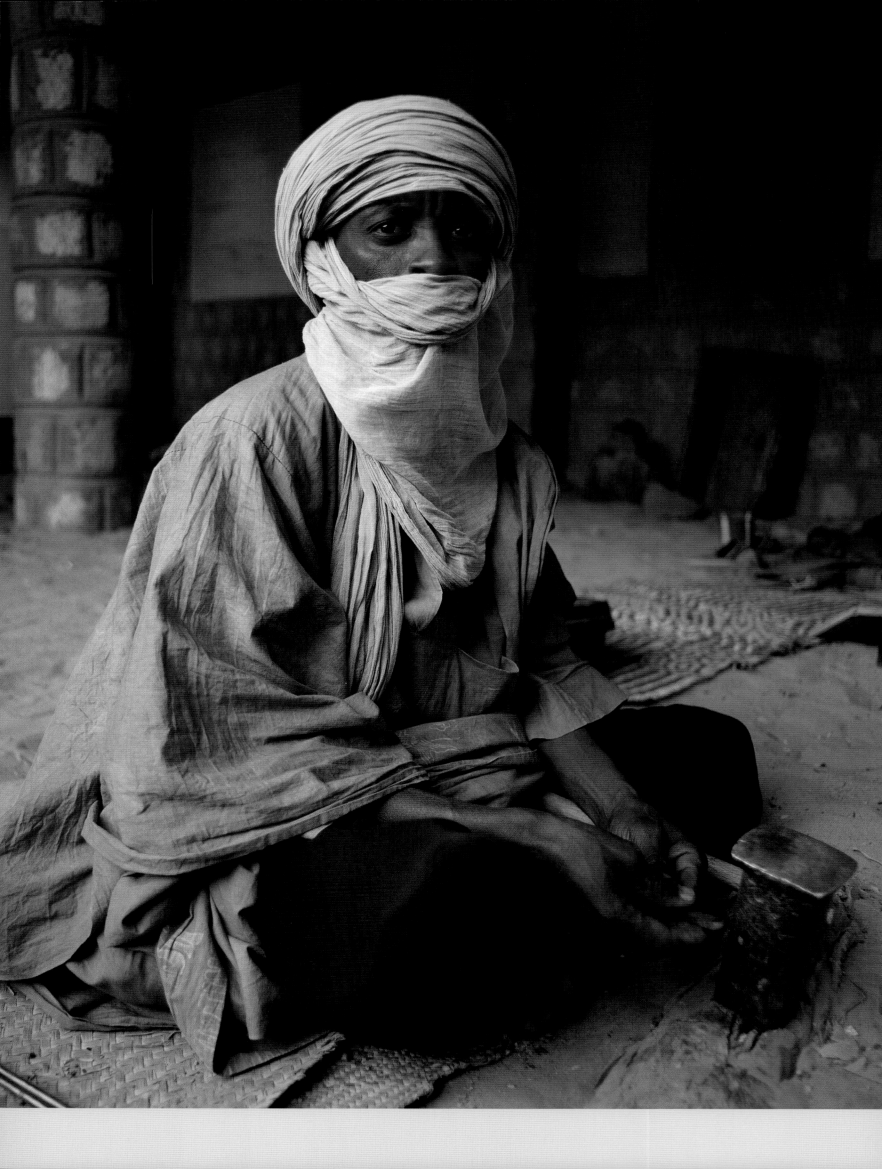

OPPOSITE A Tuareg silversmith at work in Timbuktu. The Tuareg are renowned for the skill and beauty of their artisan traditions, particularly their jewelry and silverwork.

BELOW Kabara, the port of Timbuktu, which is situated some 12 km (8 miles) south of the town.

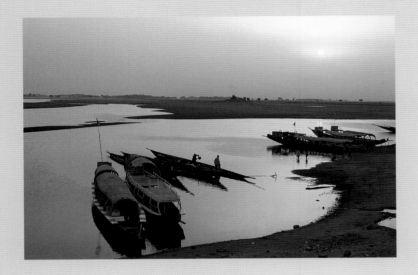

1 TIMBUKTU: WHERE THE CAMEL MEETS THE CANOE

'Salt comes from the north, gold from the south and silver from the country of the white men, but the word of God and the treasures of wisdom are only to be found in Timbuktu.'

West African Proverb

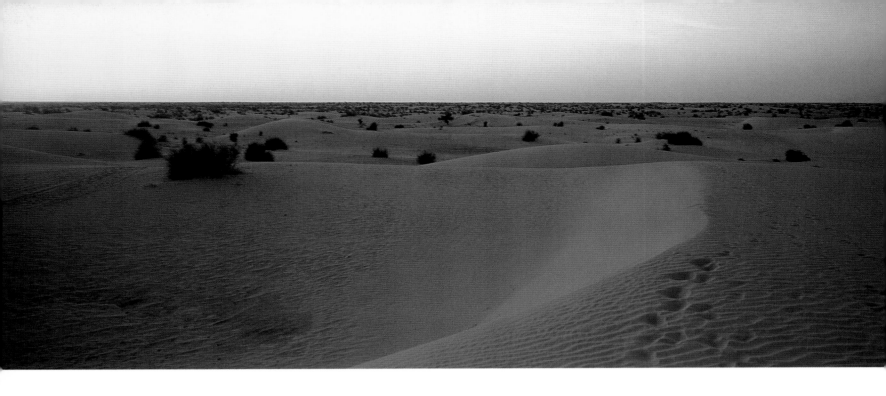

ABOVE Desert dunes on the outskirts of Timbuktu. The vast desert territories of northern Mali, stretching from the River Niger to the salt mines at Taghaza, and northeast to the present-day border with Mauritania, are known as Azawad. The explorer Heinrich Barth, writing in 1853, observed that: 'The tract of Azawad, although appearing to us a most sterile tract of country...is a sort of Paradise to the wandering Moorish Arab born in these climes. For in the more favoured localities of this district he finds plenty of food for his camels, and even for a few head of cattle, while the transport of the salt of Taoudenite to Arawan and Timbuktu affords him the means of obtaining corn and any thing else he may be in want of.'¹

The historic city of Timbuktu lies at a point where the Sahara Desert meets the River Niger along its great northward curve often referred to as the Niger Bend. This geographical setting made it a natural meeting point for settled African populations and nomadic Berber and Arab peoples. The Niger Bend or Middle Niger is to West Africa what the Nile Valley is to Egypt: an ecological lifeline and a magnet for civilization. Historically, this huge swathe of river with its floodplain has allowed for the relatively dense settlement of populations along a vast stretch of well-watered terrain. It also provided a great highway of communication across the region and a link between the lands of the desert and North Africa and the savannahs and forests in the south. In time, this strategic location was to make Timbuktu a natural locus of trade between the lands of the Mediterranean and tropical Africa, called in Arabic the *Bilad al-sudan* or land of the blacks.

The extensive human activity that has taken place in the Niger Bend for thousands of years has left behind its traces in a large number of archaeological sites. The river was a natural refuge for populations facing the increasing desiccation of the Sahara after 5,000 BCE. By 250 BCE we have the earliest evidence of urbanization in the region: archaeological work in the 1970s and 1980s at Djenne, south of Timbuktu, revealed the site of a complex society that had developed into a considerable regional centre.

Climatically, the first millennium CE was a relatively benign period for this part of the world, with increased rainfall allowing for sufficient tree growth to fuel an iron industry. This was the era in which the ancient Empire of Ghana flourished in what is now southern Mauritania and extending into northwest Mali. Since about 1100 CE the general pattern for the West African Sahel – the region bordering the Sahara – has been one of reduced rainfall, with significant long- and short-term deviations which have at times gravely threatened the lives and livelihoods of its people. Timbuktu now has an average annual rainfall of 231 mm (9.1 in.), though this varies greatly from year to year. During the hottest months, from April

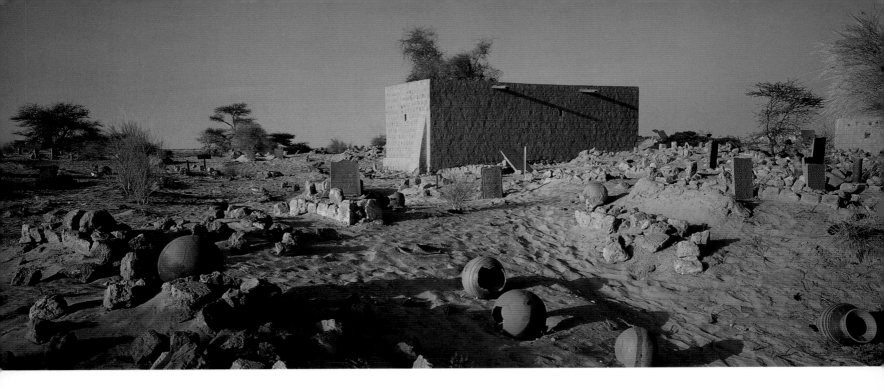

to June, Timbuktu is fiercely hot, with highest daily temperatures averaging between 41°C (105°F) and 43.5°C (110°F).[2]

In such inhospitable conditions, the river is truly a lifeline, providing year-round drinking water for humans and their domestic animals. Annual flooding creates a huge Inland Delta extending some 500 km (300 miles) to a point just upstream of Timbuktu, and stretching as much as 250 km (150 miles) wide. As the flood waters recede, a moist agricultural terrain watered by creeks and lakes is left behind. Here grains and vegetables can be grown and cattle pastured, forming a breadbasket for Timbuktu and its desert and riverine hinterland.

Timbuktu came into existence at the beginning of the 12th century as a settlement for nomads of the southern Sahara, who would camp near the river during the dry season and take their animals to graze in the inland territories during the rainy season. It was originally established a few miles from the river to avoid its humidity and water-borne diseases. While the nomads were away they would leave their belongings with their slaves, one of whom, we are told, was called Buktu, hence the name Tim Buktu or the well of Buktu.[3] These nomads were Sanhaja, most probably members of the Massufa branch of this great confederation, who were to remain an important element in the population of Timbuktu through the next six centuries.

It would seem that Timbuktu remained little more than a semi-permanent nomadic settlement in the 12th century, and probably through the 13th. But as this campsite gradually attracted permanent settlers, and commercial links were established between Timbuktu and the Saharan oases, Timbuktu became an attractive city for people from North Africa and the oases, and its population increased significantly.[4]

SOURCES OF EARLY WEST AFRICAN HISTORY

A local tradition of history writing in Timbuktu surfaced in the 16th century with the works of Ahmed Baba, and later in the great Timbuktu

ABOVE Cemetery on the outskirts of Timbuktu. Local legend has it that Timbuktu is surrounded and protected by 333 renowned saints, as well as numerous lesser saints. In the Sufi tradition, a *wali* or saint is a Muslim mystic, usually a scholar, who has achieved such closeness to God as to possess special powers or *baraka*.

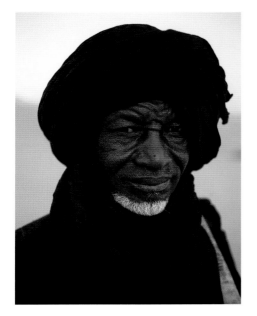

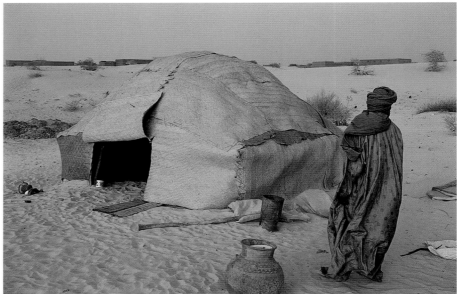

ABOVE AND OPPOSITE, LEFT TO RIGHT
A shepherd; a desert shelter; a nomad
collecting wood to make afternoon tea;
and a cow. Life in the desert is as harsh
as ever, and remains totally dependent on
traditional survival skills and an intimate
knowledge of the terrain.

chronicles the *Tarikh al-sudan* and the *Tarikh al-fattash*, both completed in the mid-17th century. Before this period, the only known written sources for the history of West Africa are by medieval Arab authors from North Africa, al-Andalus and Egypt. Such texts have many weaknesses. Their authors for the most part lacked first-hand knowledge of West Africa. They betray racial prejudice against black Africans, partly derived from the close relationship between blackness and slavery in the Arab world at the time. Their knowledge of geography was flawed: they referred to the River Niger as the Nile, assuming these two rivers had the same source. However, crucially, they did have access to first-hand sources. A number of Arab Muslims crossed the Sahara and made visits to West Africa, probably to trade, and on their return provided information to Arab writers and geographers.

Four authors in particular benefited extensively from reports gathered from visitors to the region, or from West Africans who visited the Arab world. One of them, al-Bakri, lived in al-Andalus and compiled information from Andalusian and North African merchants who had travelled across the Sahara through what is now Mauritania. This includes a precious description of ancient Ghana written in 1068. Soon after, in 1154, al-Idrisi, a geographer probably born in Morocco, wrote about areas of West Africa from what is today Senegal to Lake Chad.

The Syrian historian al-Umari wrote in early 14th-century Egypt an encyclopedia for bureaucrats that included a description of the Malian Empire, which established itself as the leading power in the region during the 13th century. Ibn Khaldun, the great North African philosopher and historian who died in 1406, gave a brief dynastic history of the Malian Empire in his general history of Islamic civilization.

To these we should add the first-hand account of the great 14th-century world traveller Ibn Battuta from Morocco, who besides visiting and writing about the Middle East and China during his lifetime, visited Ancient Mali and the Middle Niger in 1352–53 and described these regions

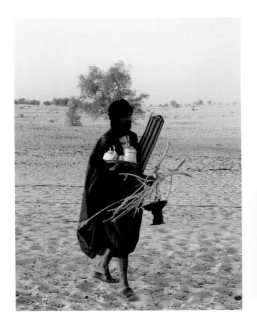
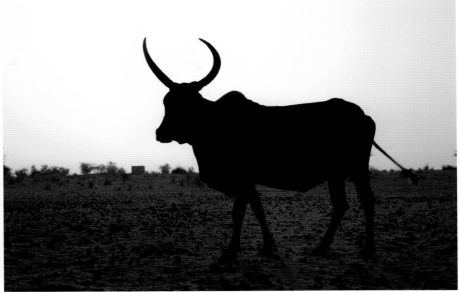

from the point of view of a tourist. He stayed six months with the ruler of the Malian Empire, Mansa Sulayman, and afterwards travelled to the Middle Niger, visiting Timbuktu. His account includes a description of his return journey on which he accompanied a caravan taking six hundred female slaves across the desert to Morocco.[5]

Another important North African who visited West Africa in the 1490s was the scholar al-Maghili, who came from Tlemcen near the Mediterranean coast. He first spent time in the oasis of Tuwat, in present-day Algeria, and then crossed the Sahara, teaching in Takedda and then Kano and Katsina. From there he moved on to Gao, where he provided advice on several issues to the ruler of the Songhay Empire, Askiya Muhammad (see pages 54–55).

Shortly after that time, the Songhay Empire was visited by Leo Africanus, a Muslim of Spanish origin whose parents had moved to Fez.[6] He travelled throughout North Africa and twice through West Africa in the early 16th century. In 1518, on his return to Morocco after visiting Egypt during a pilgrimage to Mecca, he was captured by Sicilian corsairs in the Mediterranean. They took him to Rome where they presented him to Pope Leo X as a slave. Within a year, the Pope had baptised him under the name Johannis Leo de Medicis. He remained in Rome for some time, and wrote a book published in Italian in 1550 called *Discrittione dell'Africa* (Description of Africa), including a section on Timbuktu. He came to be known as Leo Africanus.

THE PEOPLE OF THE NIGER BEND

The ethnic make-up of the Niger Bend area today is extremely complex, and is a testament to the rich and turbulent past of the region. Its populations can be placed into three broad categories according to their economic and ecological base. These have been relatively consistent over time. Along the desert fringes are pastoral nomads; nearer the river live sedentary hunting and agricultural populations, segments of which engage in inter-

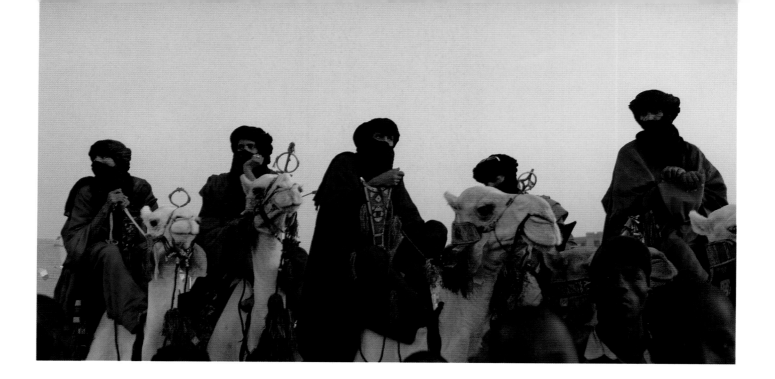

ABOVE Tuareg nomads on camels. Known as 'Masters of the Desert', the Tuareg traditionally protected – or raided – the great camel caravans passing through the desert. They also took control of Timbuktu on a number of occasions when the city's overlords fell away and left a political vacuum.

regional trade; and along the River Niger and the lakes are populations that engage in fishing and hippopotamus hunting, and provide water-borne transportation for people and goods.

Around the year 1000, the pastoral nomads of this region consisted mainly of Sanhaja and other Berber groups, with an economy based on camel and sheep rearing, long-distance transportation, and raiding and extortion. By 1600 these had been largely overtaken in the west by Hassaniyya Arabs migrating through the western Sahara from southern Morocco, and in the east by Tuareg groups migrating in from the northeast. The origins of the Tuareg are uncertain, and have been the subject of much speculation; however, their earliest proven origins are in Libya, from where they moved south and west, occupying the massifs of the Adrar-n-Iforas in Mali, the Aïr in Niger, and the Hoggar in Algeria. They are known as the 'Masters of the Desert'.

Tuareg society was traditionally divided into four hierarchical groups: warriors, scholars, artisans and slaves. Slavery has long been abolished, though remnants of the old system remain. All these Tuareg groups refer to themselves as 'Kel Tamasheq' or speakers of the Tamasheq language.[7] Tuareg women, according to Ibn Battuta's description from the mid-14th century, were 'the most beautiful of women and of the most pleasing appearance, being very white and plump.'[8]

The Tuareg are most renowned for their warriors and their artisans; less is known of Tuareg scholars, called *ineslemen* in Tamasheq. In fact the Tuareg seem to have been the first people in the region to master writing. Their alphabet, *tifinagh*, which is often found inscribed on rocks in the desert, was probably already developed by the end of Neolithic times.[9] It is still used today by some Tuareg for letter writing and has even been adapted to communications on the internet.

In the area stretching northwest of Timbuktu were Hassaniyya-speaking Arabs who linked the territories of the Niger Bend with those of

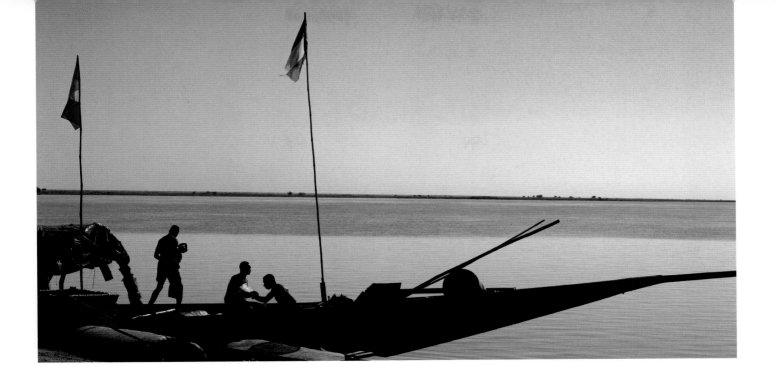

the Moroccan sultanate. They too were a population characterized by a hierarchy of warriors, religious men, tributaries, slaves and artisans, and their scholars in neighbouring Wadan and Walata shared much with the learned elites of Timbuktu.

To the south was another pastoral nomadic people of the Middle Niger, the Fulani, cattle herders who had moved from the edge of the southern Sahara in the 11th century down into the Inland Delta of the River Niger.[10] While descendants of these Fulani continue to herd cattle in the area today, other groups spread southwest to Futa Toro (in the Senegal River valley) and Futa Jallon (in the Guinea Highlands), where they became known as the Tukulor.[11] Other groups continued eastwards into what is now northern Nigeria and on to Chad and Darfur.

The Songhay are a sedentary agricultural and trading population originating from the Dendi area by what is today the Niger–Benin border. They moved northwards well before the year 1000 and made Gao their capital, living along stretches of the Niger Bend. It was during the period of the Songhay Empire in the 15th and 16th centuries that Islamic scholarship in Timbuktu was at its height. Many of the Timbuktu scholars were Songhay, including Abd al-Rahman al-Sadi, author of the *Tarikh al-sudan*.

The Bozo and the Sorko are both populations that engage in fishing. The Sorko were amongst the earliest inhabitants of the Middle Niger region, whose traditional role of providing water-borne transportation made them 'Masters of the Water'. Further south were the Mande groups, many of them traders, including the Soninke, Malinke, Bambara and Wangara.

The fact that the ethnic groups in the Middle Niger region were to a large extent distinguishable by their different occupations and adaptations to their surroundings made for precarious and shifting relationships of interdependency, cooperation, alliance and conflict.[12] Most of these groups at one time or another exercised considerable control over the

ABOVE Pirogue with Malian flags on the River Niger. As the Tuareg were 'Masters of the Desert', the Sorko tribe of fishermen and hippopotamus hunters were 'Masters of the Water' – and hence masters of that great lifeline of the Songhay Empire and its successors, the River Niger.

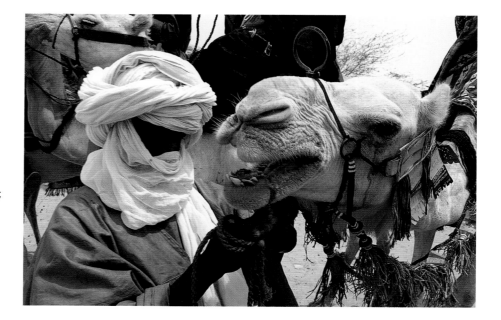

RIGHT Tuareg nomad with camel. The Tuareg call themselves 'Kel Tamasheq' or 'those who speak the Tamasheq language'; the name 'Tuareg' is a term used by outsiders. The Tuareg were originally a Berber people whose traditional economy was based on raising cattle, camels and goats, and providing security to the great trading caravans passing through the desert.

region: the Soninke in the time of ancient Ghana, the Malinke during the Malian Empire, the Songhay at the time of the Songhay Empire, and subsequently the Bambara of Segu, the Fulani of Massina, the Kounta of Arawan, the Tukulor under the empire of Umar Tall, and the Tuareg who jostled for control whenever there was a political vacuum.

THE SPREAD OF ISLAM

From its very earliest days as a seasonal camp, Timbuktu was an Islamic settlement. Islam reached the African continent about 1400 years ago. The first Muslims to enter Africa sought refuge in Christian Ethiopia in about the year 615 CE. Just a quarter of a century later many more Muslim Arabs pushed their way into Egypt during the great movement of conquest and expansion. By the end of the 7th century they had taken over all lands of North Africa to about 240 km (150 miles) south of the Mediterranean coast, all the way from the Red Sea to the Atlantic. Although some exploratory thrusts were made into the Sahara, no actual conquests were made; instead expansion turned northwards across the Mediterranean and into the Iberian Peninsula. Arabic became the dominant language of all these territories within decades, and Islam was gradually adopted by the conquered peoples.

Although the invading Arabs had made no immediate attempt to enter or cross the Sahara Desert as they penetrated North Africa, over the coming centuries Islam was introduced to some of the nomadic peoples of the Sahara, and to some of the black African kingdoms along its southern borders. This came about not through conquest or political domination, but through the agency of Muslim traders, whose primary objective was to obtain the gold that was mined in parts of West Africa, largely in territory that now lies in the Republic of Mali but by the 15th century from gold fields as far south as present-day Ghana. By the end of the 11th century a number of African rulers in this region were Muslim, and the majority populace of the Berber tribes of the western Sahara adhered to Islam.

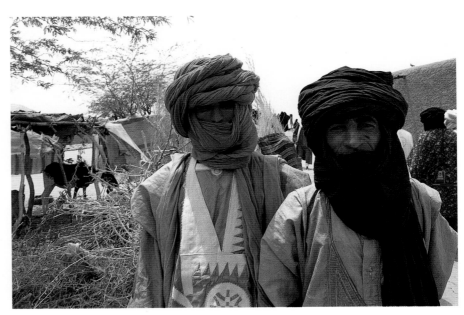

In the mid-11th century there arose among the Sanhaja nomads of the western Sahara the militant Islamic movement known as the Almoravids. The Sanhaja had originally migrated from the south of what is now Saudi Arabia across North Africa all the way to the Atlantic coastline of present-day Mauritania. During the second half of the 11th century, branches of the Almoravid movement destabilized ancient Ghana, then conquered and unified Morocco and the Arab regions of the Iberian Peninsula. Another Sanhaja group, known as the Massufa, moved south, first to what is now the town of Walata in Mauritania and then on towards the River Niger in search of pasture and water for their camels. There they established the camp that was to become the city of Timbuktu, bringing with them Islamic culture and learning, as well as the Arabic language.

Africans who converted to Islam soon learned the Arabic language so that they could read the Koran and properly offer its verses in their five daily prayers. Although Arabic did not become their main language of speech, as it had in North Africa and the Middle East under Arab rule, many sub-Saharan Africans soon adopted Arabic as their language of writing. Indeed Arabic can fairly be described as 'the Latin of Africa', for it played a role in Africa south of the Maghreb and Egypt over the past millennium comparable with that of Latin in Europe in the Medieval era. Just as the spread of literacy in Latin went hand in hand with the spread of Christianity, and as many Europeans also adopted the script of the Latin language to write their own native languages, so some Africans used the Arabic script to write their native languages.

The most dynamic and popular force to channel Islamic practice throughout the Muslim world has been Sufism or mysticism as promoted by the Sufi brotherhoods or orders. Two Sufi orders or *tariqas* came to wield strong spiritual influence over Western Africa. The first was the Qadiriyya, originating in Baghdad in the 12th century in the teachings of Abd al-Qadir al-Jilani (1077–1166), and later adopted in North Africa and by Saharan

THIS PAGE Unlike many Muslim communities, it is Tuareg men not women who traditionally veil their faces. Their fondness for indigo, and the tendency of their indigo robes and turbans to stain their skin, inspired the epithet 'the blue people'.

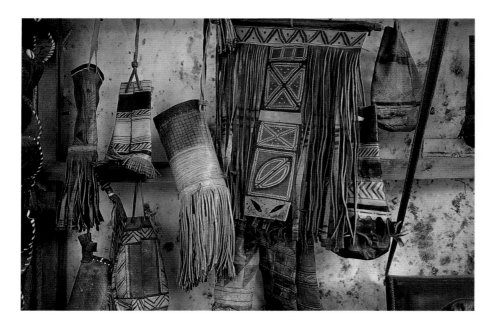

THIS PAGE Traditional Tuareg tasselled leatherwork and simple leather sandals.

tribes such as the Kounta (see page 57). A second *tariqa*, the Tijaniyya, overtook the Qadiriyya in the 19th century, though not among the Kounta. Its founder, Ahmad al-Tijani (1737–1815), was born in the Algerian oasis of 'Ayn Madi, and then moved to Fez in Morocco. His teachings were adopted by the Idaw Ali tribe of what is now southern Mauritania, and then promoted in Futa Jallon in today's Guinea by Umar Tall, who went on to conquer much of present-day Mali (see pages 59–60). The Tijaniyya *tariqa* was adopted by many West Africans in the 20th century.

Since the second half of the 20th century, however, Sufi *tariqas* – especially the Tijaniyya – have been opposed by Africans who have spent time in Arabia and come under the influence of the Wahhabiyya movement. The official doctrine of the Saudi Arabian state, this encompasses a strict and literal interpretation of the injunctions of the Koran, and opposes many Sufi practices, in particular the Sufi reverence for saints (*wali*).

TRANSSAHARAN TRADE

The people of Timbuktu were always dependent upon local trade for acquiring day-to-day provisions, and all ethnic groups were in one way or another involved in trading activity. However, the city flourished on the profits of transsaharan trade. To control the trade routes it was necessary to control the means of transportation, including those groups who made transportation possible. The Tuareg and other nomadic groups protected (or raided) trading caravans, and it was essential to have them on your side when crossing the desert. The Sorko were masters of that great lifeline of the region's consecutive empires, the River Niger. Under the Songhay Empire, they were considered a socially inferior group, who were 'owned' by the king or *askiya*; that is to say they had an absolute obligation of service.

Crossing the Sahara Desert was both dangerous and expensive and required great preparation including letters of introduction. Ibn Battuta describes how, on his way through the Sahara to Timbuktu, he hired a guide[13]

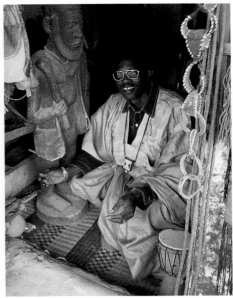

costing 100 mithqal of gold (a slave could be purchased in Timbuktu for about 80 mithqal). The guide was sent ahead with a letter to friends in the next town requesting preparations for their arrival, protection for their journey, and water. If the messenger had died on the way, the entire caravan risked a perilous fate.[14] A small caravan consisted of about 80 camels, larger caravans up to 3,000 camels.[15] Two camels could be purchased for about 37 mithqal.[16] On the other end of the journey a fleet of boats awaited at the port of Kabara, 20 km (12 miles) south of Timbuktu, after having unloaded merchandise heading for the great North. Leo Africanus described activity at the port in 1506: 'Kabara is a large town...twelve miles from Timbuktu, on the Niger. It is from there that merchants load merchandise to go to Djenne and Mali... One finds there blacks of different races, because it is the port to which they come from different regions with their canoes.'[17] The *Tarikh al-fattash* describes a fleet of 400 large boats, as well as 1,000 large and 600 small dug-out canoes at the time of the Songhay Empire.[18]

A great variety of goods were transported northward: slaves, ivory, grain, goat hides, ostrich feathers and cola nuts, among other items of tropical produce. There is little doubt, however, that it was the lure of gold that was the primary incentive for North African merchants to undertake the perils of a Sahara crossing. Gold dust was obtained from Bambuk, a region lying between two tributaries of the River Senegal, and somewhat later from Buru on tributaries of the Upper Niger. From the late 14th century Muslim traders also obtained gold mined in the pagan Akan forest areas in modern Ghana, bringing it up to Djenne and thence to Walata or Timbuktu, from where it continued north on camel back.

Myths circulated about the 'silent trade' and the 'gold plant'. Al-Umari was told: '[The gold-plant] is found in two forms. One is found in the spring and blossoms after the rains in open country. It has leaves like the *najil* grass and its roots are gold. The other kind is found all the year round at known sites on the banks of the Nil (Niger River) and is dug up.'[19]

THIS PAGE A street market and shop in Timbuktu. The people of Timbuktu have always been dependent upon local trade for acquiring day-to-day provisions, and all ethnic groups are in one way or another involved in trading activity. Historically, however, the city rose to greatness on the profits of transsaharan trade. Timbuktu was a strategic hub in commercial networks extending from the gold fields of Ghana and Guinea to the Mediterranean and beyond.

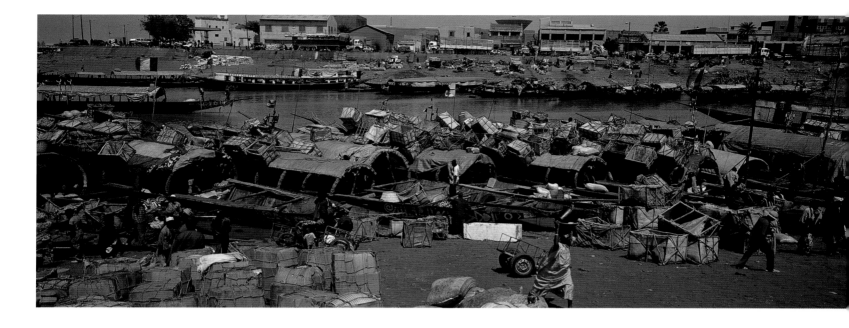

ABOVE The port of Mopti, south of Timbuktu. Mopti today is a flourishing trading centre strategically located between northern and southern Mali. Its port gives an impression of what Kabara, the port of Timbuktu, might have looked like in the heyday of transsaharan trade.

According to early Arabic sources from the 10th century, there was a careful avoidance of direct communication between gold traders from the southern regions of West Africa and traders coming from the North in order to keep the locations of gold production secret:

'They bargain with them without seeing them or conversing with them. They leave the goods and on the next morning the people go to their goods and find bars of gold left beside each commodity. If the owner of the goods wishes he chooses the gold and leaves the goods, or if he wishes he takes his goods and leaves the gold…. From there the merchants carry goods to the shore of that river.'[20]

Gold was much in demand among traders in North Africa, notably in present-day Morocco and Algeria, and was also exported to Europe. Indeed almost two-thirds of the world's gold in the late Middle Ages may have come from West Africa.[21] The most important item exchanged for the gold was rock salt, obtained from pits in central Saharan locations such as Taghaza and Taoudenite. The historian al-Umari reported that the people of West Africa 'will exchange a cup of salt for a cup of gold dust.'[22] Salt was as plentiful in the Sahara as gold was further south. Although various powers attempted to conquer and hold the areas where the salt was mined, the salt mines themselves were controlled by desert nomads and worked by their slaves. Travellers' tales told of Saharan cities made of salt,[23] just as myths spread about Timbuktu being an Eldorado paved with gold. Such fictions circulated throughout the Middle East and Europe right up to the 19th century. In reality gold, like salt, simply passed through the city; neither originated there.

Cloth, cowrie shells, tea and tobacco were also imported to the western Sahel from other parts of the world. Cloth was essential to the region's strict dress code, particularly for the long embroidered robes or *boubous* and headdresses worn by both men and women. The tailoring industry of Timbuktu provided a livelihood for many of the students of the

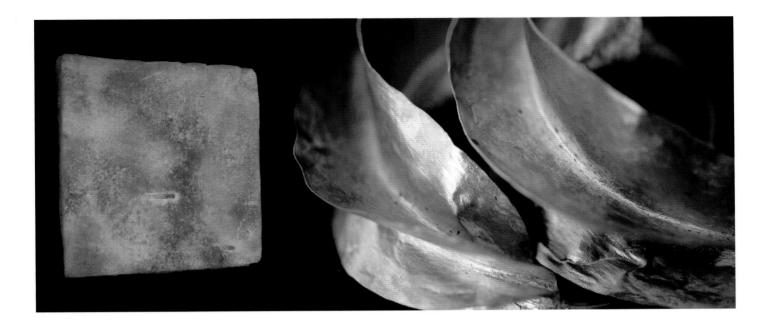

city. Locally produced cloth was also used as a type of currency, as were cowrie shells brought from the Maldive Islands in the Indian Ocean. The shells were used for smaller transactions, and there was a fixed rate of exchange between them and gold. Judging by the number of poems about tea one finds among the manuscripts of Timbuktu, this was an extremely cherished item, as it is today. Tobacco is the subject of many letters and treatises. The use of tobacco had been approved in a treatise by Ahmed Baba, one of the most respected legal authorities of the region in the 16th century, who declared it neither a narcotic nor an intoxicant.[24] The prohibition of tobacco was later to be one of the main issues in the conflict between the Fulani jihadists and the Kounta in 19th-century Timbuktu (see page 58), highlighting the continued importance of tobacco in the society and economy of the region.

However, according to Leo Africanus, the single most profitable trade item in Timbuktu was books.[25] The *Tarikh al-fattash* relates how a great dictionary had been purchased by the king for the equivalent of the price of two horses.[26] Purchasing books was a source of prestige and a socially accepted way of displaying wealth, and scholars and kings alike would acquire books during their travels or from merchants coming from the north who would bring books for local sale.[27]

Trade was characterized by significant geographical, seasonal and annual price fluctuations, and Timbuktu was often used as a depot for storing goods by merchants keen to maximize their profits. Goods were considerably cheaper before crossing the great desert as transportation costs were high; however, West Africans were known to pay high prices even before goods had traversed the desert. Al-Umari relates that:
'Merchants of Cairo have told me of the profits which they made from the Africans, saying that one of them might buy a shirt or cloak or robe or other garment for five dinars when it was not worth one.... They greeted anything that was said to them with credulous acceptance. But later they

ABOVE LEFT Rock salt, still mined in the Sahara and transported into Timbuktu and towns further south. These days the salt is usually carried by truck, but there are still camel caravans in operation. It is a great happening when a caravan arrives at a town or village.

ABOVE Gold earrings of a design worn today by women of the Fulani tribe. Over two-thirds of the world's gold may have come from West Africa in the late Middle Ages. In Timbuktu and other trading centres it was exchanged primarily for salt – often weight for weight.

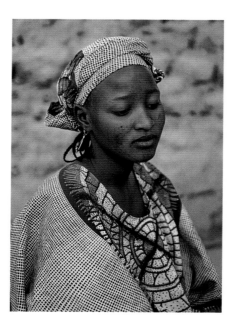

RIGHT A woman from the Bela tribe, traditionally the slaves of the Tuareg.

FAR RIGHT A wild date tree, said to be one hundred years old, in the middle of the medina in Timbuktu. Slaves brought to market were tied by their feet to this tree. Along with the trade in salt and gold, the slave trade was for centuries a major component in transsaharan commerce.

formed the very poorest opinion of the Egyptians because of the obvious falseness of everything they said to them and their outrageous behaviour in fixing the prices of the provisions and other goods which were sold to them, so much so that were they to encounter today the most learned doctor of religious science and he were to say that he was Egyptian they would be rude to him and view him with disfavour because of the ill treatment which they had experienced at their hands.'[28]

Commercial systems depended on developing and maintaining trustworthy networks along the chain of local tradesmen from North Africa to the forest regions in the south. They were also reliant on the development of legal systems for regulating trade at every trading point as well as the documentation of practically every single transaction. The following correspondence conveys something of the complexity of multi-layered trading activities in Timbuktu, involving goods left in trust, currency exchanges and commercial agents:

'I have left with Ahmed Kawa two bars of salt which you remitted to me. On my return I found that he had sold them for 12 *riyals* because he is my representative at Saraféré and I do not live in that town. You will find the amount of which I speak with Maliki Hamma. He would like, together with Tat Kabara Farma, to take my two bars of salt which you know about. You can bring him the watermelon which is with her, to give it to Samba Oumran because he is coming to me. You can give to Samba the price of the metal knife. If possible, give Samba what is agreed between us.'[29]

Customs of gift-giving also contributed to the movement of goods and people. Although the transsaharan journey was risky, the rulers of West Africa prided themselves on transporting gifts to the sultans of Morocco and Egypt. Ibn Khaldun wrote in the late 14th century about Sultan Abu al-Hasan, King of the Maghreb, who presented a gift to Mansa Sulayman, ruler of the Malian Empire. Mansa Sulayman wanted to show his apprecia-

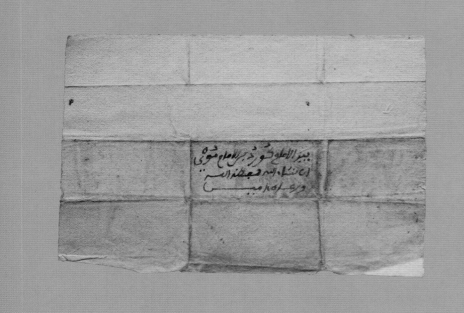

tion by offering something strange and curious from his country in return. Thus a giraffe was transported from Mali over the Sahara to Fez.[30]

In times of conflict, plundered goods were also transported across the region. The *Tarikh al-sudan* relates that the Songhay Emperor Askiya Dawud: 'fought the commander of the sultan of Mali...and defeated him. Whilst on this expedition he married Nara, the daughter of the Sultan of Mali, and despatched her to Songhay accompanied by a magnificent train containing jewelry, male and female slaves, furnishings, and household goods and utensils, all covered in gold leaf, as well as water vessels, mortar and pestle, and other items.'[31]

THE SLAVE TRADE

The transsaharan slave trade ranked among the most significant commercial activities of the region. Most ethnic groups had their own slaves who were bought and sold locally, exported to North Africa and Europe, or eventually set free. Al-Idrisi reported that 'Peoples of the neighbouring countries continually capture [the naked people south of the River Niger] using various tricks. They take them away to their own lands, and sell them in droves to the merchants.'[32]

The earliest descriptions of the West African slave trade are from the mid-11th century, when Awdaghast, in present-day Mauritania, was a location for the buying and selling of slaves. The Andalusian geographer al-Bakri recorded that the main population of Awdaghast at the time consisted of North African Berbers, but he noted that there were also black women, who as good cooks were sold for 100 mithqal each (roughly 425 grams of gold).[33] There were also light-skinned, very attractive slave girls, whose description implies that they were concubines. The slaves thus transported to North Africa were primarily used in domestic service including concubinage; however, the next most common usage was as soldiers. In the following century, black slaves were taken across the Sahara to

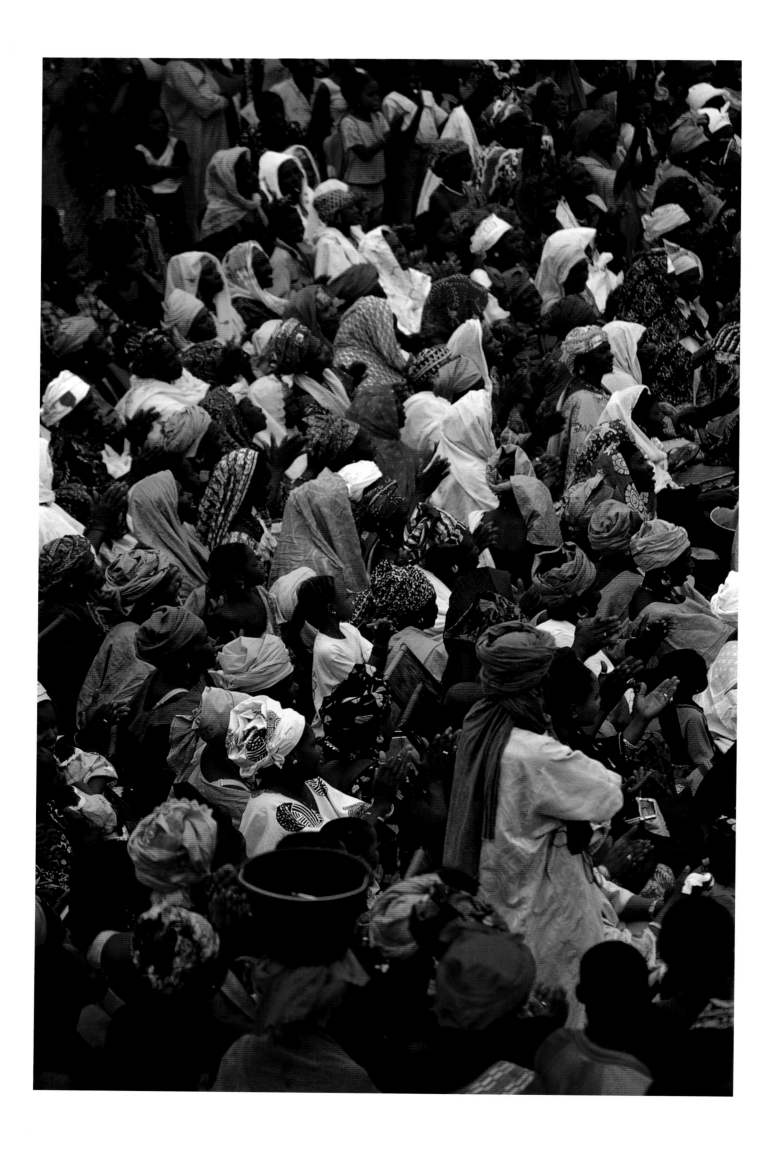

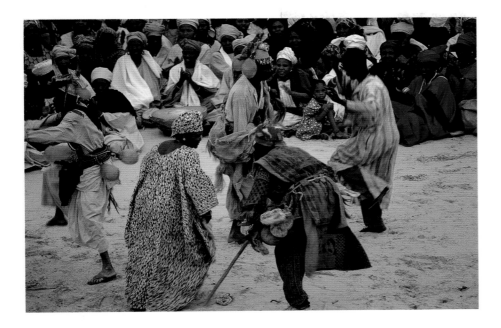

Morocco and black soldiers served the Almoravids. The army's strength was maintained by marrying male and female slaves and training up the resultant offspring – boys for the army, girls for palace service. From the 17th century the transsaharan slave trade provided the Ottoman sultans with eunuchs to guard the harem of the Topkapi palace in Istanbul, while others were sent to serve in the Prophet's Mosque in Medina or the Mosque of the Ka'ba in Mecca.

The oasis of Tuwat in the northern Sahara served as an entrepot where slaves from the south were interrogated before being sent north. In the 16th century, Ahmed Baba provided advice to traders who were trying to determine whether humans brought to Tuwat could be enslaved according to Islamic law. If they could demonstrate that they were true Muslims, according to his interpretations, the enslaved individuals should be freed. In one of Ahmed Baba's legal works he divided the lands of West Africa into two: lands of Muslims, and lands of 'unbelievers'. He stated that it is only permissible to enslave those who live in one of the lands of the 'unbelievers'.[34] According to the 14th-century legal authority Khalil ibn Ishaq, when non-Muslims were conquered, the imam had the discretion to kill them, free them, make them pay a tax or enslave them.[35] Setting a slave free was considered an act of piety and the abolition of slavery would therefore deprive Muslims of the opportunity of a personal good deed.

The average price for a slave was less than the price for a book, and the rather nonchalant attitude towards purchasing slaves in Timbuktu is demonstrated in a letter in which a shaykh asks a freed slave to buy him a great boubou and to have it cut by a very good tailor. He then asks him to purchase a slave for him with the remaining amount.[36]

GHANA, THE KINGDOM OF GOLD
According to early accounts by historians and travellers of the Arab world, the ancient Soninke Empire of Ghana located west of Timbuktu gained a

ABOVE AND OPPOSITE Celebrations in Timbuktu to commemorate the end of the Tuareg rebellion of the 1990s. Traditions of music and dance are especially rich among the peoples of Mali. Attempts by Fulani jihadists to impose an austere interpretation of Islam in the mid-to-late 19th century, including outlawing tobacco, segregating women from men, and simplifying the dress code, met with stiff resistance in Timbuktu.

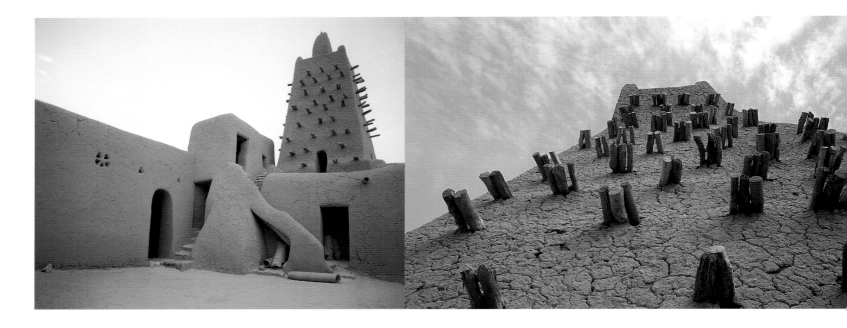

ABOVE The Djingereber, the Great
Mosque of Timbuktu. This is the oldest of
Timbuktu's three major mosques, dating
from the first half of the 14th century.

reputation for its great wealth in gold from as early as the 10th century.
Gold dust was brought up from the banks of the River Senegal to towns in
the southern Sahara such as Awdaghast and Tadmekka to be exchanged for
North African goods and transported northwards. Accounts tell us that
'[The ruler of] Ghana is the wealthiest king on the face of the earth because
of his treasures and stocks of gold'[37] and that 'no other mine in the world is
known to have more abundant or purer gold.'[38] The king was reported to
'tether his horse with a gold nugget as large as a big stone.'[39]

As the Almoravids gained control over the trade routes of the
western Sahara in the later 11th century, the merchants of ancient Ghana
dispersed and the Empire's prosperity diminished. According to Ibn
Khaldun, 'the authority of the people of Ghana waned and their prestige
declined as that of the veiled people, their neighbours on the north next
to the land of the Berbers, grew. These extended their domination over the
Sudan (people from the 'land of the blacks'), and pillaged, imposed tribute
and poll-tax, and converted many of them to Islam. Then the authority of
the rulers of Ghana dwindled away and they were overcome by the Susu, a
neighbouring people of the Sudan, who subjugated and absorbed them.'[40]

THE MALIAN EMPIRE

As ancient Ghana slowly collapsed, the Malian Empire of the Malinke
people, probably based near what is now the Bamako area, established itself
as the leading power of the region in the 13th century. The Malian Empire
inherited the riches of Ghana and extended its borders to the Atlantic Ocean.
By the late 13th century both Timbuktu and Gao were occupied and the
empire's territory covered an area about the size of Western Europe or 'four
or more months' journey in length and likewise in width'.[41] The empire
profited both from the gold mines within its lands and from gold passing
through. But the Malian ruler was hesitant to occupy the gold fields in
the forest regions further south. He claimed that each time he conquered

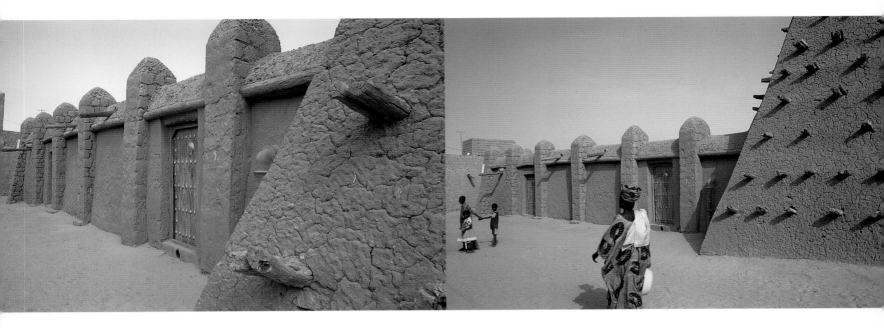

these territories, the gold would miraculously disappear, reappearing in neighbouring heathen countries: 'If we conquer them and take the land, it does not put forth anything..., but when it is returned to them it puts forth as usual.'[42] In reality the Malians did not know precisely where the gold fields were and had to rely on local producers, who only had an incentive to mine gold when they were the middlemen and the Malians the outsiders.

In the year 1325, the Malian Emperor Mansa Musa famously made a pilgrimage to Mecca laden, we are told, with 2,200 lbs (1,000 kilos) of gold. As described in the *Tarikh al-sudan*, 'Mansa Musa was a just and pious man, whom none of the other sultans of Mali equalled in such qualities. He made a pilgrimage to the Sacred House of God, departing – God knows best – in the early years of the 8th century [ie 14th century CE]. He set off in great pomp with a large party, including 60,000 soldiers and 500 slaves, who ran in front of him as he rode. Each of his slaves bore in his hand a wand fashioned from 500 mithqal (about 2 kilos) of gold.'[43]

Upon arrival in Egypt, Mansa Musa's gifts and purchases in gold were so lavish that they greatly upset the Egyptian economy. Al-Umari related that Mansa Musa 'flooded Cairo with his benefactions. He left no court emir nor holder of a royal office without the gift of a load of gold. The [people of Cairo] made incalculable profits out of him and his suite in buying and selling and giving and taking. They exchanged gold until they depressed its value in Egypt and caused its price to fall...'[44]

Mansa Musa recognized that fostering Islam was to his advantage for ruling his large empire. On his return from Mecca, he purchased works on Maliki law, the school of Islamic law dominant in West Africa. He also ordered the construction of the Djingereber Mosque in Timbuktu under the supervision of the Andalusian scholar and poet Abu Ishaq Ibrahim al-Sahili, who had travelled back with him from Mecca. Some years later during his reign, another large mosque was built in the Sankore quarter in the north of the city, financed by a woman from the Aghlal,

THIS PAGE AND OPPOSITE RIGHT Timbuktu's Sankore Mosque. Each year following the rainy season the mosques are restored by the town's population, who share the task of replastering the external walls with a fresh mud concoction. The protruding wooden sticks serve as scaffolding, enabling the highest surfaces to be reached.

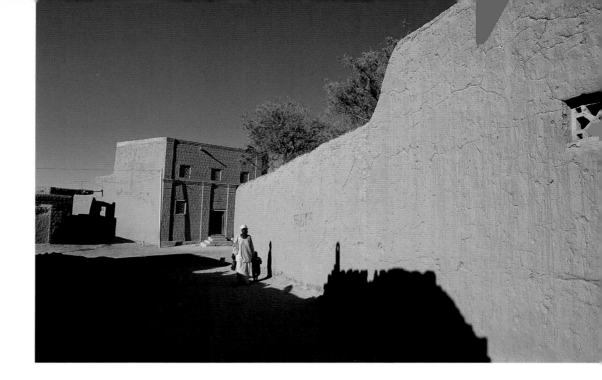

a religious Tuareg tribe. The Sankore quarter became a dwelling place for many scholars, especially the Massufa, who established the quarter as the pre-eminent location for Islamic teaching and study in the city.

The city of Timbuktu represented both the Islamization of Africa and the Africanization of Islam. When Ibn Battuta visited in 1352 he was greatly impressed by the city and its inhabitants – their lack of injustice, complete security, their care for the goods of a deceased visitor, their conscientious worship, their beautiful clothes, their ability to recite the Koran by heart. He was, however, taken aback by some of their customs, for example that a man could have female companions. And he was thoroughly shocked by the practice of some local women of going naked in public. 'The women's custom when they go into the sultan's presence is that they divest themselves of their clothes and enter naked...their female servants and slave girls and little girls appear before men naked, with their privy parts uncovered...I saw about 200 slave girls bringing out food from the Sultan's palace naked.'[45]

Islamic traditions established under Mansa Musa were threatened when in 1343 the pagan Mossi tribe attacked Timbuktu: 'The Mossi sultan entered Timbuktu, and sacked and burned it, killing many persons and looting it before returning to his land.'[46] But the Malians recovered from the devastation and went on to rule the city for a further hundred years.

As Malian power eventually did wane in the early 15th century, the Tuareg took advantage of the growing political vacuum. 'The Tuareg began to raid and cause havoc on all sides. The Malians, bewildered by their many depredations, refused to make a stand against them. [The Tuareg] said: "The sultan who does not defend his territory has no right to rule it."'[47] In 1433 the Tuareg drove the 'Malians' out of Timbuktu and back to their southern regions.

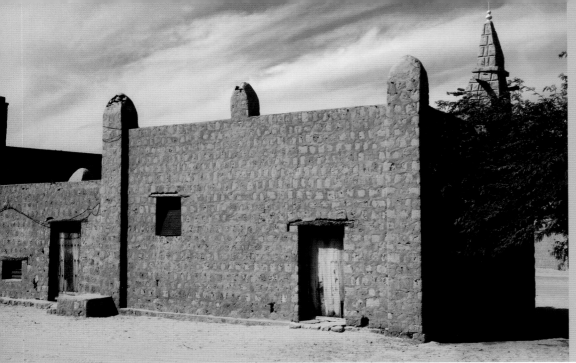
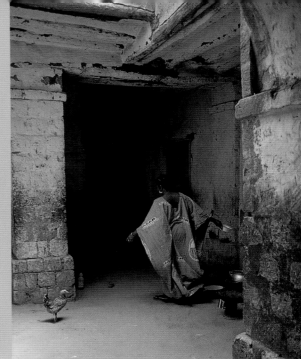

THE SONGHAY EMPIRE

In the early 15th century, the Songhay from Gao took over the territories of the former Malian Empire, including Timbuktu. The Timbuktu chronicles describe the 'bad' and 'good' rulers of the Songhay Empire. The expansionist Songhay ruler Sonni Ali Ber distrusted Timbuktu and became the pagan villain. He 'perpetrated terrible wickedness in the city, putting it to flame, sacking it, and killing large numbers of people.'[48] He also presided over a decline in the city's commercial fortunes. Gold traders from the south feared that under Sonni Ali they would lose control over their goods and transactions, so instead they started to export the gold via Kano in modern Nigeria, thus bypassing the Songhay territories.

Following a coup d'état, Timbuktu continued to be ruled by the Songhay for another century under a succession of benign and effective rulers of the Askiya dynasty who moved the centre of power northwards and not only restored the prosperity of the region and its scholars but presided over what is regarded as the city's Golden Age. According to the *Tarikh al-fattash*, 'One cannot count either the virtues or the qualities of [Askiya Muhammad], such is his excellent politics, his kindness towards his subjects and his solicitude towards the poor. One cannot find his equal either among those who preceded him, nor those who followed. He had a great affection for the scholars, saints and *talebs* (men of learning).'[49] Askiya Muhammad was also honoured further afield. During his pilgrimage to Mecca, 'the Sharif of Mecca...put on him a black turban and named him imam',[50] while the Abbasid caliph of Cairo gave him authority to rule Songhay in his name, legitimizing him as an Islamic authority, at least in the eyes of Timbuktu's elites.

Like all the great kingdoms of this region, the Songhay Empire flourished by maintaining the security of the transsaharan trade routes and controlling the means of transportation, whether that be a camel caravan or a fleet of canoes. However, this was the beginning of the period

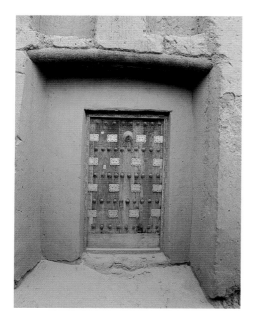 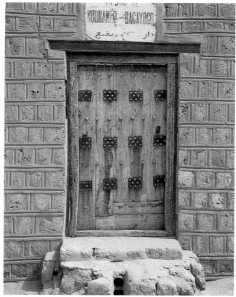 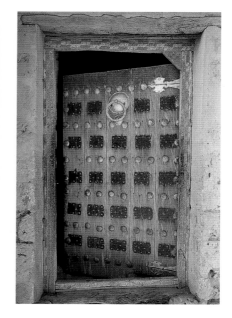

THIS PAGE AND OPPOSITE Heavy wooden doors ornamented with metal studs, panels and knockers are a characteristic sight in Timbuktu.

of European exploration and expansion, which brought new challenges. The Songhay Empire was greatly weakened when the Portuguese occupied ports on the west coast of Africa and diverted the gold trade to the Atlantic Ocean, bypassing the traditional transsaharan routes. By the time Leo Africanus visited Timbuktu in the early years of the 16th century and wrote about the city in his *Description of Africa*, the gold trade was already waning, as much as half of it rerouted to the coast.

JEWISH SETTLEMENTS IN THE SAHARA[51]

In the 15th century or earlier Timbuktu was visited by Arab traders from the oasis of Tuwat in the northern Sahara together with Jews who had settled in North Africa after being exiled from Palestine by the Romans in the 1st century CE. Many Jews were also living in the city of Tlemcen north of Tuwat near the Mediterranean coast, where they had settled together with Muslims when Spain was overtaken by Christians. The actual status of these Jewish merchants is not easy to decipher, for Muslim scholars had mixed feelings about them: some portrayed them as wealthy merchants, others as impoverished ghetto dwellers. Antonius Malfante, a Genoese merchant who tried to do business in Tuwat in 1447, described an affluent and secure Jewish community:

'There are many Jews who lead a good life here, for they are under the protection of several rulers, each of whom defends his own clients. Thus they enjoy very secure social standing. Trade is in their hands, and many of them are to be trusted with the greatest confidence....'[52]

However, in a letter to North African scholars seeking a legal opinion (*fatwa*) on whether local Jews should be allowed to maintain a synagogue, the *qadi* or judge of Tuwat claimed that the Jews were 'downtrodden and humiliated, mainly living in a single street where their synagogue was situated among the houses.' The North African scholar al-Maghili wrote a treatise on the Jews, describing them as 'enemies of God'

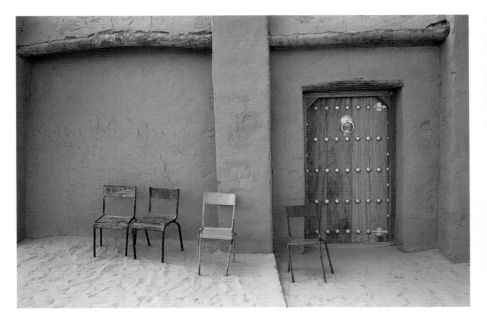
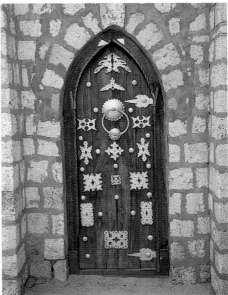

and providing scurrilous anecdotes intended to portray them as treacherous and filthy in order to justify killing their men, enslaving their women and children and seizing their property. He later persuaded the Songhay Emperor Askiya Muhammad to forbid the entry of Jews into his territory.[53]

Although Jews were officially banned from the Songhay Empire – on the advice of al-Maghili – this policy was not systematically enforced. When Mungo Park explored Western Africa in the late 18th century, he was told by an Arab he met near Walata that 'there were many Jews at Tombuctoo, but they all spoke Arabic, and used the same prayers as the Moors.'[54] In the 19th century more Jews came from North Africa (especially Morocco) to Timbuktu to pursue commerce, and some of the documents they created – in Arabic, but often with Hebrew remarks inserted – still exist in Timbuktu (see page 92). One Jewish community is known to have survived just south of Timbuktu, for the *Tarikh al-fattash* (completed 1665) tells of a Jewish settlement where numerous wells with 'glazed' sides supplied water for horticulture, producing vegetables of much higher quality than those grown in the flood plains of the Niger River.[55]

THE MOROCCAN OCCUPATION

In 1591, the Songhay Empire rapidly succumbed to an invasion force from Morocco. The Moroccans had already used both diplomacy and force to wrest the salt pans of Taghaza from Songhay control.[56] But this was not enough: Sultan al-Mansur of the Sadian dynasty sought control over riverine transport, both boats and their crews, and he also had ambitions to take over territories as far as the gold fields further south – ambitions that gave him the nickname Dhahabi or 'the Golden'. The Sultan sent an army of Spanish, Berber and Arab mercenary soldiers called the Arma to conquer Gao and Timbuktu. The Arma included 4,000 musketeers, while the Songhay military had but bows and arrows.[57] As al-Mansur's forces were in the process of subduing the Songhay, they wrote to the local chief

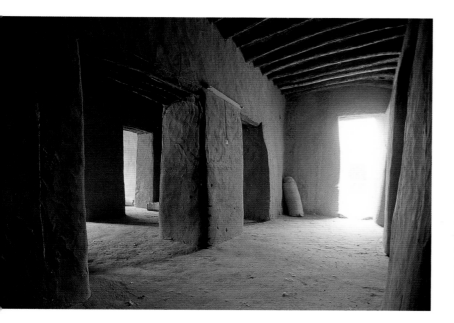
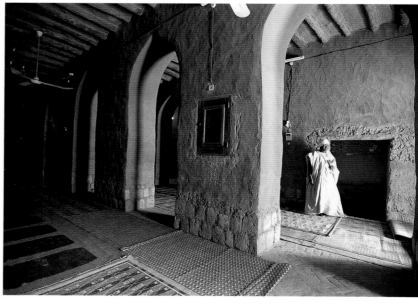

Interior of the Sidi Yahia
Mosque, Timbuktu, with Imam Mahmoud
Hasseye Sidi Yahia. The mosque was
originally built in the 15th century, though
it has been rebuilt several times. Its imams
have always been descendants of the first
imam, Sidi Yahia al-Tadallisi, patron saint
of Timbuktu, in whose honour and name
the mosque was first built.

demanding that he hand over 'the whole of the annual quota of boats which
you used to give to the [Songhay] *askiya* and that they continue to perform
their necessary duties.'[58]

At first the Arma soldiers treated the Timbuktu population with
brutality: 'Pasha Mahmud entered their houses and removed all the valu-
ables, household goods, and furnishings in quantities that no one but God
could measure, some being the scholars' own property and some the
property of those who had deposited it with them. His followers plundered
whatever they could lay their hands on, and brought dishonour upon the
scholars, stripping their womenfolk and committing acts of indecency.'[59]
A contemporary English observer in Morocco, Jasper Thomson, reported
the arrival from Timbuktu of the leader of the Arma, Pasha Jawdar, on 28
June 1599 with thirty camel-loads of gold dust, as well as great quantities of
pepper, unicorn (probably rhinoceros) horn, a certain wood used for
dyeing, fifty horses, many eunuchs and dwarfs, men and women slaves,
and '15 virgins, the Kings daughters of Gago [Gao] which he sendeth to be
the Kinges concubines'.[60]

Large numbers of fighting men were sent from Morocco to keep the
Sadian flag flying in the Middle Niger, but with diminishing economic
returns for the Sadian state.[61] The Moroccans had put an end to the initial
wave of pillaging and established Timbuktu as the administrative capital
of the occupied areas, which were ruled by a Pasha appointed from
Marrakesh. But in reality they never fully dominated the region. The Arma
integrated with the local population, marrying women from noble Songhay
families and creating a new social elite. In 1612 this elite deposed the Pasha
and seized power. The Arma went on to dominate the Niger Bend for
another century. But as the transsaharan gold trade declined, so their power
and prestige diminished.[62] Ultimately a new power vacuum was created,
this time eventually to be filled by the desert shaykhs.

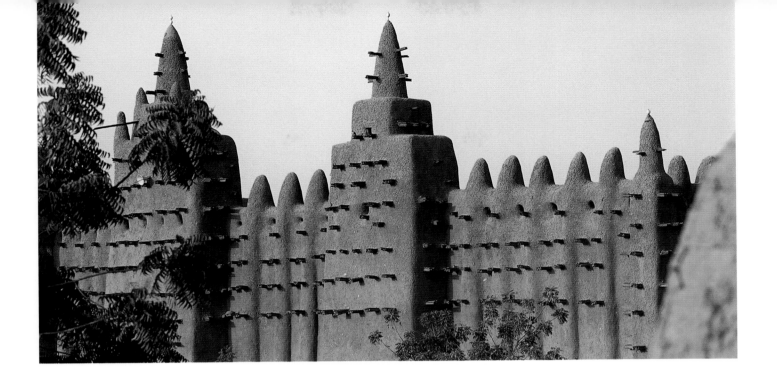

THE DESERT NOMADS

Life in the great desert or Azawad was made possible by man-made wells. Various groups gained control over the region by digging wells, which allowed desert towns such as Arawan and Boujebeha to flourish. As well as being masters of the trade routes, the Tuareg also had control over the wells until the mid-18th century, when both the salt mines and most of the wells were taken over by the Kounta.

The early history of the Kounta is unclear, but from the mid-16th century they began to emerge as a distinct and relatively large tribe, roaming over wide areas of the Sahara, and eventually settling in the oasis of Tuwat. In the mid-to-late 18th century a rift occurred in the dominant family. One brother migrated to what is now southern Mauritania, while another, Shaykh Sidi al-Mukhtar al-Kabir, combined pastoralism with commerce and established a network of trading posts from Wadi Dar'a through Tuwat to Timbuktu in the west and Katsina in the east. This great leader of the Kounta was known for his qualities of learnedness and sanctity, political astuteness and commercial acumen. The Kounta produced numerous scholars in the 19th and 20th centuries, of whom the best-known and most prolific were direct descendants of Shaykh Sidi al-Mukhtar al-Kabir.[63] They provided spiritual leadership for a great part of the region through the establishment of *zawiyas*, religious schools or lodges where they also disseminated the teachings of the Qadiriyya Sufi order. Arawan eventually served as a refuge for scholars fleeing from conflict and political feuding in Timbuktu.

Kounta and Kel al-Suq Tuareg scholars provided learned council, kept accounts, gave legal and medical advice, and educated youth. While the scholars provided the pen, others wielded the sword. Various Tuareg warrior groups exerted considerable control in the region through both protecting and raiding passersby. There was substantial rivalry between the various Tuareg factions, and the Kounta often acted as mediators; indeed this role seems to underpin a good deal of their political influence.

ABOVE The Great Mosque of Djenne, built in 1907. The Sudano-Sahelian architectural style spread hand-in-hand with the Islamic faith, so that mud brick mosques in this style (though nowhere else on such a scale) are at the centre of dozens of villages and settlements across Mali.

ABOVE A tailor advertises his services in Timbuktu. In the mid-17th century the *Tarikh al-fattash* reported 26 houses in Timbuktu with workshops for training tailors, each master tailor employing 50–100 apprentices. Enrolment was restricted to students of a certain level of education. Work in the tailoring industry secured students an income that enabled them to further their studies.[64]

By the beginning of the 19th century, a sector of the nomadic Kounta shaykhs of the southern Sahara had also gained administrative control over Timbuktu. Through the network of *zawiyas* they had gained great influence on customs and conduct across the region, both in matters of trade and in daily life. Their disciples carried the Qadiriyya *tariqa* widely over West Africa. They worked to retain the independence of Timbuktu in the face of concerted attempts at domination by the Fulani of Masina.[65]

The Kounta were renowned as promoters of peace, but even they were obliged to resort to force when their authority over Timbuktu was challenged by jihadist Tukulors led by Umar Tall.

THE FULANI OPPOSITION

For forty years, starting in 1826, the Kounta's authority in Timbuktu was under attack from jihads launched from the Fulani state of Hamdallahi in Masina, a region south of the Inland Delta of the River Niger. This Qadiriyya-inspired regime was founded by Ahmadu Lobbo, who claimed to be the spiritual successor of Askiya Muhammad, and it was initially supported by the leadership of the Kounta, despite many differences. One of these concerned the segregation of women. While Ahmadu Lobbo and his descendants believed women should be segregated from men in accordance with the teachings of Islam, the Kounta protested, knowing this was against the customs of the desert people and would incite strong resistance.[66] Lobbo also attempted to impose a ban on the consumption of tobacco, one of the trade items from which the Kounta had prospered.

In 1846 Ahmad al-Bakkay al-Kounti negotiated a pact with the Fulani of Masina under which the administration of Timbuktu remained in Songhay hands, but with a Fulani judge (*qadi*) and tax-collector who supervised the payment of an agreed tribute. Ahmad al-Bakkay al-Kounti was a grandson of al-Mukhtar al-Kabir who had succeeded to the religious and political leadership of the Kounta. In 1853 the German scholar and explorer

 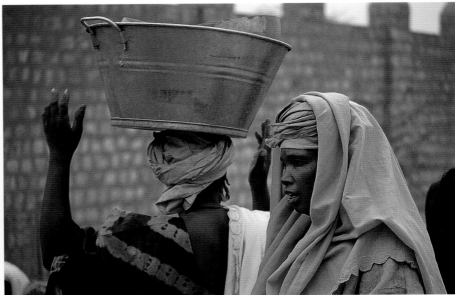

Heinrich Barth witnessed how the Fulani oppressed the people of Timbuktu: 'The [Fulani] had obtained...a slight advantage in political superiority, and they followed it up without hesitation and delay by levying a tax of 2,000 shells upon each full-grown person, under the pretext that they did not say their Friday prayers in the great mosque as they were ordered to do... Besides levying this tax upon the inhabitants in general, they also devised means to subject to a particular punishment the Arab part of the population who had especially countenanced the shaykh [al-Bakkay] in his opposition against their order to drive me (Heinrich Barth) out, by making a domiciliary search through their huts, and taking away some sixty or eighty bales of tobacco, an article which forms a religious and political contraband under the severe and austere rule of the Fulani in this quarter.'[67]

Masina was subsequently occupied by rival Tukulors (a group ethnically close to the Fulani) under the leadership of Umar Tall, originally from Futa Toro in what is now northern Senegal. On his return from pilgrimage to Mecca, Umar Tall had joined the Tijaniyya and adopted a more political and militant practice of Sufism than the region was accustomed to. He and his followers fell into conflict, both intellectual and military, with adherents of the Qadiriyya in the Niger Bend and with the established Bambara state of Segu. Umar Tall launched a jihad and led a large group of Tukulor north, occupying regions to Masina and then up to Timbuktu in 1862. There, to the distress of the Kounta, he attempted to force the Tijaniyya *tariqa* on the people of Timbuktu.

Al-Bakkay was much against jihads since he felt they bred tyrants, and he pleaded with Umar Tall to seek peaceful solutions to their differences; but when agreement broke down, he too was forced to put down his pen and take up his sword. He went on the attack with help from rivals of Umar Tall including Tuareg and Songhay elements. They joined forces with contingents of the defeated Fulani of Masina to besiege Hamdallahi, regaining Timbuktu and conquering Masina in 1864. Umar Tall fled to suffer a mysterious death in

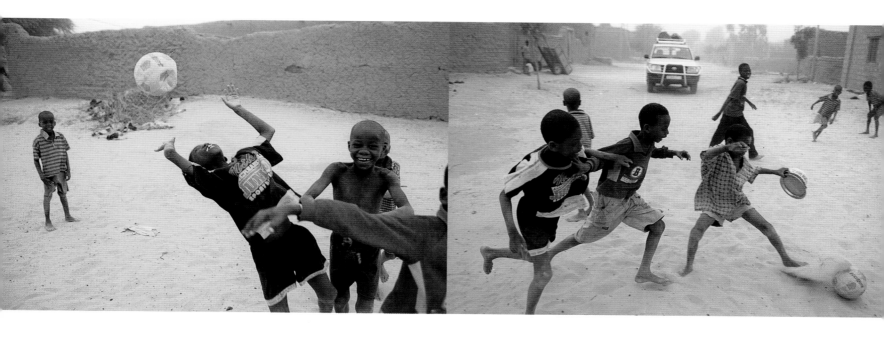

the land of the Dogon south of Masina. Al-Bakkay died soon after in 1865 during an attempted Tukulor counterattack at Saredina, where he was buried.

Of the Kounta, Barth observed: 'It is really surprising that a family of peaceable men should exercise such an influence over these wild hordes, who are continually waging war against each other, merely from their supposed sanctity and their purity of manners.'[68]

EUROPEAN EXPLORATION

Barth was not the only European witness to the early Fulani hostilities. There was great popular fascination with Timbuktu in early 19th-century Europe, and a race was launched to be the first to come to the 'great city of gold'. Very little was known of the economic and geographic realities of the region; the full course of the River Niger was not drawn on European maps until after 1830. Hitherto European cartographers, following medieval Arab and Jewish maps, had shown a connection between the Niger and the Nile, or alternatively represented the Niger as originating in an area around Lake Chad and flowing westwards to Senegal. In sum, Europeans knew less about the region than Arab historians of the 10th–11th centuries. European adventurers were sent one after another to explore these uncharted territories. One after another, they succumbed to tropical diseases or were killed by hostile locals who felt threatened by rival trading interests or who believed Christians had no business in Islamic territories.

The first European to reach Timbuktu and return alive was the Frenchman René Caillié who, disguised as an Arab, entered West Africa through Senegal and spent two weeks in the city in 1828. He recollected how: 'On entering this mysterious city, which is an object of curiosity and research to the civilized nations of Europe, I experienced an indescribable satisfaction... Timbuktu must contain at most about ten or twelve thousand inhabitants. The population is at times augmented by the Arabs, who come with the caravans, and remain a while in the city. The streets are clean, and

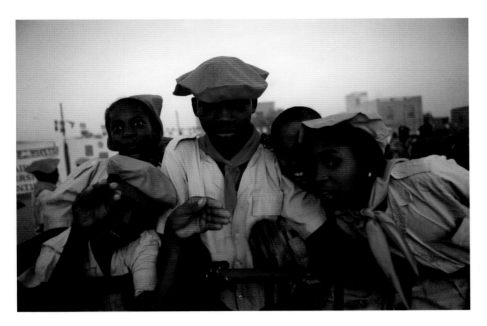

sufficiently wide to permit three horsemen to pass abreast. Both within and around the town there are many straw huts of a circular form, like those of the pastoral Fulani. Timbuktu contains seven mosques, two of which are large; each is surmounted by a brick tower.'[69]

Heinrich Barth was sent by, and on behalf of, the British government to West Africa to evaluate the potential of establishing commercial relations in the region. After almost three years of travelling through Muslim lands in West Africa from Lake Chad, he reached Timbuktu in 1853 and stayed for seven months. Being fluent in Arabic he thought he could disguise himself as a Muslim, but his Christian biases were soon revealed. The first European explorer to reach Timbuktu, Gordon Laing, who arrived there two years before Caillié in 1826, had been murdered on his return voyage across the Sahara. Barth fared better. When he left Timbuktu, al-Bakkay al-Kounti accompanied him to beyond Gao and gave him a letter of recommendation, which served to protect him all the way to the banks of Lake Chad:

'Do not be deluded by those who say, "Behold, he is a Christian! Let no kindness be shown to him! Let it be counted acceptable to God to hurt him!" for such sentiments are contrary to the Koran and the Sunna, and are repudiated by men of intelligence. It is written, "God does not forbid your showing kindness and equite to those who do not wage war with you on account of your religion, nor expel you from your abodes, for God loves the equitable.'[70]

Thanks to al-Bakkay's protection, Heinrich Barth made it home and wrote one of the great accounts of Central Africa and the Niger Bend.

FRENCH COLONIZATION

The process of French colonization of what was referred to as French West Africa or the French Sudan largely took place between 1880 and 1892. The French began to move in from their colony in Senegal in the 1880s, dismantling piece by piece the Islamic empire which had been established

ABOVE Although geographically isolated, the people of Timbuktu are in tune with the outside world via radio, the internet, mobile phones and an array of technology left behind by tourists and development projects.

ABOVE RIGHT Ibrahim Abbas, son of the watchman at the Ahmed Baba Institute in Timbuktu. Aged nine in this photo, Ibrahim is an aspiring photographer.

by Umar Tall. However, the Tuareg resisted and retained control over the desert regions for over a decade. In 1880 the French Colonel Flatters wrote to the Tuareg chief of the Hoggar in Algeria requesting safe passage through the Sahara. The chief replied saying he had received and understood his request, but that he would not comply. Flatters took the risk and he and most of his men had their throats cut; the rest were poisoned.[71]

In the closing years of the 19th century, two great grandsons of Kounta chief al-Mukhtar al-Kabir adopted opposing stances to French colonial overrule. Zayn al-Abidin declared a jihad against the French, following their occupation of Timbuktu in 1894, and continued to harass them in the first two decades of the 20th century. Shaykh Bay bin Sidi Umar, a scholar and man of saintly repute, took up residence in the Adrar-n-Iforas in the northern Sahara and encouraged both the Iforas and the Hoggar Tuareg to avoid conflict with the French. He came to be recognized by the French as a judicial authority in the region, though he held no formal post.

By 1894 French forces had conquered as far inland as Timbuktu. For the first time since the brief Mossi invasion of 1343, Timbuktu was controlled by non-Muslims. However, the French succeeded in defeating the Tuareg only following a long struggle, finally extending their control to the northern regions of the Sahara as late as 1916.[72]

The imposition of the French language and French schools by the colonial administration had a devastating effect on the scholarly traditions of the region. The Arabic language was superseded by French in all administrative affairs and the Arabic *madrasa*s were converted to French *médersas* designed to promote French educational objectives within an Islamic context. The Tuareg continued to resist French domination by refusing to send their children to French schools. Families hid away their treasures including their collections of manuscripts for fear they would be confiscated by the colonial powers.

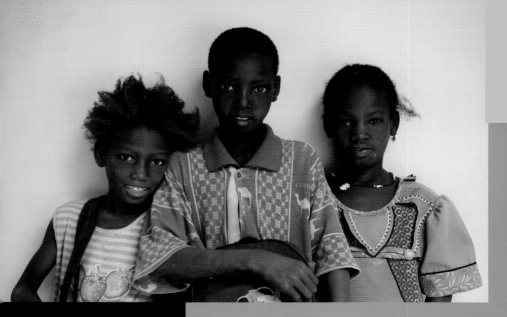

Plates II: Portraits

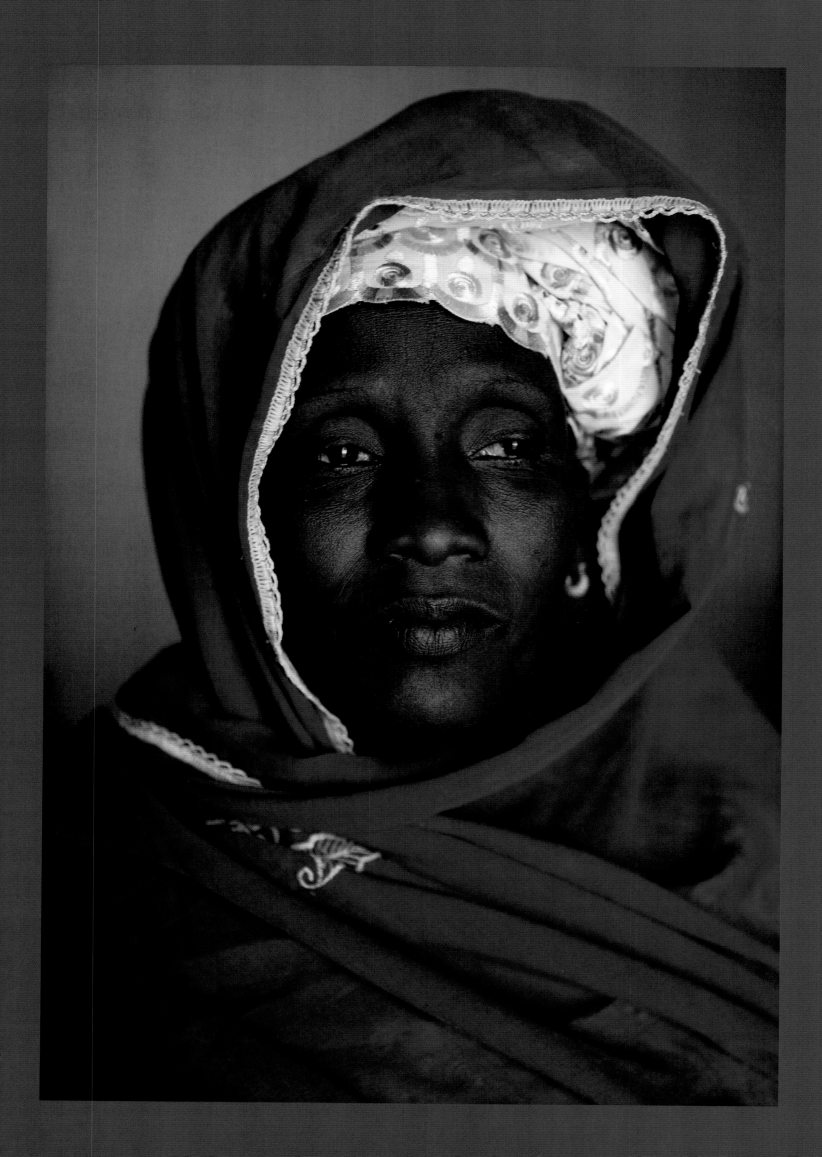

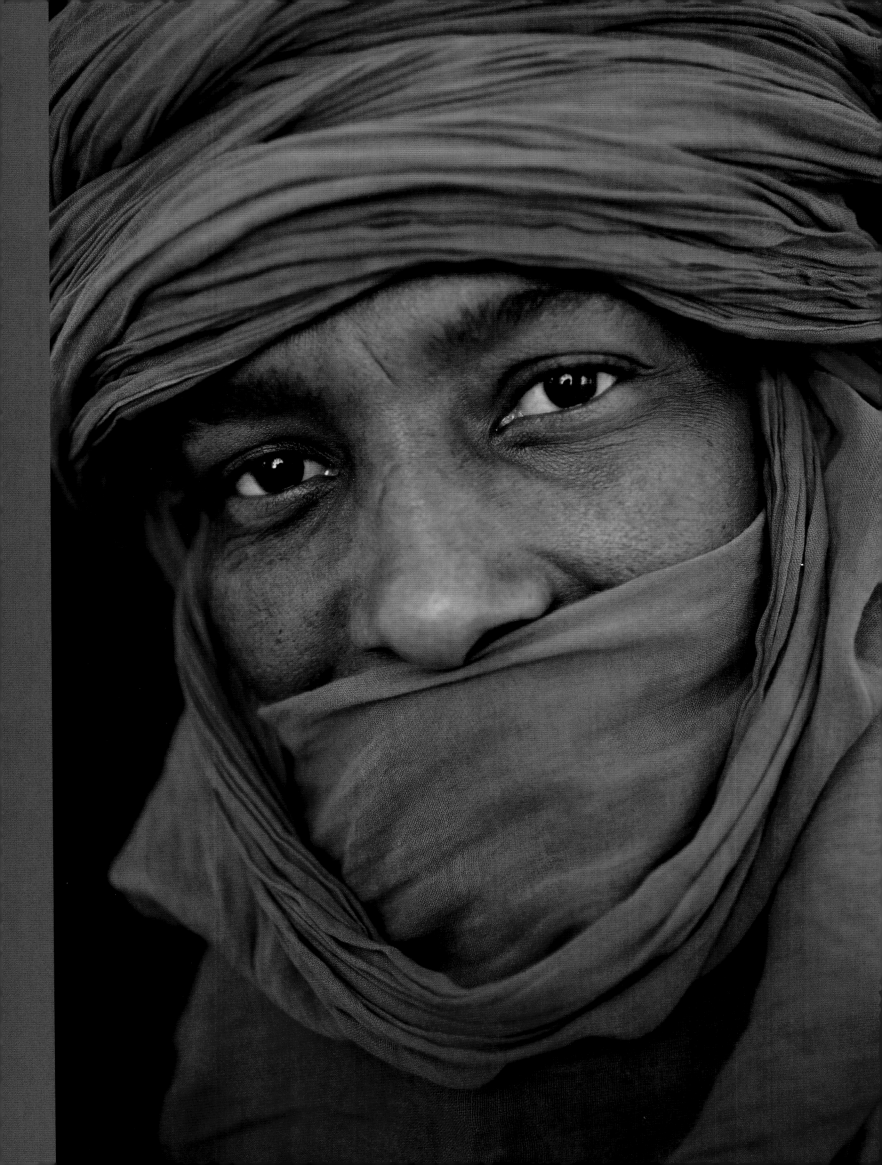

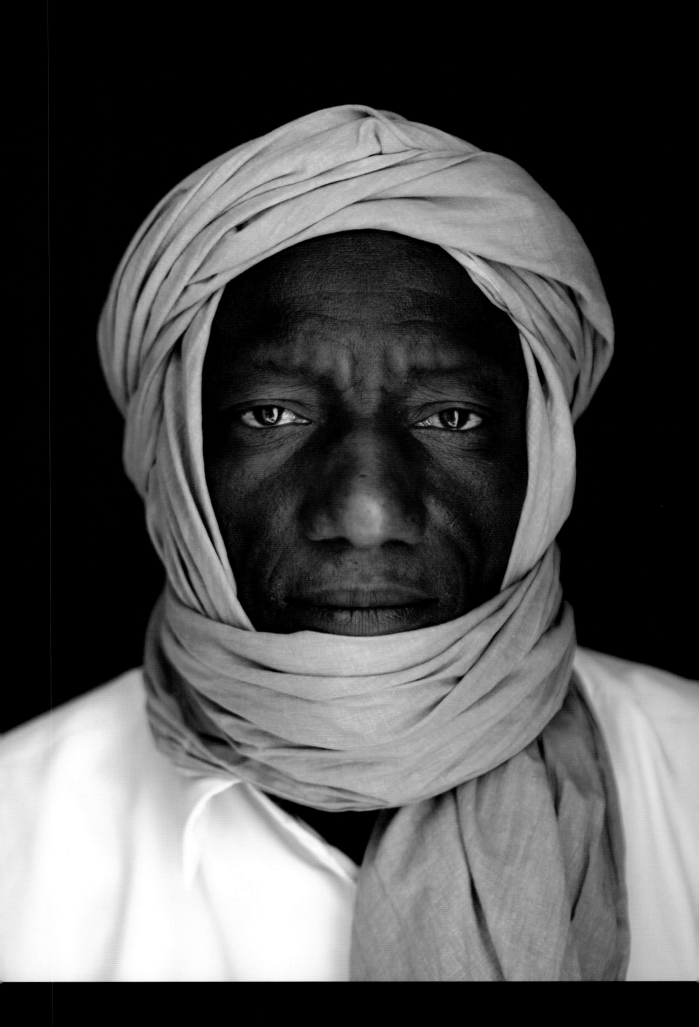

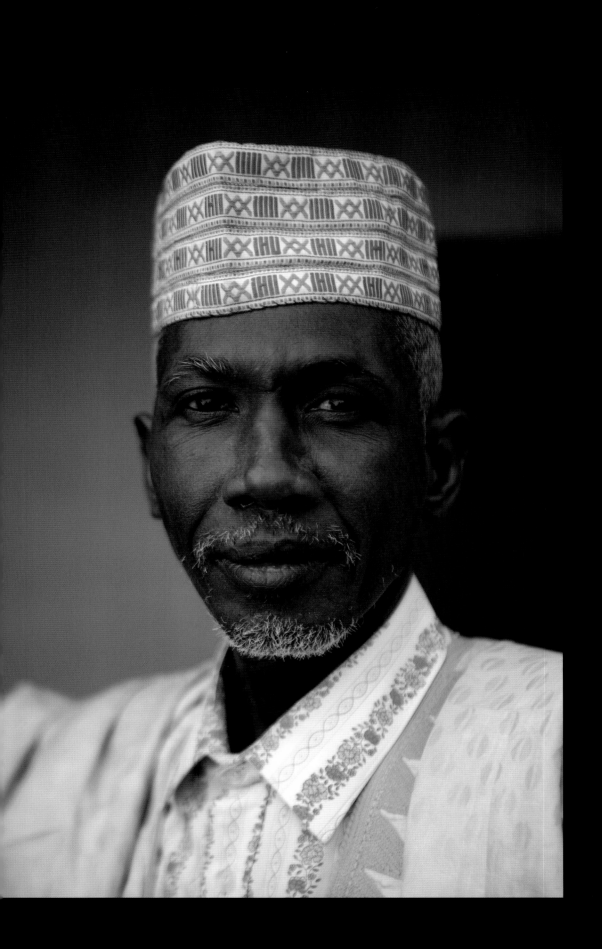

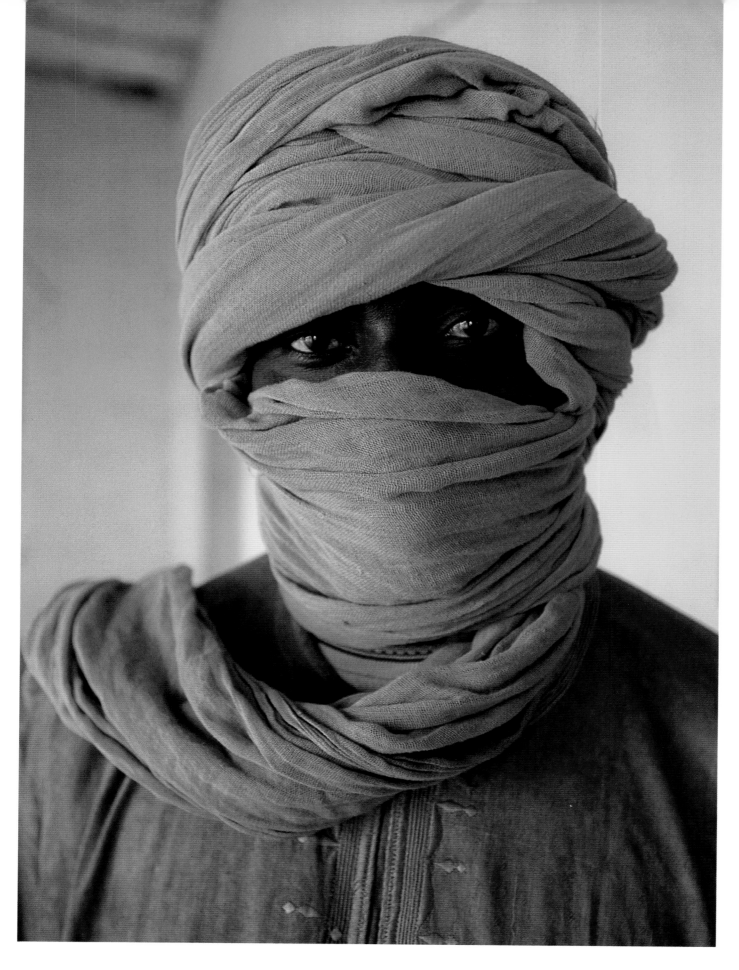

PAGES 63–65 Three children of Timbuktu; mother of a disabled child; Mohamed Alher ag Almahdi, head of a Tuareg artisan's association.

PAGES 66–67 Mahmoud Maiga (left) and Alphadi Oumar

(right), members of the Board of Directors of the Maigala/ Almoustapha Konaté Library.

ABOVE AND OPPOSITE Men of Timbuktu wearing the traditional desert turban.

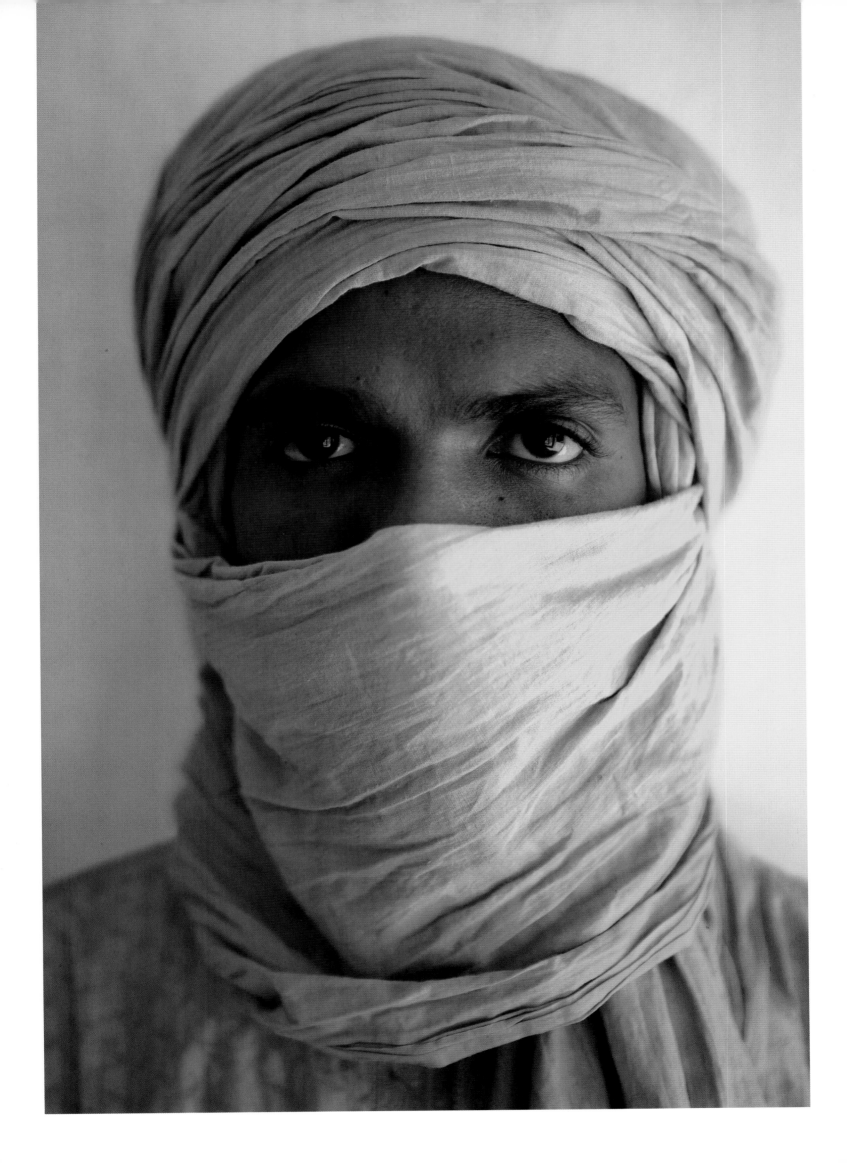

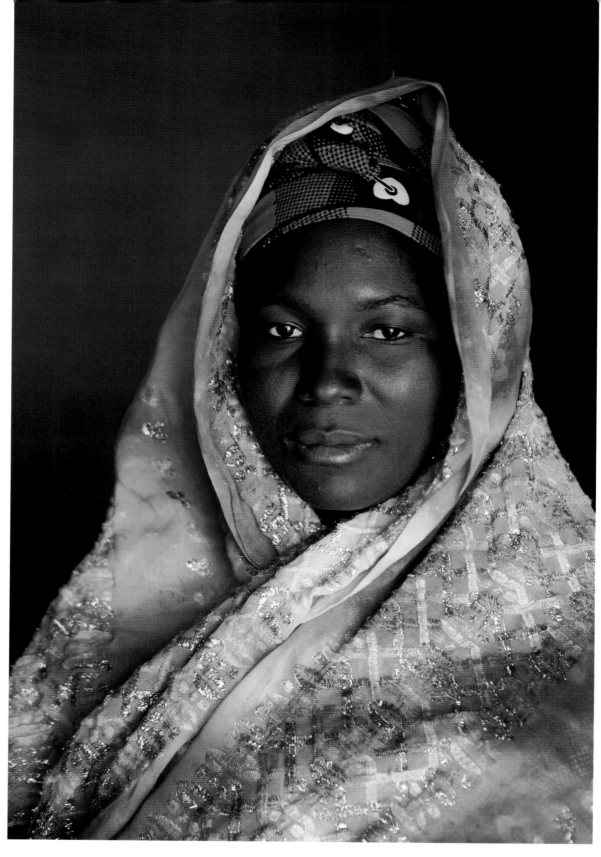

ABOVE Mother of a disabled child in Timbuktu.

OPPOSITE Tahara Abbas, founder of an association for the disabled of Timbuktu which is dedicated to education and enterprise.

OVERLEAF, LEFT Traditional healer and herbalist Ali Attiram Maiga with a tortoise, one of the ingredients in his armoury of traditional cures.

OVERLEAF, RIGHT Fulani shopkeeper Akamis Dicko, who sells his wares under a tree at a street corner in Timbuktu.

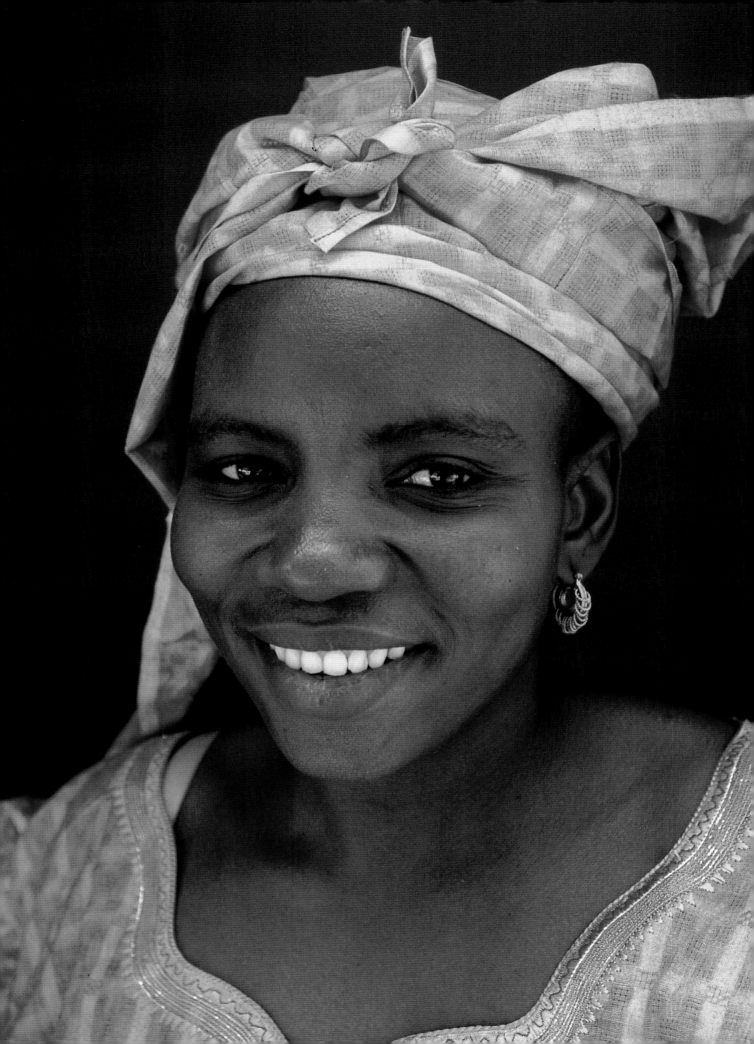

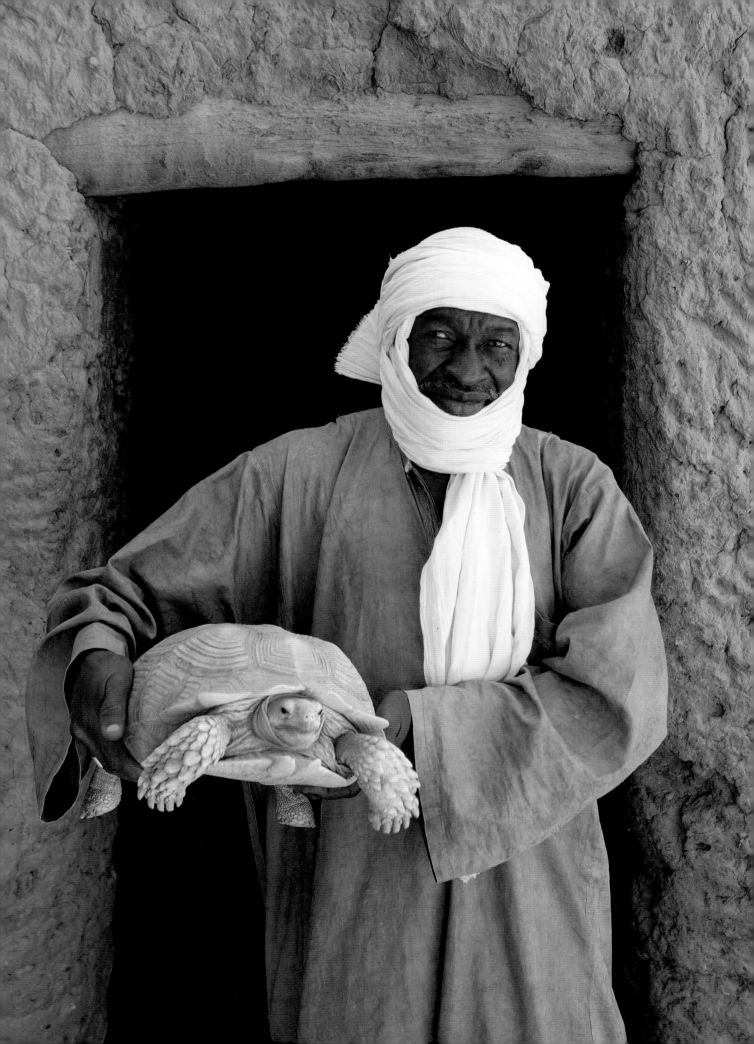

ABOVE Boy in a New York shirt photographed at the Maigala/Almoustapha Konaté Library. The young people of Timbuktu are proud of their city's heritage while also being attuned to the wider world.

OPPOSITE Hamma, local guide and soccer star, has assisted the authors and photographer of this book since he was nine years old.

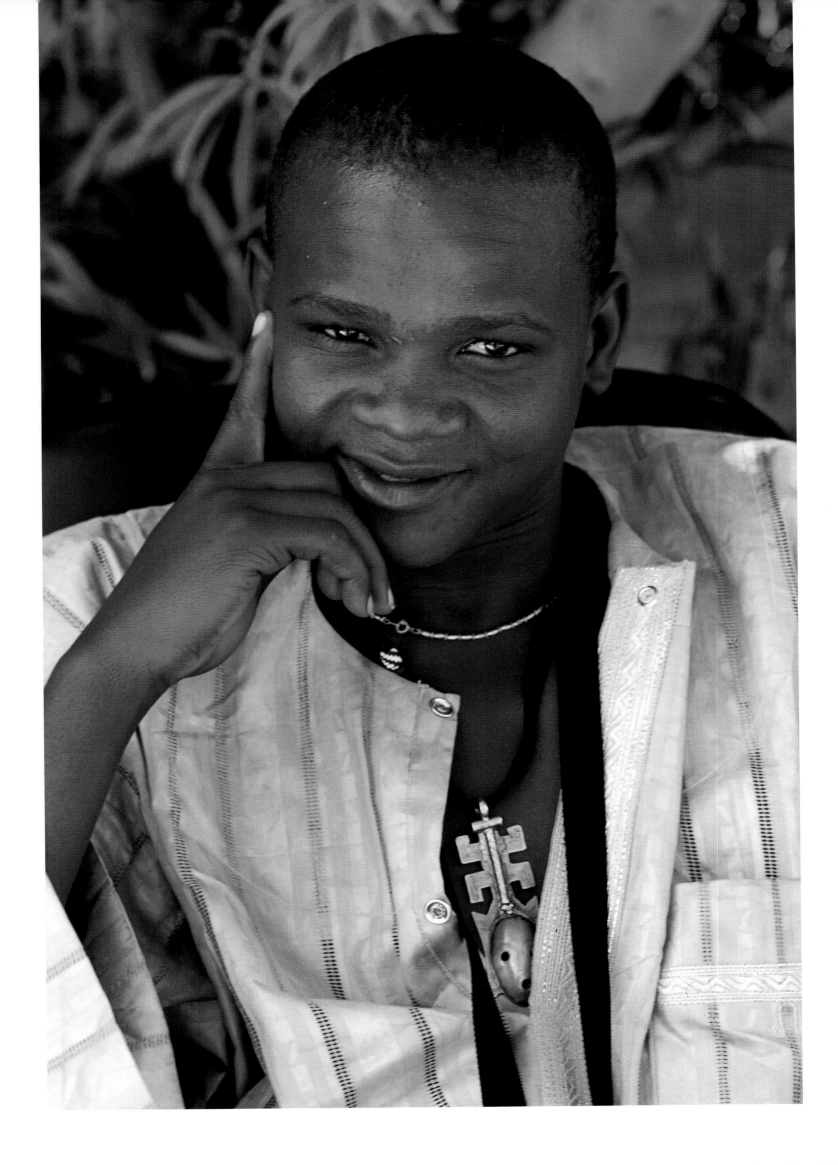

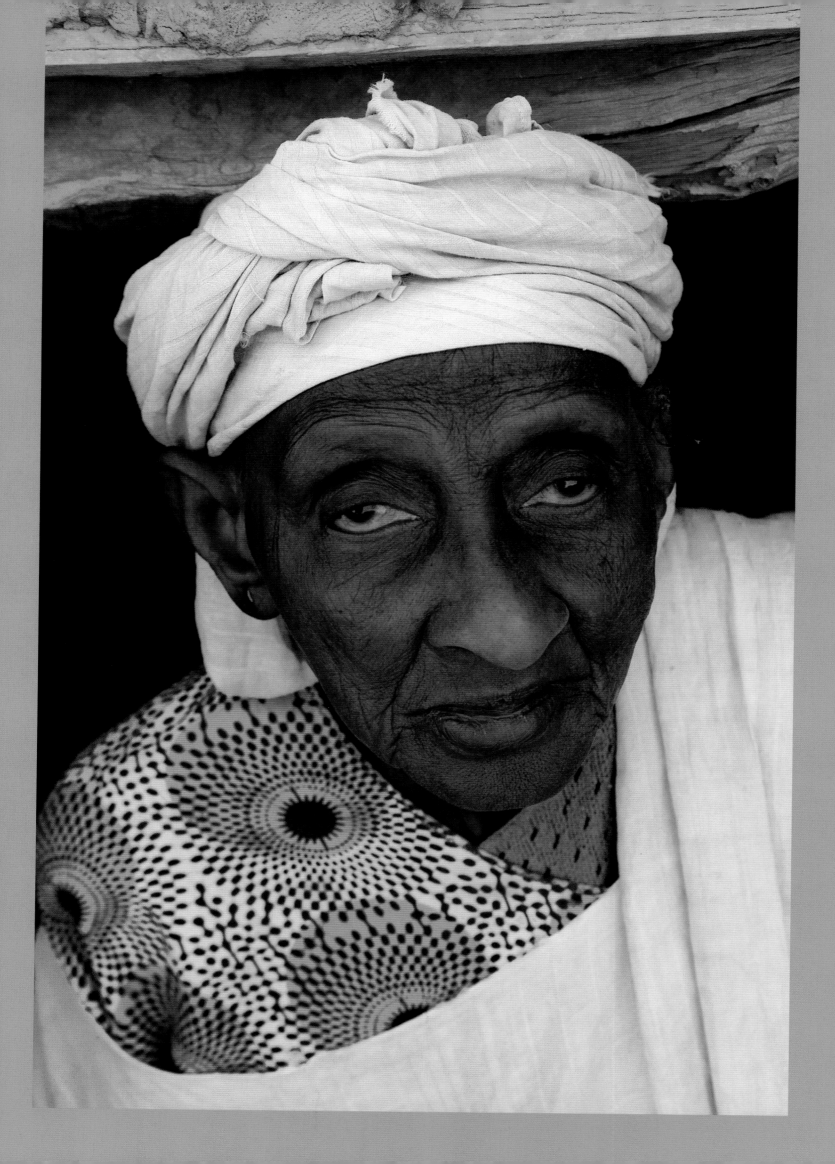

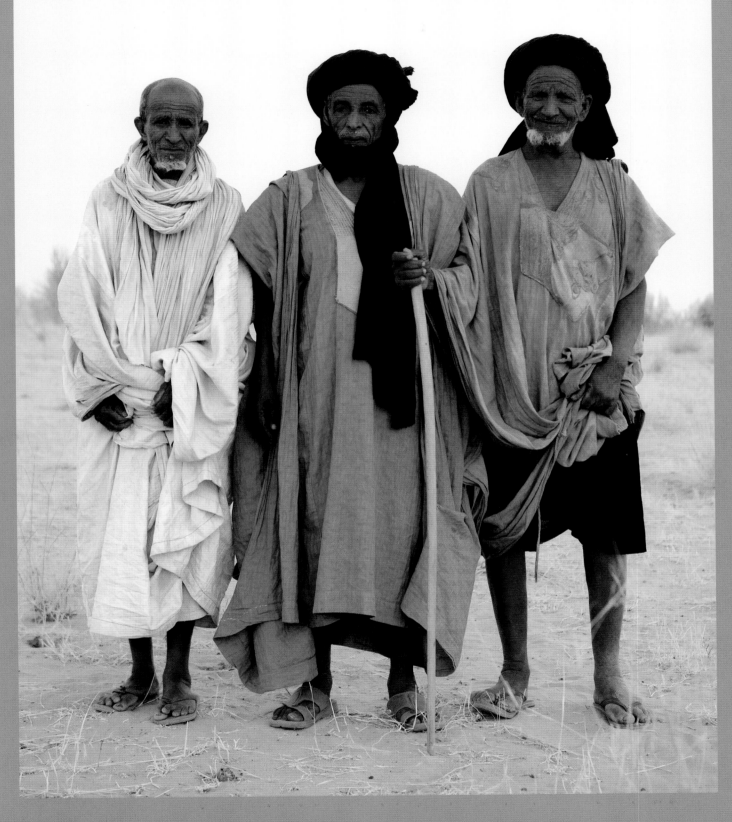

Opposite An elderly inhabitant of Timbuktu. Life expectancy in Mali today is around fifty years.

ABOVE Three nomadic elders at an encampment near Timbuktu.

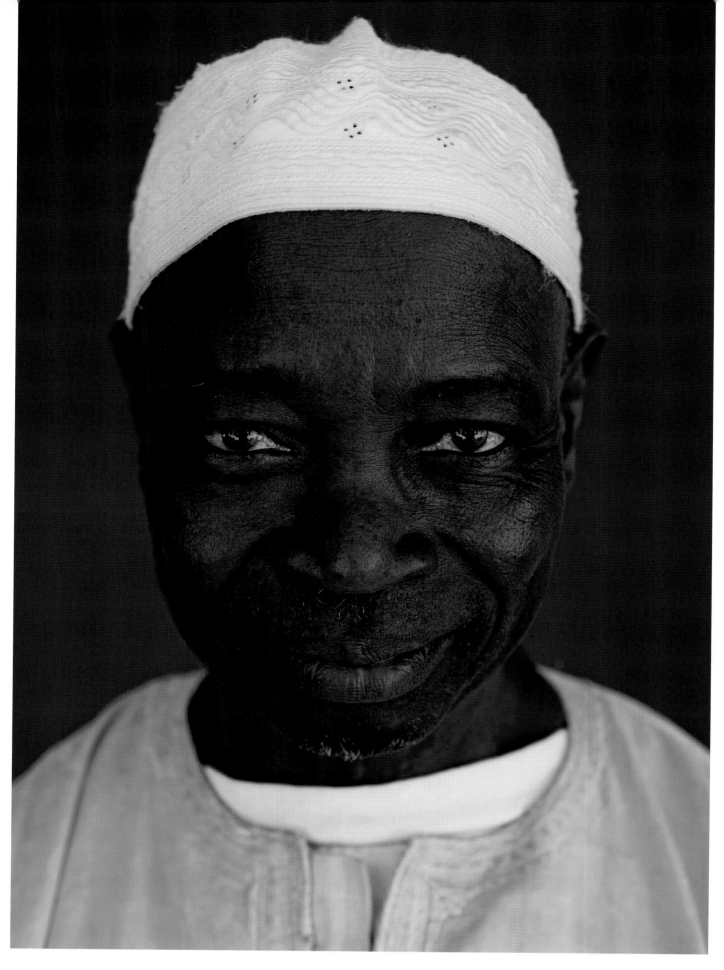

ABOVE Djibril Doucouré, caretaker of the manuscripts at the Ahmed Baba Institute since its creation in the 1970s.

OPPOSITE Yiddar Ag Tahiya, a Tuareg in a white turban.

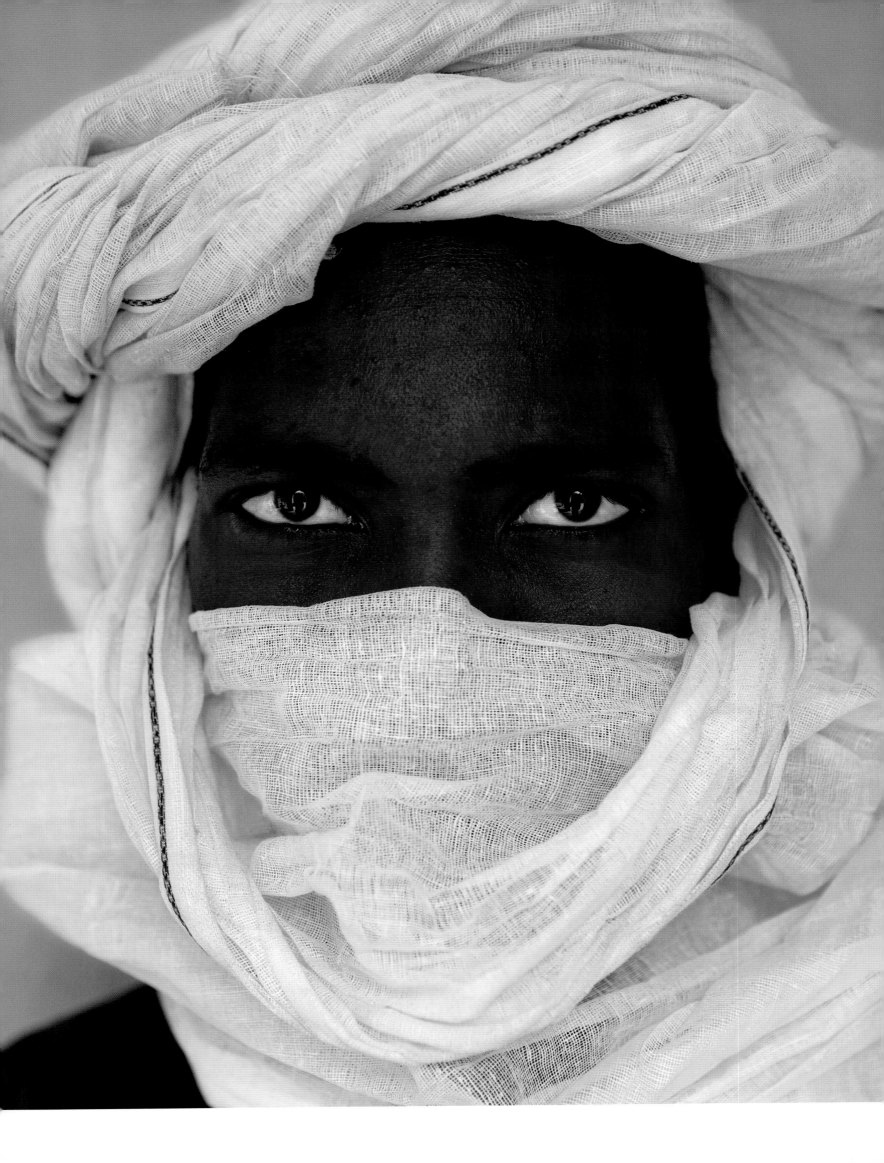

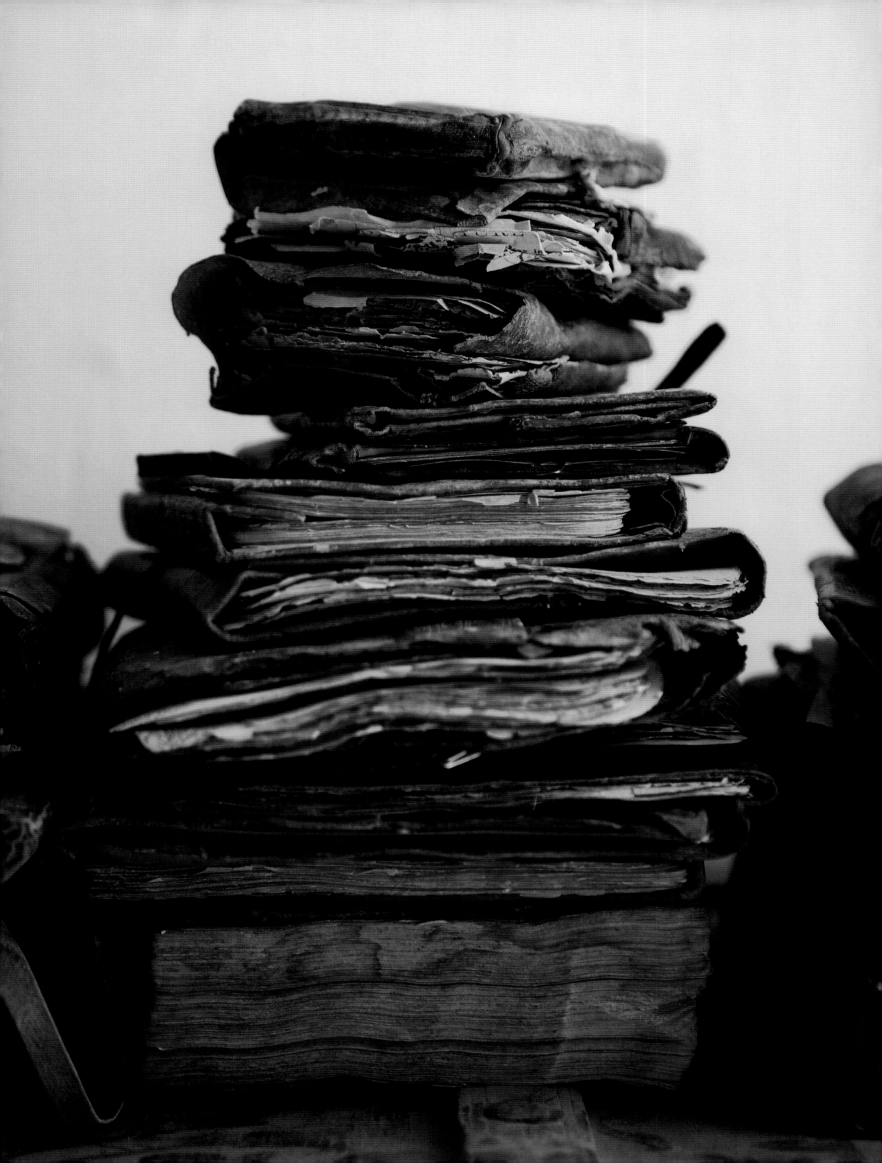

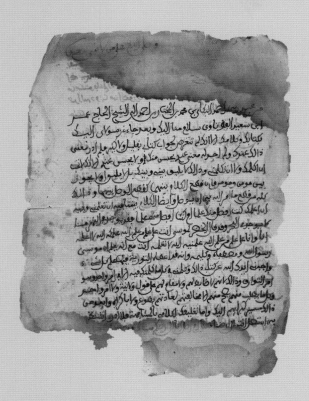

2 TIMBUKTU:
A SANCTUARY
FOR SCHOLARS

'In Timbuktu there are numerous judges, scholars and priests, all well paid by the king, who greatly honours learned men. Many manuscript books coming from Barbary are sold. Such sales are more profitable than any other goods.'

Leo Africanus

The famous pilgrimage of Mansa Musa in 1325 aroused great interest abroad in the Malian Empire, which became known far and wide for its wealth and piety. As Timbuktu established itself during the 14th century as a centre of commercial interchange between tropical Africa and Saharan and Mediterranean Africa, it began to attract men of religion as well as men of business – the two categories sometimes overlapping. By the mid-15th century it was as much a city of learning as it was a city of commerce.[1] Its prosperity meant that scholars could afford the leisure to study and teach and had the means to buy and commission copies of books. These conditions attracted scholars and students from the entire region – from West African towns such as Djenne and Walata, from the Saharan oases, and from Mediterranean Africa.

The *ulama* or learned men of Timbuktu fulfilled a wide variety of roles. They all had their constituencies: *qadis* dispensed justice and were leading citizens of their communities; imams had their mosque congregations; teachers had their colleagues and students; rural holymen were like parish priests, involved in all aspects of the life-cycle of their flock; other learned men provided medical or legal advice. The role of the *qadi* was particularly significant and arose from the great dynamism of commercial life in Timbuktu, and the need to protect stored goods and to settle disputes between city dwellers and passers-through. By means of their spiritual leadership and *qadi* functions, the scholars regulated the affairs of Timbuktu, negotiated with rulers and exerted a great influence on the politics and the administration of the city. The same scholar might hold both the post of *qadi* and the post of imam during his lifetime. Collectively, their task was to uphold the faith and to translate it into action. That could include ensuring that the rulers themselves observed the religion faithfully. On occasion, inevitably, they came into conflict with the city's overlords.

Timbuktu's scholars experienced a major setback in 1468, when the city was sacked by Sonni Ali Ber (r. 1464–92), ruler of the expanding

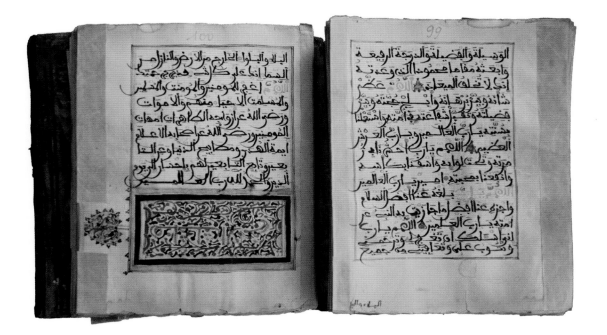

Songhay Empire. Sonni Ali had an ambiguous attitude towards Islam. He drove the Sanhaja out of Timbuktu and undertook a purge of the scholars, particularly those of Sanhaja stock, whom he suspected of aiding and abetting their ruling kin, the Tuareg.[2] Many fled to Walata, and many who remained lost their lives. But his successor Askiya Muhammad (r. 1493–1529) was the first of a new dynasty, and his accession brought a sea-change in relations. Askiya Muhammad was a considered to be a sincere Muslim. He soon went on pilgrimage to Mecca, and returned imbued with the *baraka* or divine grace of one who has visited 'God's House' (*bayt Allah* – the Ka'ba). He adopted a conciliatory approach towards the scholars, setting the stage for a century of equilibrium between the ruling estate and the religious estate, each respecting the domain of the other, and overtly or implicitly giving the other support.

By the 16th century Arabic-Islamic scholarship was again flourishing in Timbuktu, and many scholars set up permanent residence there. During the period of the Songhay Empire down to 1591, there was considerable support for the Muslim scholars of the city and the renovation of the city's mosques was underwritten by the state. A subtle balance was achieved between the ruling estate and the diverse body of scholars, mystics and holymen who made up the religious estate. The Songhay Askiyas, while exercising full political power, saw that it was in their interest to maintain harmonious relations with these men of religion. Gifts in cash and kind, including slaves, grants of land and privilege, especially exemption from taxation, ensured their moral support and spiritual services and, importantly, protected rulers from the possibility of their calling down divine retribution.

Askiya Dawud, who reigned from 1549 to 1583, is said to have established public libraries in his kingdom. The *Tarikh al-fattash* tells us that: 'Askiya Dawud...was a sultan held in awe, eloquent, a born leader, generous, magnanimous, cheerful and good-humoured, fond of joking. God

THIS PAGE Pages from a copy of the *Tarikh al-sudan* in the Ahmed Baba Institute. Completed in 1655 by Abd al-Rahman al-Sadi, this work is ranked as one of the great African chronicles.

bestowed on him the goods of this world in abundance. He was the first to establish repositories of goods and even libraries. He had calligraphers copying books for him, and would sometimes make gifts of these to scholars. I was told...that he had memorized the Koran, and had studied the *Risala* [a book on Islamic law] from beginning to end. He had a shaykh who would come to him and teach him during the middle hours of the day.'[3]

SCHOLARSHIP IN THE POST-SONGHAY ERA

The Golden Age for the Timbuktu scholars, however, did not outlast the Songhay Empire. Following the Moroccan conquest of 1591 the scholars again found themselves suspected of treason, and in 1593, several were arrested by the Moroccan Pasha. Believing that the scholars had been behind an uprising in the city, the Pasha ordered that their goods and libraries be systematically plundered. This harassment lasted until the Sultan al-Mansur sent emissaries to Timbuktu to instruct the Pasha not to do them any further harm.[4] But after the scholars had already been in prison for almost five months, the Pasha began to dispatch them to Marrakesh, a journey which took 64 days across the desert. The entire Aqit family of reknowned scholars was exiled to Morocco, where all but Ahmed Baba died.[5] The status of the scholars of Timbuktu was thus eroded, and many departed for other centres of learning. The tradition of teaching continued, but there was a perceptible decline in standards of scholarship in the city during the 17th century.

In the period following the Moroccan invasion, Timbuktu's scholarly traditions were upheld through historical writing in the form of local chronicles and biographical dictionaries. History was never part of the teaching curriculum in Timbuktu, nor anywhere else in the Islamic world. Apart from 'sacred history' – the life of the Prophet and his companions, and the 'Rightly-Guided' caliphs – it was a 'worldly' subject, one of which a well-educated scholar might be expected to have some knowledge, but

Left Pages from the *Tarikh al-fattash*
in the Ahmed Baba Institute. This second
major Timbuktu chronicle was written
primarily by Mahmud Kati and completed
by his descendants in 1665.

not seen as knowledge leading to salvation. Nevertheless, it is clear that
Timbuktu scholars took a keen interest in history. Although the chronicles
of Timbuktu were not compiled until well into the 17th century, both
the *Tarikh al-sudan* and the *Tarikh al-fattash* were partially based upon
accounts handed down orally or in written form from earlier periods.
Historical writings helped Muslim communities to define their identities,
a necessary exercise for those living in remote areas surrounded largely
by non-Muslim peoples. Local histories were also a useful affirmation of
community solidarity for those dwelling in recognized centres of Islam,
such as Timbuktu, Arawan and Djenne. The Timbuktu chronicle tradition
which developed at this time appears to have spread far and wide over
West Africa.

The *Tarikh al-sudan,* completed in 1655 by Abd al-Rahman al-Sadi,
deserves to be ranked as one of the great African chronicles. It covers the
history of the Middle Niger region from the founding of Timbuktu to the
Moroccan occupation. Without it, our knowledge of the workings of one of
Africa's greatest pre-modern empires would be considerably diminished
and our understanding of a notable Islamic civilization much impover-
ished. During his travels in West Africa, Heinrich Barth found a copy of
what was probably the *Tarikh al-sudan* (although he attributed it to Ahmed
Baba), and much of the historical information in Barth's writing about
West Africa was extracted from this text.

The *Tarikh al-fattash*, attributed to Mahmud Kati, is the other great
chronicle of Timbuktu and the Middle Niger region. This was written about
the same time as the *Tarikh al-sudan*. Three sons of Mahmud Kati com-
pleted the work which was later revised by a son of his daughter and finally
finished in 1665.

These chronicles were often called upon in subsequent periods to
legitimize political rights. One surviving manuscript version of the *Tarikh
al-fattash* was textually manipulated by an early 19th-century scholar of

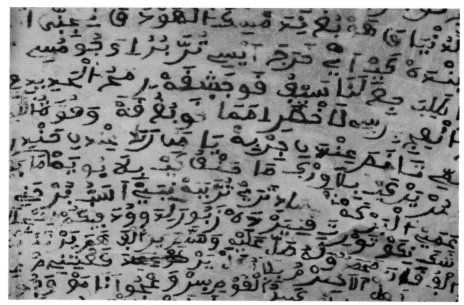

ABOVE Exercising the pen with the Arabic alphabet on a piece of parchment. From the Ahmed Baba Institute.

RIGHT A sea of letters on a manuscript from the Mamma Haïdara Library. A wooden board with strings attached (see page 98) was often used to make faint imprints on the paper which helped the writer keep his lines straight, though evidently not in this instance.

Masina at the bequest of Shaykh Ahmadu Lobbo (d. 1845), ruler of the Islamic state of Hamdallahi in Masina in the southern Inland Delta. He adjusted the chronicle to support his claim to be the twelfth 'true caliph' of Islam and the rightful successor to the territory and resources (especially the servile groups) of the Songhay emperor Askiya Muhammad.[6]

From the second half of the 18th century, there was a significant revival of intellectual activities in almost the entire Sahelian region, which gave rise to a dramatically increased level of literary production. Two nomadic tribes, the Kounta and the Kel al-Suq, played a leading part. Over five hundred works were authored by Kounta scholars in this period. In the course of the 18th and 19th centuries, desert shaykhs from these and other clerical groups eclipsed the urban scholars as the region's political and spiritual authorities.

INTERNATIONAL NETWORKS OF SCHOLARSHIP

Timbuktu was by far the most important centre of Islamic scholarship in the Middle Niger region during the period up to 1800, especially after 1500 when it surpassed both Walata and Djenne. There had been in the 15th century much coming and going of scholars between these cities and Timbuktu, but in the 16th century Timbuktu became the chief pole of attraction. The other great city of the area, Gao, capital of the Songhay Empire, produced no writers, so far as we know, for most scholars preferred to distance themselves from the seat of political authority.

Islamic knowledge of the Timbuktu scholars in the 16th-century period came from a variety of sources. There were scholarly networks connecting Timbuktu with Fez,[7] and some North African and Andalusian scholars visited or settled in or near Timbuktu. But even more significant were connections forged with fellow scholars in Egypt and Mecca during pilgrimage journeys.[8] Through pilgrimages to Mecca, continuous contacts were made with the great scholars and centres of learning in the Middle

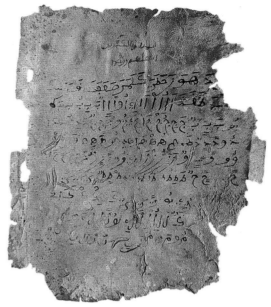

East. Many West African scholars spent time en route in Egypt studying with scholars of repute, particularly those associated with the prestigious al-Azhar Mosque, where they received teaching authorizations (*ijaza*) in various disciplines. Known as the 'cradle of Islamic learning', the schools associated with al-Azhar specialized in Islamic law, theology, and the Arabic language, as well as – for a period – philosophy and medical studies.

The Egyptian scholar Jalal al-Din al-Suyuti, one of the most celebrated scholars of his day, took a lively interest in the affairs of West Africa. The Songhay ruler Askiya Muhammad is said to have met and studied with him in Egypt during his pilgrimage journey in 1497. Al-Suyuti wrote for him a small work on government drawn from the literature of the *Hadith* (the words and deeds of the Prophet Muhammad), and gave him advice, admonitions, *fatwas* (formal legal opinions), and his *baraka* (blessing).

TEACHING TRADITIONS

The core of the Islamic teaching tradition is the receiving of a text, which is handed down through a chain of transmitters or *silsila* from the teacher to the student, preferably through the shortest and most prestigious set of intermediaries.[9] Typically, the student would make his own copy from his teacher's dictation and then read it back to him, or listen while another student read his copy. When he had a correct copy he could then study the meaning of the text and its technical intricacies through lectures delivered by his teacher, and at a higher level by question and answer. Many different texts would be studied along with commentaries written at other times in other parts of the Muslim world. These teaching methods continue to this day in much of the Islamic world.

The mosque that was chiefly associated with teaching was the Sankore Mosque. Sankore is a quarter in the northeast of Timbuktu, and its name means 'white nobles', the term 'white' here referring to the light-skinned Sanhaja. The Sankore quarter attracted many scholars to live,

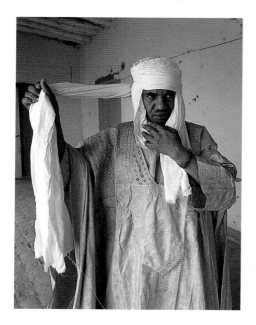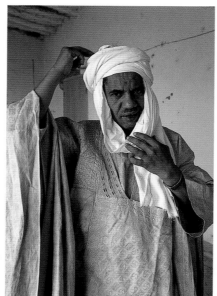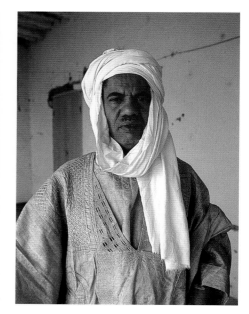

THIS PAGE Ali ould Sidi, head of
the Cultural Mission of Timbuktu,
demonstrates putting on a turban.
A student at his graduation ceremony
would be turbanned and beautifully
dressed, and would recite the first part
of the Koran in front of colleagues,
scholars and relatives.[10]

study and teach, thus gaining a reputation as a centre of higher learning,
a type of 'Latin Quarter'. However, there is no evidence of a centralized
teaching institution in Timbuktu, nor of an official diploma provided by
these institutions other than the traditional turban endowed upon the
learned. The Djingereber and Sidi Yahia Mosques were also used as loca-
tions for classes. But much of the day-to-day teaching process took place in
scholars' houses, probably in special rooms set apart, where the scholar had
his own private library which he could consult when knotty points arose.
Teachers issued individual licences or *ijaza* authorizing students in turn to
teach particular texts. The value of such a licence lay wholly in the reputa-
tion of the teacher.[11] It was not unusual at that time to study under six or
seven different tutors, one for each subject. The tutor would be compen-
sated by the student with money, poultry, cows, sheep, clothing, or services
depending upon the means of the student's family.[12]

During the height of the Songhay Empire, it has been estimated
that Timbuktu had perhaps as many as 25,000 students, amounting to a
quarter of the city's population.[13] The level of teaching was comparable to
that of many centres of learning in North Africa and the Middle East. One
professor is reported to have arrived in Timbuktu with the intention of
teaching, but after participating in a discussion with some of the city's stu-
dents and seeing the level of their learning, he was humbled and decided to
become a student himself.[14]

Treatises on teaching techniques have survived among the manu-
script collections of Timbuktu. These include discussions of methods for
learning to read, advice on how to improve memory, suggestions on what
should be taught, and descriptions of the ideal teacher. As for the ideal
student, according to one author he must be:
'modest, courageous, patient and studious; he must listen carefully to his
professor and have a solid understanding of his lessons before memorizing
them. The students must learn to debate between themselves to deepen

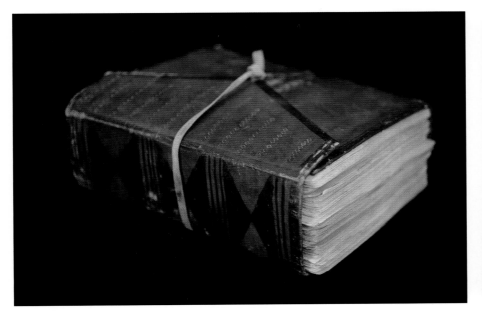

their understanding of the material. They must always have a great respect and a profound love for their teacher, because these are the conditions for professional success.'[15]

THE TEACHING CURRICULUM

Most of the books in the libraries of Timbuktu were related to the religion of Islam, many imported, copied from imported editions, or translated into local languages. They included Korans, collections of *Hadith*, Sufi writings, theology, Koranic exegesis, law, and related disciplines. Poetry in praise of the Prophet and seeking his intercession was a popular form of writing. By the 15th century, Timbuktu's scholars were producing original works as well as compiling new derivations and commentaries on established texts as aids to teaching.

There was no 'official' curriculum in Timbuktu, but certain texts were fundamental across generations. The Koran, memorized in childhood, was of course the foundation. Also regularly studied were the two 'authentic' collections of *Hadith*, the *Sahih* of al-Bukhari and the *Sahih* of Muslim, as well as the *Kitab al-Shifa* by the Almoravid Qadi Iyad, a work of piety centred on the Prophet, his qualities and the reverence due to him. Next in importance were the fundamental works of the Maliki school of Islamic law, the dominant form in West Africa, North Africa and Egypt, which is still studied along with its manifold commentaries today. By the late 16th century scholars had available to them the great twelve-volume collection of Maliki *fatwas* of North Africa and Andalusia by Ahmed al-Wansharisi (d. 1508). Other principal texts of the Maliki school of Islamic law included the *Risala* of Ibn Abi Zayd of Qayrawan (d. 977) and the *Mukhtasar* of Khalil ibn Ishaq of Alexandria (d. 1374).

From Ahmed Baba's account of his own education we know that other disciplines were available for study in 16th-century Timbuktu too, including rhetoric, logic, prosody, astronomy, and of course Arabic

LEFT A copy of the *Dala'il al-Khayrat* from the Ahmed Baba Institute. See also page 91. Like its calligraphy, the geometric cover design of this work reflects its Hausa origins.

ABOVE Manuscript with loose cover from the Mohamed Tahar Library. It was traditional in Timbuktu to leave manuscripts unbound but wrapped in a loose leather cover, often with a flap and tied with string. Several works might be assembled under a single cover, causing headaches for modern cataloguers.

THIS PAGE Pages from a Koran in calligraphy typical of the Hausa. Today in the Ahmed Baba Institute, this manuscript demonstrates the strength of relations between Timbuktu and the Muslim communities of Hausaland, the area east of the Niger River which now straddles southern Niger and northern Nigeria.

OPPOSITE A manuscript copy of the *Dala'il al-Khayrat* by al-Jazuli, again in typically Hausa calligraphy. Written in Morocco in the 15th century, this prayer manual quickly spread to sub-Saharan Africa as well as eastwards throughout the Muslim world as far as Sumatra. From the Ahmed Baba Institute.

grammar and syntax. We also know that textbooks were purchased, copied and studied on a wide range of disciplines such as Islamic law, morphology, rhetoric, literary analysis, mathematics (calculus, geometry), geography, philosophy, botany, medicine (pharmacopeia, medicinal plants), astronomy, astrology, mysticism, dogma, occult sciences, geomancy and music.

Texts from outside of West Africa circulated within the region. Some were imported; others belonged to scholars who settled in Timbuktu and brought their libraries with them. Such texts would be copied both by the scholars and their students. Scholars would also make abridged versions and write comments in the margins to facilitate teaching, or put the text into verse to make it easier for students to memorize.

Original works by Timbuktu scholars included extensive bibliographical listings, and many of these manuscripts were available throughout the region. In his treatise on slavery written in 1615, Ahmed Baba was able to quote from Ibn Khaldun's great history and from a book about Ethiopians by al-Suyuti. He also made his own copy of Ibn Khallikan's famous biographical dictionary, a part of which is still preserved in Timbuktu. Towards the end of the 16th century the scholar Ahmad b. Anda ag Muhammad ordered the copying of the twenty-eight-volume Arabic language dictionary the *Muhkam*, written by the Andalusian scholar Ibn Sidah in the mid-11th century. Parts of this have survived and are preserved in two Moroccan libraries. We also know that he purchased the eighth and final volume of *Sharh al-Ahkam*; if he bought the final volume, it is fair to infer that he already owned the other seven volumes. Clearly, he was an avid book collector and must have owned a considerable number of manuscript books, although his library has never surfaced. Important works were even to be found outside the main cities. Ibn Battuta reported how his host in a village on the River Niger led him by the hand into his council room; there were 'many weapons there – shield, bows, and lances as well as a copy of the *Kitab al-Mudhish* by Ibn al-Jawzi.'[16]

الحمد لله وكفى و صلى الله على المصطفى

وبعد وقد ثبت بذمة ومال على ابن عبيد احمد ابن محمد بن ابراهيم السلا ح
سبعة وعشر خال وربع لما سكه الذهب اليالة الذهب ابراهيم ابن عمران يعقوب
من قبل المنه والدارة وكذا بيوض والاجل بينهما اربعون يوما والاقبال
الزلاى الشتاء بتاريخ يوم الجمعة الثاني عشر المحرم عام اسامه
وبه كتب من الشهد الله واستكتبناه وهو يعلم انه تم به الاشهاد
عبيد ربه عثمان ابن بنية خليل بن الامام المختار الجناوى تيب على الكاتب

محد وراك لدلا دكر وكر يدى وحى
عدد حكم ودس لد ولدد سدى ملكدادكى
الحمد لله وكفى رحيد درح ولاره و صلى الله على المصطفى

وبعد وقد ثبت بذمة ومال محمد الكبير ابن جامع البهند اوى ثلاثة
وعشر وفحص لما سكه اليالة ابن الكمران يعقوب البلهوى من قبل
شفة الاكل ويرحنة الكو اهر والاجل بينهما اربعون يوم
والبحال الزلاى الشتاء بتاريخ يوم الاربع الرابع والعشرون
من شهر الله المحرم عام اسامه وبه كتب من الشهر الله
عثمان ابن بنية خليل بن الامام المختار الجناوى تيب عليه وعلى المسلمين
اجمعين

وتاريخ النصف كاعلاه والاجل كذلك والقض على صبر الجود والاحسان
والكاتب كاعلاه

عف دى درح ١٥٠٠ كردين

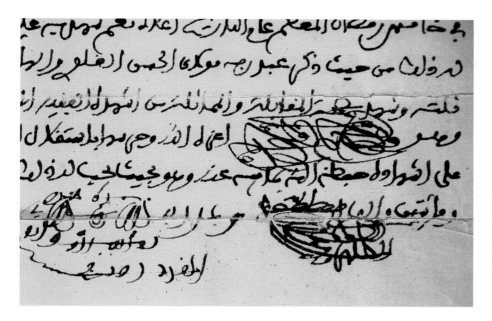

Many of the books studied in Timbuktu were derived from Arabic translations of ancient Greek or Persian texts. These included, among others, the Greek astronomer Ptolemy, who was a basic reference for the Islamic study of astronomy, the Greek philosophers Plato and Aristotle, the Persian medical philosopher and scholar Avicenna (Ibn Sina, 980–1037), and the ancient Greek 'father of medicine' Hippocrates. During Heinrich Barth's travels, al-Bakkay al-Kounti showed him a copy of the Arabic translation of Hippocrates that had come to West Africa as a gift from the British explorer Captain Clapperton who understood that scholars in the region appreciated books more than any other good. '[Al-Bakkay] taking out of his small library the Arabic version of Hippocrates, which he valued extremely, was very anxious for information as to the identity of the plants mentioned by the Arab authors.'[17]

A WEALTH OF CONTENT

Arabic writings of West Africa cover all aspects of life and intellectual pursuits in the region. Surviving manuscripts range from small notes on a single page to volumes of 400-plus pages. They fall into two broad categories: texts of a 'literary' character such as religious treatises, chronicles and poems, which may be attributed to an author; and texts of a documentary character including letters, contracts and commercial documents, in particular documents relating to property ownership, regional and transsaharan trade, and slavery.[18] In between these are formal legal opinions (*fatwas*) and reports (*risalas*), often on quite specific topics and addressed to particular individuals or groups.

A typical commercial document included a proclamation such as 'Let all who read this document know...'. Then the author would document the identity of the purchaser and the seller, provide a detailed description of the commodity, declare the legal validity of the sale, and state that the purchaser had paid the price in full. The document would then provide the

ABOVE LEFT A page from the *Tarikh
al-sudan* from the Ahmed Baba Institute.
Manuscripts often feature notes and
commentaries in the margin. A text
may have been originally written by one
scholar, copied by another, and annotated
by yet another. Sometimes the notes are
comments on the text; other times they
are entirely unrelated. Such notes are
often what makes a manuscript unique
and of particular interest, though at the
same time more difficult to catalogue.

ABOVE CENTRE Comments on the
grammar of a versified text from the
Mohamed Tahar Library.

ABOVE RIGHT Annotations on a
versified teaching manual on how to
write and pronounce the Arabic glottal
stop (*hamza*), a problem familiar to
students of Arabic past and present.
From Al-Wangari Library.

identity of the drafter and its date. Many legal documents also included a
statement of the validity of the contract, i.e. that the parties to it were legally
competent, free from restraint, in full possession of their mental faculties
and that their transaction was a lawful one according to Islamic law, the
Sharia. Finally 'Praise to God and blessings upon the Prophet' would be
stated at the end as at the beginning of the document.

Original writings by local Timbuktu scholars include the historical
chronicles (*tarikh*), correspondence, poems, legal opinions (*fatwas*), com-
mentaries and annotations. Polemical writings surfaced in the mid-19th
century and mainly articulated the rivalry between the Qadiriyya and the
Tijaniyya Sufi orders. Attacks on Sufism as a whole appeared generally in
the second half of the 20th century as the Saudi Arabian impact on Muslim
Africa promoted anti-Sufi sentiments.

It can be difficult to distinguish between books and letters when
classifying manuscripts since some letters are very long, such as al-Bakkay
al-Kounti's 482-page letter to Akansus, a former Moroccan cultural minis-
ter and one of the great figures of the Tijaniyya order. This tradition of
writing detailed responses continued to the 20th century.[19]

MARGINAL ANNOTATIONS

Scholars from Timbuktu often wrote in the margins of manuscripts. These
notes are generally of two types: comments relating to the original text or
previous annotations; and comments which are totally divorced from the
text, where the writer used the margins to record external events, presum-
ably simply for lack of paper. There are several examples of texts which have
been copiously annotated by a single author or by several authors. Some-
times the reader would write notes in the margins about the process of
reading the manuscript: 'Today I read to this page... and then such-and-
such came to borrow this work...' But other times these notes provide us
with some of the most important historic information from the region.

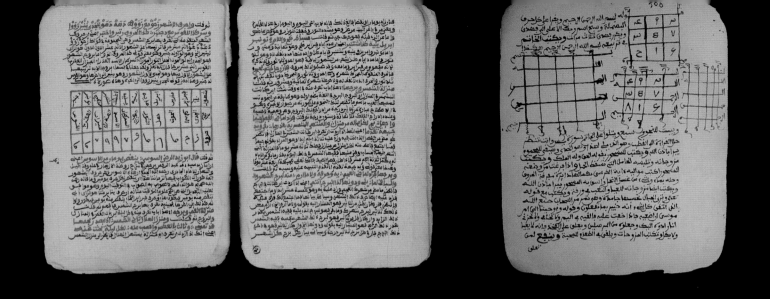

Perhaps one of the most significant recent rediscoveries are the marginalia that are a feature of many of the manuscripts from the collection of the Fondo Kati. According to the historian and director of the library, Ismael Diadié Haïdara, these include a total of 6,162 notes written in Andalusia, the Maghreb and Timbuktu. Some were written by Ali bin Ziyad, who fled from Andalusia in the mid-15th century; most were by his descendants. Among the notes written by Alfa Kati Mahmud,[20] over half pertain to historical events, while the rest concern medicine, natural phenomena, legal issues, and letters to the Songhay Emperor Askiya Muhammad. One very interesting item from the Fondo Kati is a work on the Prophet Muhammad produced with very wide margins to its text. The 16th-century owner used those margins not to comment on the main text, but to record important events of the day. In one instance he reports heavy rainfall causing flooding, while another, dated December 1505, speaks of fire in the night sky until dawn, perhaps a sighting of comets. He also noted down news of his fellow citizens: in one case a marriage, in another the death of Ahmed Baba's grandfather in 1535.

ABOVE LEFT AND CENTRE Pages from a work on astrology from the Mamma Haïdara Library. The table shows how the signs of the zodiac correspond to the months of the year.

ABOVE RIGHT Page from a pharmacopeia in the Ahmed Baba Institute. Although Malian scientists today are at the forefront of study of traditional medicine, and as many as 80% of Malians continue to use traditional remedies, little research has yet been undertaken into the region's tradition of Islamic medicine and pharmacology.[21]

LITERATURE IN AFRICAN LANGUAGES

In addition to the abundant Islamic literature in Arabic in Western Sudanic Africa, there are also Islamic literatures written in African languages – so-called *ajami* manuscripts. These include writings in, among others, Fulfulde (the language of the Fulani), Tamasheq (the language of the Tuareg), Songhay and Hausa. They survive today both in the various libraries in Timbuktu and throughout the region of the ancient Malian and Songhay Empires.

The *ajami* manuscripts extend to all fields of scholarship, and include traditional medicine, plants and their properties, occult science, and diplomatic correspondence. Throughout the region, one also finds important works of poetry written in Tamasheq, Songhay and Fulfulde.

عبواية النسر

الفول والتمر لسان مسائر كل مجودة ان كنت عمها ثلث
رساخ الكبد لجمع الحفظ من الشيا طل او كل رطب
ان تملك صبى مغفل احفظ من كل ما يهم
وعينه بالعزعز ولمعالم لجملة العبيد والنجاة
ددريه للتنجيس وعين السوم وجملة الاوهام والتنقط
سرار زله لحدة البصر بنزيد في التقوى والنظر
نجمه للبسم ومبلاذك ان كننت البانا اربع

بواية الغراب مما اخذ راسه وحرفه ودهى بزملى
مع الزيت الرسر جانه بيسوح التفكر ويقويه ...

والتذاصر زله من ٥ ٩ ٨ ٧ ٤ × ✕ ⊞ ⊡ ⁘ × ⊙ ✕
: ⌐ د × ال ال ال ٧ ⁝ ⁝ ⁘ ⌐ ⁚ ⁚ ⁝ ⁙
⊞ ⁝ والقلاث للغلام الخ يكون في العيم من
اهرار ن وهى سخونه توقصر ما م العين
اد فى الغلام باخ الله والله تعلم

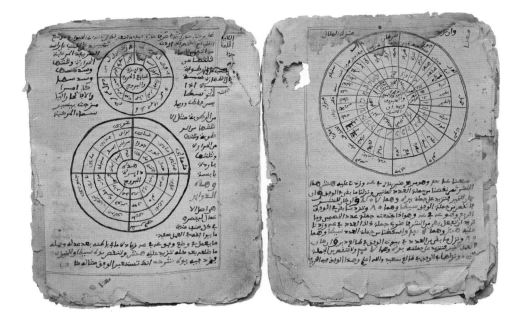

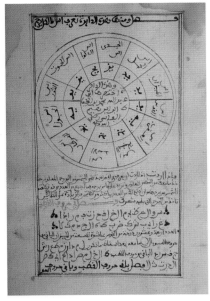

The best known *ajami* manuscripts in West Africa are those of the Fulfulde literature of Futa Jallon in today's Guinea, as well as the Hausa and Fulfulde literature of Sokoto in northern Nigeria.[22] Writers used local languages extensively, particularly at the end of the 19th century and the beginning of the 20th, as a medium for popularizing Islam and also for promoting *jihads*. Fulani scholars wrote works on Islamic disciplines of law, mysticism, grammar, theology, occult sciences and pharmacopeia as well as history and literature. The Fulani ruler Seku Ahmadu himself wrote texts denouncing the innovative practices of the people of the Western Sudan, including nomination of a *muezzin* who is not qualified, purchase of very expensive and abundant clothing, and burial of the dead in mosques. Many African languages have at some point been written using slightly modified forms of the Arabic script, though since the colonial era this has been largely abandoned in favour of the Roman script. Nonetheless, West African languages spoken by Muslim peoples have absorbed a considerable number of Arabic loan words, some of them through North African dialectal usage. Many historic manuscripts are written in an Arabic which is difficult to understand even for confirmed Arabic scholars if they do not also master the language and cultural environment of the author.[23]

TIMBUKTU'S MANUSCRIPT COPYING INDUSTRY

Books were not only imported to Timbuktu but copied there, and it was above all this tradition of copying which permitted scholars to furnish their libraries. In the early 16th century, Leo Africanus had remarked, with some evident astonishment, that some items of European origin were sold in Gao for four or five times their European price. There is little doubt that locally produced manuscript books were always cheaper than those imported from across the Sahara.

The copying industry in Timbuktu appears to have been extensive and well organized. Our evidence of this lies in colophons dating from as

OPPOSITE Document written in Tamasheq, the language of the Tuareg, using their *tifanagh* alphabet. From the Mamma Haïdara Library.

ABOVE LEFT AND CENTRE *On the Knowledge of the Stars*, from the Mamma Haïdara Library. An understanding of the stars was essential for navigation through the desert and calculating the seasons, and was also central to astrology. This work was copied by in 1731 by Musa b. Muhammad b. al-Hasane al-Kansusi.

ABOVE RIGHT Manuscript on astronomy from the Maigala/Almoustapha Konaté Library. The Islamic science of astronomy was based on the works of ancient scholars such as Ptolemy, to which were added discoveries made by Muslim scholars.

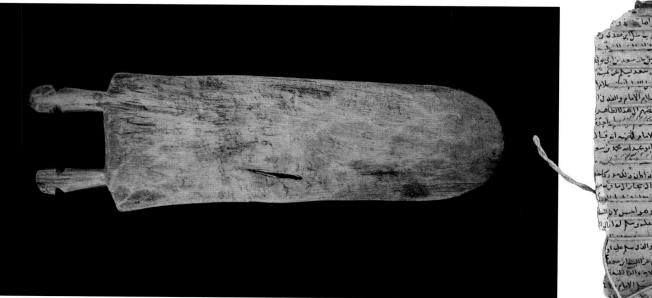

ABOVE A wooden tablet for writing out verses of the Koran as they are memorized. Such tablets are still used by Koranic students in Mali today.

ABOVE RIGHT This board with string attached was used by writers and copyists to keep their lines straight. The string was pressed against the paper to create the faint imprint of rules.

early as the 16th century. These inscriptions at the end of a book cite not only the title and author, but also the date of the manuscript copy and the names of the scribes who produced it. Sometimes they give further details of those involved in the work, including not just full names of the copyists but also of 'proofreaders' and 'vocalizers'[24] and of their employer. They may also include the name of the person for whom the manuscript was copied and the fees paid, who provided the blank paper, and the dates of beginning and ending the copying of each volume (allowing us to estimate how long it took to complete the work). Such colophons, in essence, constitute a labour contract, and they indicate that manuscript copying was a professional business. Working full-time to complete their contracted tasks, the copyist would work at a rate of around 140 lines of text per day, while the proofreader worked through around 170 lines per day.

Two volumes of the twenty-eight-volume *Muhkam* by Ibn Sidah commissioned by the scholar Ahmad b. Anda ag Muhammad contain remarkable evidence of the copying industry in late-16th-century Timbuktu. They each feature a second colophon, in which the proofreader records that he verified the accuracy of the copying, and records what he was paid. The copyist received 1 mithqal of gold per volume, and the proofreader half that amount.

CALLIGRAPHIC TRADITIONS OF WEST AFRICA

Arabic was the principal language of literacy in West Africa for a thousand years down to the colonial period, and the forms of Arabic script used in West Africa all derive from North African or Andalusian hands. Much work remains to be done in studying and classifying these different scripts. Nonetheless, the different types of calligraphy found in Timbuktu, including on imported manuscripts, can be categorized as follows:
• Eastern (Oriental) calligraphy (in many forms, including Naskhi, Thuluth and Riq'a), which was used by calligraphers of the Middle East and their students. This is characterized by the simplicity of its letters.

- Maghrebian and Andalusian calligraphy (Mabsut, Mujawhar and Zemmami), used by the Moroccans and their students. This is distinguished first and foremost by the placement of dots on certain Arabic letters.
- Saharian (sahrawi) calligraphy, used by the Moors and their students. This is characterized by its angularity, with unusual height in certain letters as well as exaggerated lengthening of others.
- Suqi or Sanhajan calligraphy, used by Berber scholars. This is a distinctive style associated with the scholars of the Kel al-Suq.
- Sudanese (sudani), possibly originating from Maghrebian calligraphy with some influence from ancient Kufic. Used by the Songhay, Fulani, Tukulor, Soninke, Wolof and Hausa, this is characterized by thick letters.
- Kufic, an angular and geometric style, was used by early scribes to copy the first Korans and for engravings on stones. In West Africa, it was often used to write the word Askiya.[25]

ABOVE LEFT An inkwell and a stone for sharpening calligraphy pens (*calem*).

ABOVE Calligraphy pens or *calem*.

MANUSCRIPT BINDINGS AND MATERIALS

West African manuscripts are generally not bound, but consist rather of loose unnumbered sheets (folios) wrapped in leather covers or, in recent times, protected by cardboard. In the Middle East the buyer of a manuscript would traditionally then take it to a binder of his choice, so manuscripts purchased abroad often remained unbound. West Africans typically left them this way, some say to facilitate teaching – pages could be distributed to several students at a time. Often the sheets are neither numbered nor do they have catchwords (*raqqas*) or a word at the bottom of the page that is repeated on the top of the next page to help the reader maintain the correct sequence. They have nonetheless been kept in order, confirming the mastery of the scholars and students who memorized these texts. Manuscripts such as the Koran which were meant to be carried around would often be placed in a small pouch to be hung around the neck or put in a pocket.

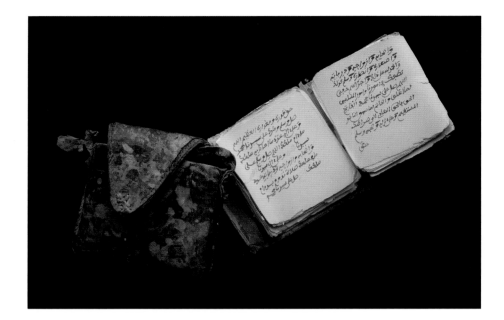

Watermarks can often provide clues as to when particular manuscripts might have been copied. From the modest work which has been done on watermarks and the export of paper to West Africa, it appears that paper was imported from northern Italy, Normandy, Morocco, al-Andalus and probably Egypt. Reports from Tlemcen expressed great anxiety over the use of paper bearing watermarks that featured Christian symbols.[26] When Mediterranean papers began to be manufactured from bleached coloured rags, they retained enough chemicals to assure their self-destruction within a few hundred years. Hence many of the manuscripts extant today are copies of earlier works, made as the older papers disintegrated. Although most of the manuscript works in the region are on paper, some are written on parchment made from skins of sheep, goat and gazelle, either imported from Morocco or produced locally. Heinrich Barth reported a great zeal for paper: 'All these people, who possess a small degree of learning, and pride themselves in writing a few phrases from the Koran, were extremely anxious to obtain some scraps of paper, and I was glad to be still enabled...to give away some trifling presents of this kind.'[27]

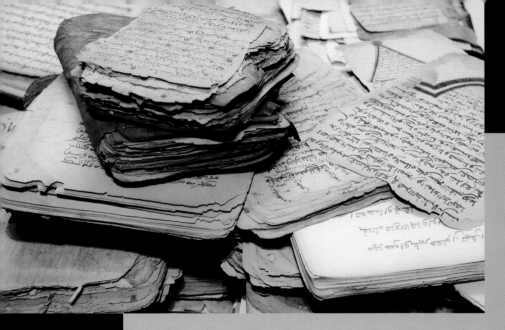

Plates III: Manuscripts

١٦٢

من بعد والتحميد بعينه لله الكريم المتعال وجعلنا على منصور الدولا
يعرف بالله الغرير الوها باش عنه اتباع اثر(ا) بعد الخامس
الظالم الحاجي وانصر شيخا فيه الدانصر حتى يقبل منعطع الكه
واجا ما ونمشهد عن منو واحزانما وبلعبنا ارض الى ارض بعذبنا
ربع من بعض حتى وصل بنا السبب الى السبع الجبل بعناية من مهلا
الغوة والخيل وبلكنا مسلكناا مسلكه احد وفبلنا الاموال سلاب
ولاسرنا حلاف بص جبلاى بابهامن مشارفها ومغا رمنا من صاحب
منبى ود عنكنا وبلغ داجا بواد عوثنا وانلا بوالتشهوتنا
حتى انطلتنا لاجابتى لصاحب كبروا وغير جنبزلو الباودمر وا
لوبنامة عينىرا عنيسبزلليس هماربين متجدد والمولانسل
نصى وامع تعلى السمع والكجاعتة دكالوالكل هلا رينع منا من الخد
بالشجا عتة السماعتة وتبروا من جميع اعداانا وقلموا وكابع
كك بعروة الاعرى الاعتنا بكطلبروامنا داامان على منبعى تمى
ولا دمع بها عليينا فى خدلوا بالعمود والميثاف بنمصفا اينا
اولايقبتتو انفلا بهم دانخنفلا بى اثرى حتى غلا وبنلا كة
خذا واحدومم منكم للا الحب دور وغناة وضيغا اضوم من الخي
لكبم ولبلا ومصبى اوبه كنبى بمرالمبلى داوصبدا انعروعنه الحلابه
وانباعم ونشمنت موسه تكا دينا عمر حولح علبى بحذلالا
الفاار دا عمود والنشور جيجشنا المو بد المتصور دبنا هشنا
لما توفد عيسم بنفض العنره والجا تة باعى بزل مشواع لاعخيل
اعنتا فح مبد دبرا نيار بم ويتا البيم حتى انتمرا بومتنا لنعا

اللَّهُمَّ صَلِّ عَلَى سَيِّدِنَا مُحَمَّدٍ فِي الْأَرْوَاحِ

وَعَلَى جَسَدِهِ فِي الْأَجْسَادِ

وَعَلَى قَبْرِهِ فِي الْقُبُورِ

وَعَلَى آلِهِ وَصَحْبِهِ

وَسَلِّمِ اللَّهُمَّ صَلِّ عَلَى سَيِّدِنَا
مُحَمَّدٍ كُلَّمَا ذَكَرَهُ الذَّاكِرُونَ

PAGE 101 A batch of newly acquired manuscripts at the Mamma Haïdara Library in Timbuktu.

PAGES 102–3 A manuscript copy of the *Tarikh al-sudan* in the collection of the Ahmed Baba Institute. Completed in 1655 by Abd al-Rahman al-Sadi, this 'History of the Blacks' recounts events in the Middle Niger region from the founding of Timbuktu in *c.* 1100 to the decades that followed the Moroccan occupation in 1591, focusing in particular on the Songhay Empire from the mid-15th century until 1591, and the Pashalik of the Arma of Timbuktu from that date down to 1655.

PREVIOUS PAGES The *Dala'il al-Khayrat* in distinctive Hausa-style calligraphy, from the the Ahmed Baba Institute. This devotional work written in Morocco in the 15th century by Imam al-Jazuli is among the most popular of its genre, and is still read across Muslim West Africa today.

OPPOSITE AND ABOVE Manuscript from the Mamma Haïdara Library showing the famous circles of al-Khalil ibn Ahmad, a philologist who died in Basra, Iraq, in the late 8th century. Al-Khalil is credited with founding the science of prosody, the study of poetic metre and the art of versification. Since all poetic metres in traditional Arabic poetry are composed of a sequence of either one long and two short, or a short and a long syllable, al-Khalil showed that it is possible to depict them in groups arranged in a circle, with each metre starting at a different point. This device was often repeated by other scholars. The reading and writing of poetry was an important element of the culture of Timbuktu, where one finds verses of devotion to the Prophet Muhammad, adoration of a woman or a man, and even poems about tea. Often poetry was written upon a death and read at the funeral. Works on grammar and law were recast in verse to facilitate learning.

فصل اذا أردت حجابا غائبا او شخص تحبه فاكتبه ما أتاني به

صحيحة من خادمين دفلغ من البرحان هولاء وزعجار وما خورد وساعة

الزهرة د ويوم وهطا وأه فنطا سرطار لبينة اركان سعرا واركان الى ئثا

لم الر متوسطة وقسمحط تا فوقة القصل الرى انت فيم وتوكل

خاحم الثا فوبة وصمرا جوه وتفتح بطل الثوا فد فانه بحضى

اذا امضى فخ رمساقة التكار بعمر الله تعا وهر لما تكتنه

فصل مزدال الكحال مرتكب و ورنه ويضعها
بوف الكحال مرهوف الفيص ثن خذ مغلفة وضخ فيها قليلا
من الرماد ومخ يوذ الى ماء بصرة ذار تن مخ المعلفة فوف
الصليب فار النار يحمر بها صاحب الكحال اخرجه يده بجم
مخلفها عارف راصنا عة الى يض قالوا جبر دار الكحال
ثم يمكث تغرها حتى يتفضح وينل مخ الغايه وبها صا
حبه وهذا ما تكتب هذه الدايه

بسم الله الرحمن الرحيم من محمد بن المختار بن احمد الى الشيخ الحاج عمر
ابى سعيد العلوى ناوى سلام منا اليك وبعد جاء رسولاى اليك
كتابك وكلامك لا اذكرك تنعم جواب كتابى بقبلوا وايبه علم اد رغتنى
ذلك عندك ولم اجدله معنى عندي يحسن منك أو لا يحسن عنه لا اذكرانت
انا اكلمك ولا ان تكلمنى وذلك ما يليق بينى وبينك بل لا يليق ولا يجوز
بينى موسى وموصى فان فتح الكلام بينهم كفتح الوطى بينها وذلك
كله من فتح ما امر الله به ان لا يوطى واذا بطل الكلام بينتاهيهم ان تعلمنى وطيهم
اذا علمك كنت اوطا منك علما او انت اوطا منك علما وقربى وحرة الله من هذا
ما يوجب حبره اليك وقربا ال الخبر لموسى اذنت على علم علمكه الله علمكه الله لا اعلمه
انا وانا على علم من علمنيه علمنيه الله لا تعلمه كنت مع انه بغلام موسى
رسول الله وصحبه وكليمه وانه فقرا عهاه النورية منهم على علم شرء
واجبني انوك ابوك الله عرتنك ذلك وكلني بذلك ما كل ما لك كذبهم لاجل امر واحد وسو
امر التوارق وذلك ما نهي ما طابه لهم واصفاء نهي على اصول ولاينة ولا امر واحفر
وكل ما بغلب منهم يخ منهم لا يخالفهم لعاد تنبع بطوع وبا اباكرام واباه وصى
ذلك حسين كبراهيم اليك واصانع لتبلغك لكلامى بالسناحة على لادو اتشنك
به انشهر انت الاصنا...

بسم الله الرحمن الرحيم

باب و من اراد لا يـ ... ـه ة

اهبى وله يكون بثـ ... اود

يموت خبيا تكتب اسم الله

ته عطم وعلفه ٪ على الـ ... ـبريم

العسرو لا بنظا ان شله الله ان

الله اصطفى لكم الـ ... ـي

ولا تموتن الا وا نتم

مسلمون تمت

PAGES 108–9 Pages from a book of writings related to healing, covering subjects including chemistry, geometry, remedies and esoteric themes. It is often the case that one manuscript ranges across an eclectic array of disciplines, greatly complicating the work of modern cataloguers. From the Mamma Haïdara Library.

PAGE 110 Letter from Ahmad al-Bakkay al-Kounti to Umar Tall, written in the mid-19th century and today in the Mohamed Tahar Library. Al-Bakkay was the leader of the Kounta, a desert people known as promoters of peace and as mediators in conflict between warring factions. He pleaded with Umar Tall to allow the people of Timbuktu to continue in their traditional Qadiriyya Sufi observations and not be forced to follow the more ascetic and militant Tijaniyya.

PAGE 111 An *ajami* manuscript, on parchment, from the Mamma Haïdara Library. The script is Arabic, but some of the language is Songhay. Other West African languages that were written in Arabic script included Tamasheq, Hausa, Fulfulde and Wolof.

OPPOSITE This illustration on a manuscript in the Ahmed Baba Institute represents the rhythms of Moroccan music and their subdivisions, as well as their influence on human health. It is from an 18th-century treatise on culture, copied in 1822.

ABOVE Another page on music from the same manuscript. West African musicians today still play the kora, a stringed instrument made from a gourd and plucked like a harp.

سورة البقرة مدنية

بسم الله الرحمن الرحيم

الم ذلك الكتاب لا ريب

فيه هدى للمتقين الذين

يؤمنون بالغيب ويقيمون

الصلوة ومما رزقناهم

ينفقون والذين يؤمنون بما

أنزل إليك وما أنزل من قبلك

وبالآخرة هم يوقنون أولئك

بسم الله الرحمن الرحيم

الحمد لله رب العالمين الرحمن

الرحيم مالك يوم الدين إياك

نعبد وإياك نستعين اهدنا

الصراط المستقيم صراط

الذين أنعمت عليهم غير

المغضوب عليهم ولا

وللادم العشر والمجد السدس

فلد ورم للعمل لعد خت

بالعدد ثلاثة ثم جمع البها

سهم واحد وقسم جميع

كنها على ثلاثة لسماو النفس

له وبلغ سبعة وعشرين سهما

ب جمل من الوابم

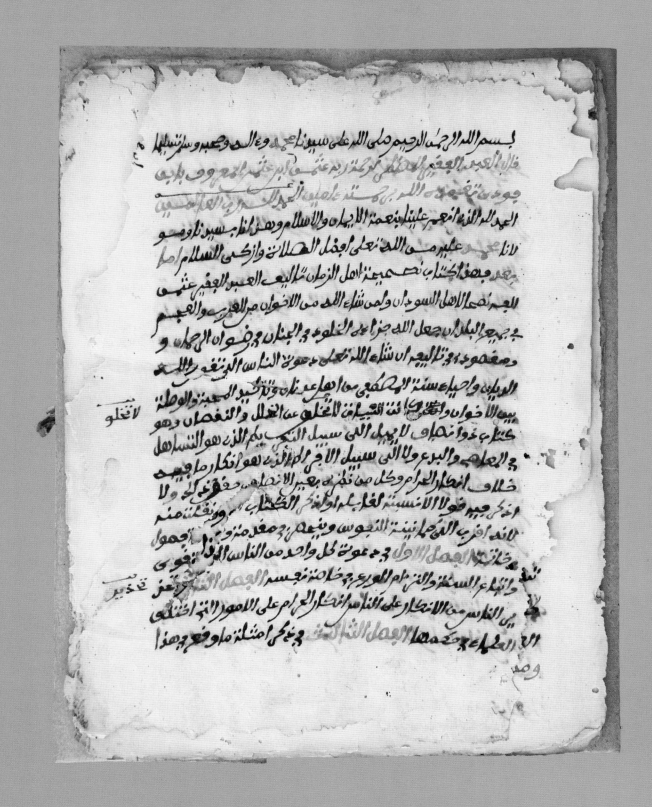

OPPOSITE When the commentator on this manuscript from Al-Wangari Library ran out of space in the margins, he wrote his comments on a separate piece of paper and attached it with string.

ABOVE *Kitab Nasa'ih li-ahl az-zaman* by Uthman b. Muhammad Fodiye, founder of the Caliphate of Sokoto in Hausaland at the turn of the 19th century. Addressed to the peoples of West Africa, both Arab and non-Arab, this work promotes love amongst brothers and expresses suspicion of innovations that transgress religion. Shaykh Uthman wrote a number of books in Arabic and composed long poems in Fulfulde. The Kounta shaykhs mediated between the often rivalling Caliphates of Sokoto and Hamdallahi.

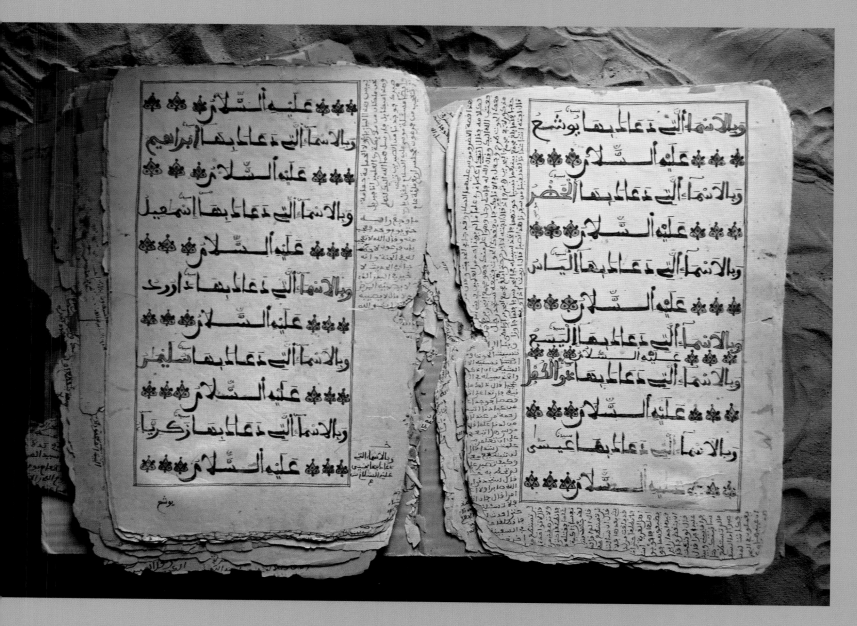

ABOVE Copy of the *Dala'il al-Khayrat*, prayers to the Prophet Muhammad, from the Mohamed Tahar Library.

OPPOSITE Koran in calligraphy typical of the Hausa. From the Ahmed Baba Institute.

OVERLEAF Pages from a Koran, copied in Maghrebi calligraphy, which includes a note reporting that it was purchased for a Moroccan king for 50 mithqal of gold. From the Mamma Haïdara Library.

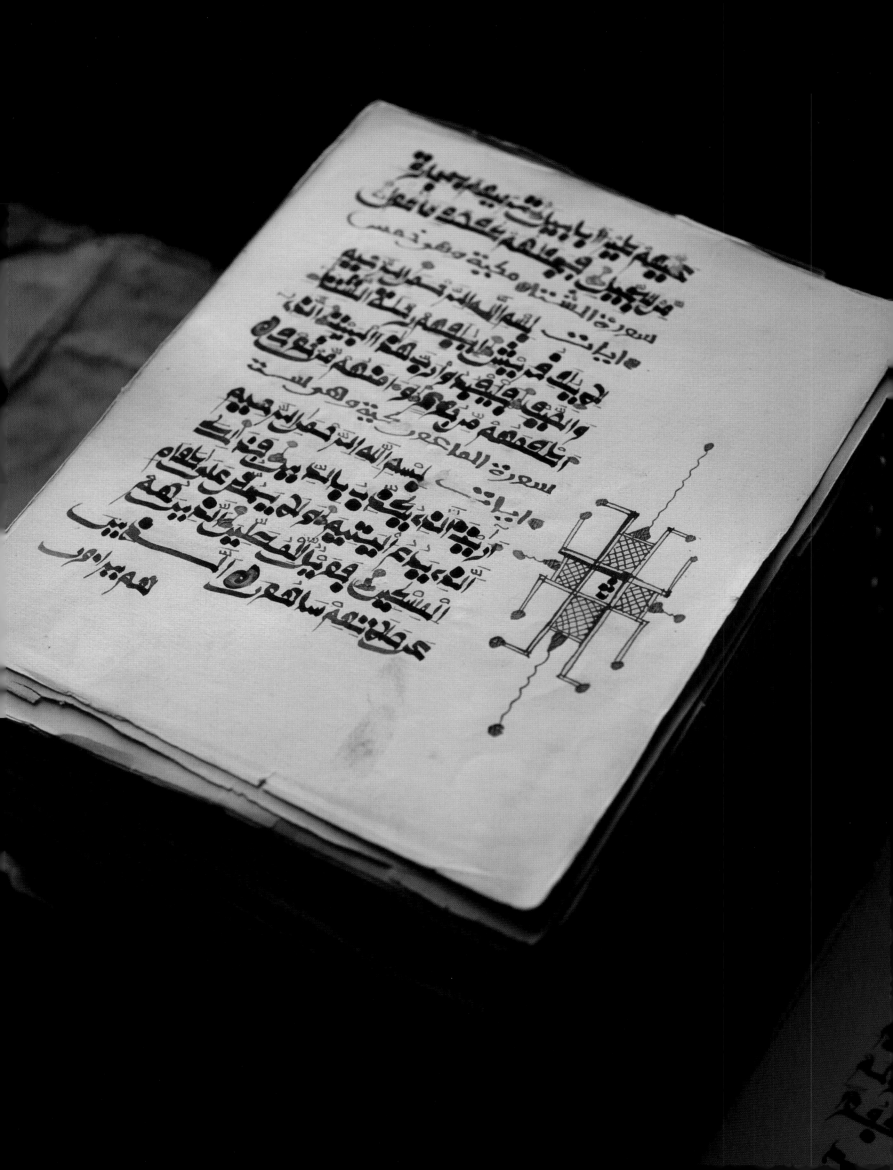

الاخرة جينا بكم لفيفا وبالحق انزلنه وبالحق نزل وما ارسلنك
الا مبشرا ونذيرا وقرا نا فرقنه لتقرا ه على الناس على مكث
ونزلنه تنزيلا قل امنوا به او لا تومنوا ان الذين اوتوا العلم من قبله
اذا يتلى عليهم يخرون للاذقان سجدا ويقولون سبحن ربنا ان كان
وعد ربنا لمفعولا ويخرون للاذقان يبكون ويزيدهم خشوعا
قل ادعوا الله او ادعوا الرحمن ايا ما تدعوا فله الاسما الحسنى

ولا تجهر بصلاتك ولا تخافت بها وابتغ بين ذلك سبيلا وقل الحمد
لله الذي لم يتخذ ولدا ولم يكن له شريك في الملك ولم يكن له

ولي من الذل وكبره تكبيرا سورة الكهف مكية

بسم الله الرحمن الرحيم

الحمد لله الذي انزل على عبده الكتب ولم يجعل له عوجا قيما لينذر
باسا شديدا من لدنه ويبشر المومنين الذين يعملون الصلحت
ان لهم اجرا حسنا ماكثين فيه ابدا وينذر الذين قالوا اتخذ الله
ولدا ما لهم به من علم ولا لابائهم كبرت كلمة تخرج من
افواههم ان يقولون الا كذبا فلعلك بخع نفسك على
اثرهم ان لم يومنوا بهذا الحديث اسفا انا جعلنا ما على
الارض زينة لها لنبلوهم ايهم احسن عملا وانا لجعلون ما عليها
صعيدا جرزا ام حسبت ان اصحب الكهف والرقيم كانوا

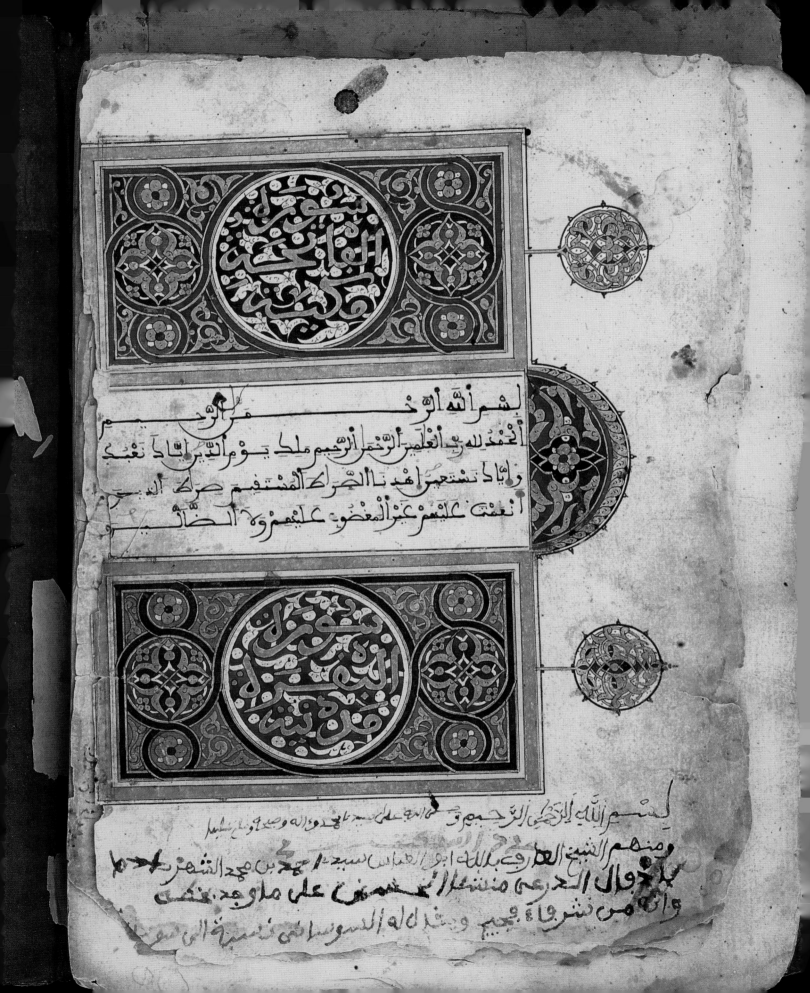

بسم الله الرحمن الرحيم

الحمد لله رب العالمين الرحمن الرحيم ملك يوم الدين اياك نعبد
واياك نستعين اهدنا الصراط المستقيم صراط الذين
انعمت عليهم غير المغضوب عليهم ولا الضالين

بسم الله الرحمن الرحيم

فسيكم ضم وكسر صحابهم وتخفف قالوا إن علمه دلا

وهذين في هذا رجح وثقله دنا فاجمعوا أصلا وافتح الميم جولا

وقل ساحر سحر شفا وتلقف أ رفع الجزم مع أنى نجل مثلا

وأنجيتكم واعدتكم مارزقتكم شفا لا تخف بالقصر والجزم فصلا

وحا فنحل الضم في كسر رضى ولام نحلل عند وا في نحلا

الكهن فأصمم كرها أهله أمكنوا معاو أفتحوا أني أنا أباحلها

ونوز بسا والنازعات طوى دكاو لاخترتك أخزنا فاز وبقلا

وأنا وشام قطع أشد قوضم وأند اعيرم وأصم وأشرك كلكلا

مع النخو أقص بعلج فسا ان ماد اثوى وأصم سوى فندكلا

ويكسر باقيم وفه وبسدج مال وقوف في الأصول تأصلا لح

PREVIOUS PAGES 122–23 A heavily annotated treatise on phonetics from the Maigala/Almoustapha Konaté Library. The study of Arabic was an important element of the Timbuktu curriculum. For Arabic was not only the language of Islam and its sciences, it was a means of communication across long distances – the lingua franca of West Africa, much as Latin was the lingua franca and the language of literacy in Europe in the Medieval era.

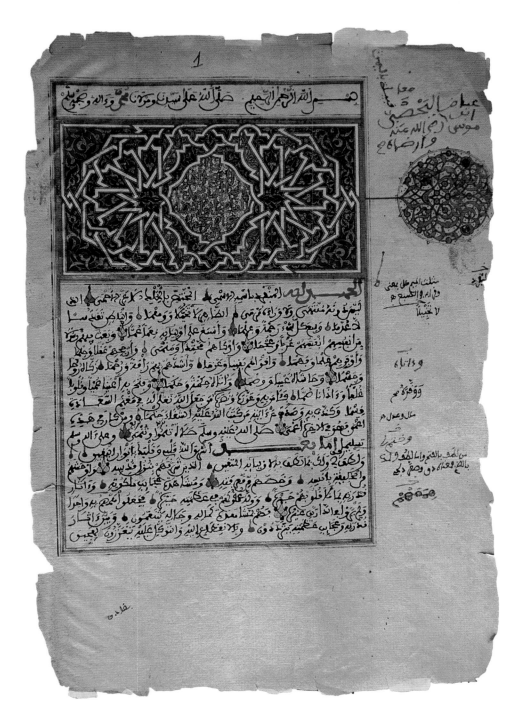

OPPOSITE A Koran copied in 1672 by the Moroccan calligrapher Abdallah b. Masoud b. al-hajj al-Senhadji. Many of the illuminated manuscripts found in Timbuktu today were originally copied in the Maghreb, Egypt or the Middle East and transported to Timbuktu. This beautiful volume is one of the great treasures of the Ahmed Baba Institute.

ABOVE The *Kitab al-Shifa* by Qadi Iyad (d. 1149), transcribed in Maghrebi calligraphy. This popular devotional work described the noble qualities of the Prophet Muhammad.

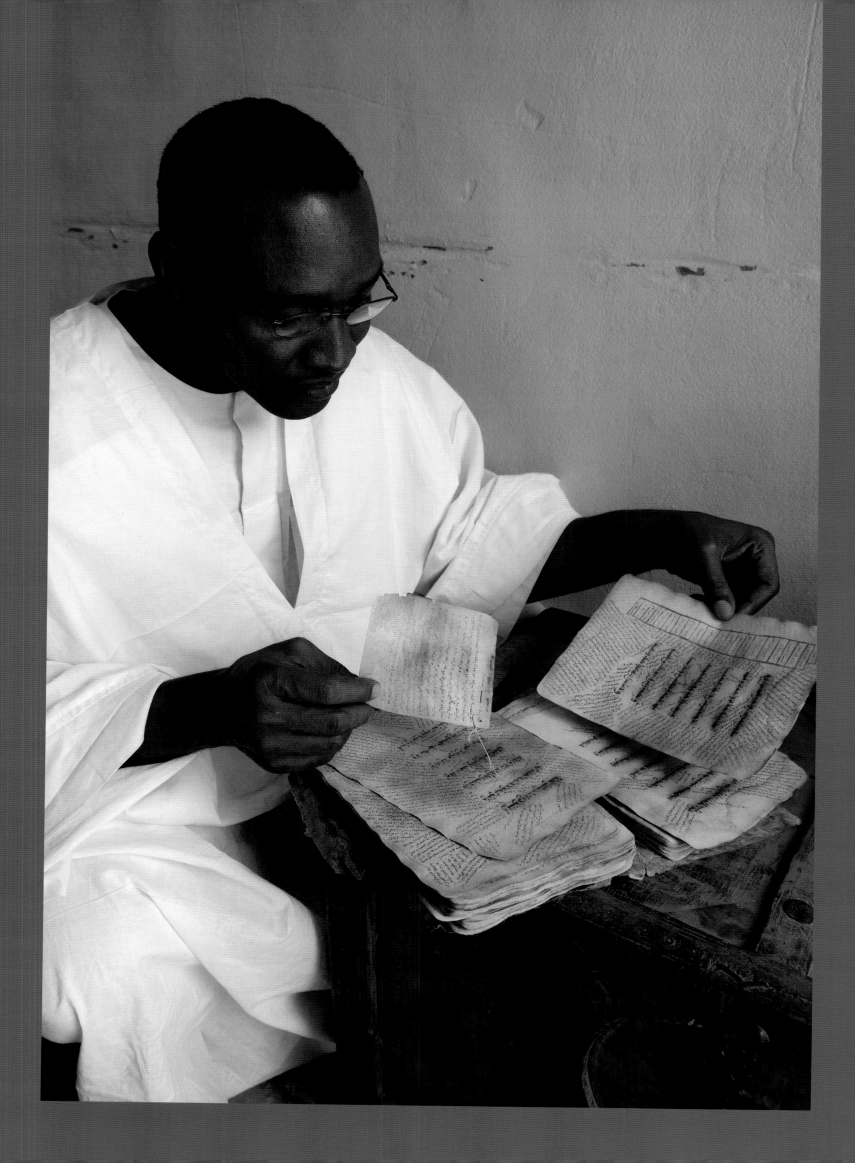

OPPOSITE Moctar Sidi Yahia al-Wangari, Director of Timbuktu's Al-Wangari Library and descendant of 16th-century teacher and scholar Muhammad Baghayogho al-Wangari.

BELOW Manuscripts at Al-Wangari Library waiting to be classified. These are contained in the chest pictured on pages 148–49.

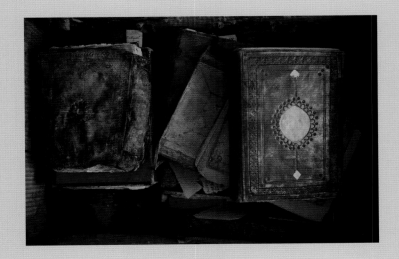

3 TIMBUKTU:
SCHOLARS AND LIBRARIES
PAST AND PRESENT

'It is clear that Timbuktu was, and still is, a homeland for scholars, and one of the most important places in sub-Saharan Africa for Islamic knowledge. God willing, it will remain so. God bless its people.'

John Hunwick

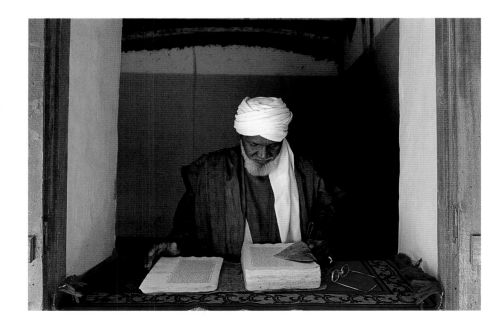

The manuscripts of Timbuktu are a testimony to the legacy of the literate culture of Islam which has developed over the past 600–700 years in Africa in general and the Niger Bend in particular. Extraordinarily rich collections of Arabic manuscripts still survive, often precariously, in private libraries in the city of Timbuktu and indeed across the entire Sahel stretching from the Atlantic to the Indian Ocean. The principal resource of Timbuktu scholarship lay in the libraries of individual scholars, some of which were evidently quite large. The celebrated scholar Ahmed Baba, deported to Morocco in 1593 following the fall of the Songhay Empire, complained to the sultan of Morocco that his library of 1,600 books had been plundered; and his, so he said, was one of the smaller libraries in the city.[1]

THE TIMBUKTU SCHOLARS

Teaching circles were formed in Timbuktu around the great families of scholars. These were typically affluent merchant families, whose wealth allowed scholars the time and means to study, travel and buy books. Students often married the daughter of their master or shaykh. Intermarriage between scholarly families, and between scholarly families and royalty, strengthened bonds and influence, and fostered a culture of cooperation that reinforced both the quality and the impact of teaching traditions. This coming together of scholars from a wide area attributed to making Timbuktu a rich and dynamic centre of learning.

Knowledge of Islamic sciences was transmitted from teacher to student through successive generations in a continuous chain of learning. Muhammad al-Kabari – referred to as the 'Master of Masters' (see page 130) – taught Muhammad Aqit's son Umar, Sidi Yahia al-Tadallisi, and probably Anda ag Muhammad, whose family married into the Aqit family. The succession of learning passed through a number of generations of these families and then on to Muhammad Baghayogho who then taught Ahmed Baba.[2] This continuous chain of learning was severed by the

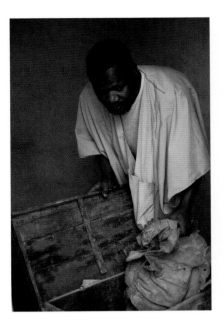

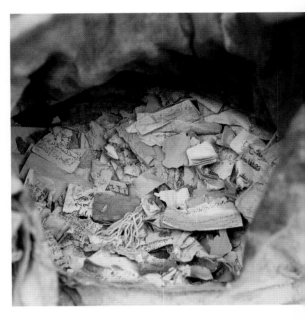

Moroccan occupation in 1591, although scholarship was kept alive to an extent by the two great historians of the 17th century, Mahmud Kati and Abd al-Rahman al-Sadi. A new chain was established in the 18th and 19th centuries with the emergence of the Kounta and the Kel al-Suq, only to be severed again by French colonization in the late 19th century. Nevertheless, throughout the 20th century some West African Muslims continued to pursue their education in Arab countries, especially Egypt, at Al-Azhar University in Cairo. In the 21st century, interest in Timbuktu's traditions of scholarship has undergone a new renaissance. Thanks to the efforts of scholars and curators and to significant support from the international community, the manuscripts, scholarship and the city of Timbuktu just might survive.

TIMBUKTU'S MOST NOTABLE SCHOLARS AND HOLYMEN

The following brief biographies recount the lives and achievements of some of the individual scholars who resided in Timbuktu or had a great influence on Timbuktu scholarship. Most of these scholars amassed great libraries, some of which can still be found in Timbuktu today, frequently maintained by their descendants.[3]

Abu Ishaq Ibrahim al-Sahili (*c.* 1290–1346)

The earliest scholar from the Mediterranean region to settle in Timbuktu was an Andalusian by the name of Abu Ishaq Ibrahim al-Sahili, who met Mansa Musa in Mecca in 1324 and accompanied him back to Mali.

Al-Sahili was born in Granada, where his father was head of the corporation of spice and perfume sellers. He received training in jurisprudence and for a time was a public notary. However, he seems to have disgraced himself while under the influence of marking nut,[4] in which state he proclaimed himself a prophet. He set out for the east, and after travels in Egypt, Syria, Iraq and the Yemen, made the pilgrimage to Mecca in 1324.

RIGHT Imam Mahmoud Baba Hasseye in his home. The Imam is a descendant of Sidi Yahia al-Tadallisi, a 15th-century scholar, teacher and holyman who was the first imam of the Sidi Yahia Mosque. His ancestors also include Muhammad Baghayogho al-Wangari, one of the most celebrated scholars of 16th-century Timbuktu, and also a former imam of Sidi Yahia.

After a period of residence at the Mansa's court, al-Sahili settled in Timbuktu, where he was responsible for supervising the construction of the Djingereber Mosque as well as the residence of the Mansa himself. He was trained in Islamic law, and was a talented man of letters. What precise contribution he may have made to Timbuktu's intellectual heritage is not known. Nevertheless, there is evidence that he strengthened Mali's ties with Morocco. He was invited to serve the Marinid Sultan Abu al Hasan, but declined and spent the rest of his life in Timbuktu, where he left children who later settled in Walata. His literary skills are evident in the elegant verse and rhyming prose that has survived.

Muhammad al-Kabari known as Modibbo Muhammad (active 1450s)
Referred to as the 'Master of Masters', Muhammad al-Kabari is at the top of the chain of transmission of Islamic learning of Timbuktu.[5] He came from a town on the River Niger towards the southern reaches of the Inland Delta. His ethnic origins are not known, but it is likely he was of Mande or Soninke stock. According to al-Sadi, he settled in Timbuktu in the middle of the 15th century and taught both the jurist Umar b. Muhammad Aqit and Sidi Yahia al-Tadallisi. He is credited with being the locus of many manifestations of divine grace and when he died is said to have been buried in a plot alongside no less than thirty of his townsmen. His date of death is unknown.

Sidi Yahia al-Tadallisi (d. 1461)
This Sufi shaykh was reputed to be a *sharif*, a descendant of the Prophet Muhammad, with a genealogy going back through al-Hasan, son of Fatima and Ali. Coming from the Mediterranean coast some 50 miles (80 km) east of Algiers, he arrived in Timbuktu in *c.* 1450, in the middle of a period when the Tuareg controlled Timbuktu. He was welcomed by the Sanhaja governor who had great affection for him and honoured him by building

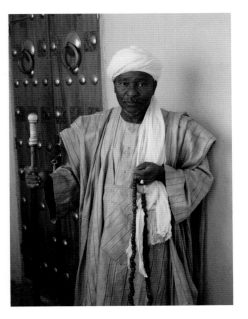

a mosque in his name and making him its imam. He was the contemporary of scholars such as Muhammad Aqit and Anda ag Muhammad, whose descendants constituted the leading learned families of Timbuktu over the next century and a half. No students of his are recorded, though it is known that he studied with Muhammad al-Kabari.

Sidi Yahia al-Tadallisi remained imam and taught in the courtyard of the Sidi Yahia Mosque until his death in 1461. He was buried in the mosque, and his descendants have served as its imams for over five hundred years to this day. He was greatly respected and is considered the patron saint of Timbuktu. The *Tarikh al-sudan* praised him in the highest terms: 'Sidi Yahia attained the very pinnacle of scholarship, righteousness, and sanctity, and became famous in every land, his *baraka* (divine grace) manifesting itself to high and low. He was the locus of manifestations of divine grace, and was clairvoyant.... No foot more virtuous than Sidi Yahia ever trod the soil of Timbuktu.'[6]

Muhammad Aqit (active mid-15th century)

One of the most important families among all the 16th-century scholars in Timbuktu were the Aqit of the Massufa. The first member of the Aqit family to live in Timbuktu was Muhammad Aqit. He was a Sanhaja scholar of the Massufa branch who traced his ancestry over fourteen generations back to Abu Bakr b. Umar, who may perhaps be identified with the Almoravid leader of that name who died in 1087.

Muhammad Aqit had lived in a tented encampment in Masina in the Inland Delta, but moved his family away to forestall intermarriage with the local Fulani. He migrated first to the Walata area and later to Timbuktu. He had a longstanding quarrel with Akil, the Sanhaja governor of Timbuktu, with whom he was finally reconciled in 1450, when he was able to settle permanently in the Sankore quarter. Many of the Aqit became imams of the Sankore Mosque over the following century and some were

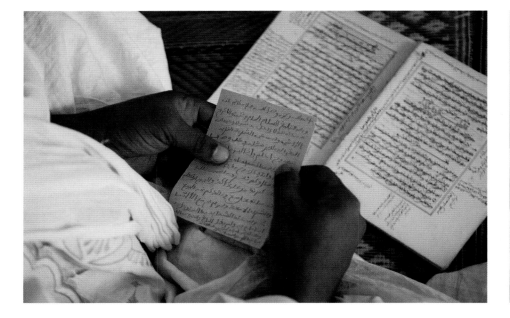
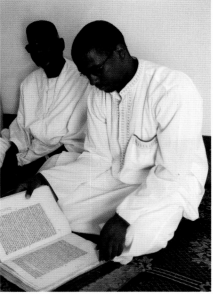

ABOVE Consulting a manuscript in the newly founded Maigala/Almoustapha Konaté Library.

ABOVE RIGHT Sidi Allmenn Maiga, the Library's Director. Sidi Allmenn was educated by his father and was appointed to this role because of his devotion to learning. He has ambitions to catalogue the collection.

also judges (*qadis*) of Timbuktu. Muhammad Aqit was a celebrated teacher, and is said to have popularized the teaching of the *Mukhtasar* of Khalil ibn Ishaq in Timbuktu. The *Tarikh al-sudan* says of him that 'Jurisprudence from his mouth had a sweetness and elegance, his easy turn of phrase, making the subject wonderfully clear without affectation.'[7]

Anda ag Muhammad (d. 1446)

One of the great Sanhaja scholars and teachers, Anda ag Muhammad was *qadi* of Timbuktu during the Tuareg rule of the mid-15th century. After his death his family suffered the persecutions of Sonni Ali in 1468, when two of his sons were killed and his daughter, who was married to the son of Muhammad Aqit, was imprisoned. His son, Mahmud b. Umar, fled to Walata, but eventually returned to become *qadi* of Timbuktu in 1480. Many of Anda ag Muhammad's other descendants lived to be imams of the Sankore Mosque, responsible for reciting the *Kitab al-Shifa* of Qadi Iyad – a devotional work on the attributes of the Prophet – at the Sankore during major religious festivals.[8] However, they left the leadership of Timbuktu in the hands of the Aqit, who maintained that role until the Moroccan invasion in 1591. During the Arma administration they acted again as *qadis*. Between them, the two families provided the intellectual and religious leadership of Timbuktu for some two centuries.

Anda ag Muhammad and his family were known for excelling in the realm of grammar. His own son was known as al-Mukhtar al-Nahawi (al-Mukhtar the grammarian). One of his descendants, Sayyid Ahmad, wrote a commentary on a famous work on grammar which was used extensively in learned circles in Fez. Copies have been preserved in Morocco and Egypt and the work was apparently still being consulted in the late 19th century since it was part of the Umarian library in Segu.[9]

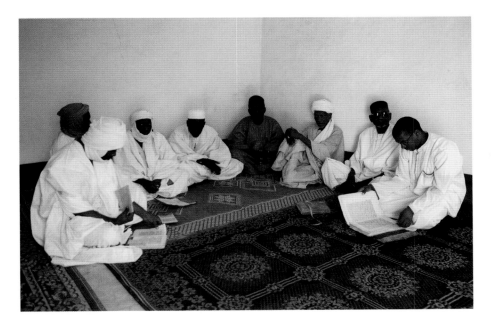

Ahmed Baba (1556–1627)

Ahmed Baba was undoubtedly the most acclaimed member of the Aqit family. He studied with his father, with his uncle, and then with Muhammad Baghayogho al-Wangari. Ahmed Baba wrote some seventy works in Arabic, many on jurisprudence, and some on grammar and syntax. One of his most famous writings was the *Nayl al-Ibtihaj*, a collection of biographies of Maliki scholars. This contains a description of his own father as 'an understanding scholar, highly accomplished, knowledgeable and versatile – a specialist in *Hadith*, in jurisprudence, rhetoric and logic.' The description then relates how his father in 1549 made a pilgrimage to Mecca where he met a number of renowned scholars.[10] This work provides first-hand information both about the Timbuktu scholars and scholars from abroad who influenced them. Ahmed Baba also wrote a book replying to questions on slavery sent to him from the Tuwat oasis far north of Timbuktu where slaves were assembled and scrutinized before being sent to North Africa. He decreed that if they were judged to be true Muslims, then they should be set free.[11]

Ahmed Baba spent the first half of his life in Timbuktu. In 1593, he was expelled and transferred to Marrakesh, where he was imprisoned for two years. Even after his release he was forced to stay in Marrakesh until 1608. During his stay he taught in the Mosque of Nobles (*Jami' al-Shurafa*), and was asked to give many *fatwas*. Among his students were the *qadi* of Fez, the *mufti* of Meknes, and the celebrated Andalusian historian Shihab al-Din al-Maqqari. Some Moroccans even claim him as one of their scholars. But while in Marrakesh Ahmed Baba expressed his affection and longing for his city in these poignant lines of verse:

'O traveller to Gao, turn off to my city.

Murmur my name there and greet all my dear ones,

With scented salams from an exile who longs

For his homeland and neighbours, companions and friends.'[12]

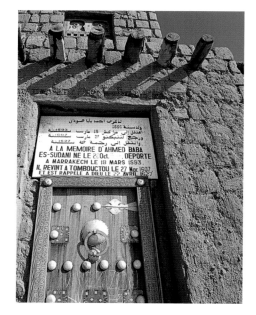

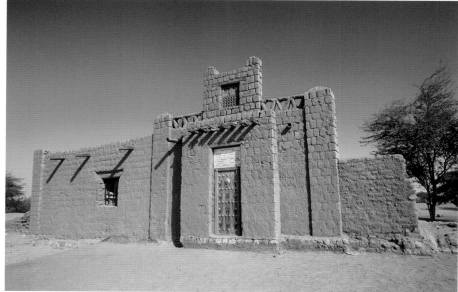

THIS PAGE The house of Ahmed Baba, who returned to his longed-for home town of Timbuktu in 1608, following sixteen years of forced exile in Marrakesh.

Of all the Timbuktu scholars exiled to Marrakesh, Ahmed Baba was the only one to survive; the others died in an epidemic of plague. Upon his return to the beloved city of his birth, he continued to teach and write, but he held no public office. His own library had been confiscated and many of his works can still be found in the National Library in Rabat. In 1970 a centre for conserving manuscripts of the Timbuktu tradition was created in Timbuktu in Ahmed Baba's name.

Muhammad Baghayogho al-Wangari (d. 1594)

Muhammad Baghayogho al-Wangari was perhaps the most celebrated teacher of his generation. He was a scholar whose family originated from the Juula, a Mande group who were both scholars and long-distance merchants. Muhammad Baghayogho was born in Djenne, and in his youth in the mid-16th century migrated to Timbuktu along with his brother Ahmad. He studied with Ahmed Baba's father, and then taught Ahmed Baba himself, who considered Baghayogho to be his shaykh and admired him tremendously,[13] as is apparent from his description:

'Our shaykh and our [source of] blessing, the jurist, and accomplished scholar, a pious and ascetic man of God, who was among the finest of God's righteous servants and practising scholars. He was a man given by nature to goodness and benign intent, guileless, and naturally disposed to goodness, believing in people to such an extent that all men were virtually equal in his sight, so well did he think of them and absolve them of wrongdoing. Moreover, he was constantly attending to people's needs, even at cost to himself, becoming distressed at their misfortunes, mediating their disputes, and advising them to have love for learning and to closely follow his teaching. He spent most of his time doing this, with affection for those concerned, with his own utter humility, helping them and caring for them, and his lending them of the most rare and precious books without searching for them again, no matter what discipline they were in. Thus it was that he lost

a [large] portion of his books – may God shower His beneficence upon him for that! Sometimes a student would come to the door of his house and send him a note listing the book he was looking for, and he would take it out of his library and dispatch it to him without even knowing who the student was. In this matter he was truly astonishing, doing this for the sake of God Most High, despite his love for books and his zeal in acquiring them, whether by purchase or copying. One day I came to him asking for books on grammar, and he hunted through his library and brought me everything he could find on the subject.'[14]

Ahmed Baba's description not only conveys his admiration; it also informs us of the existence of a large library in Timbuktu, and the distribution of its books among students and scholars. This library was inherited by the descendants of Muhammad Baghayogho al-Wangari following his death in 1594; now, more than four centuries later, a collection of manuscripts belonging to his descendants survives in Timbuktu. Known as Al-Wangari Library, it is looked after by Moctar Sidi Yahia al-Wangari in a building on Rue Heinrich Barth, just north of the Sidi Yahia Mosque (see page 142).

Abd al-Rahman al-Sadi (1594–c. 1656)

Abd al-Rahman al-Sadi, author of the *Tarikh al-sudan*, was a former imam in Djenne who was employed by the Arma administration of Timbuktu. In 1646 he became chief secretary to the Pashalik in Timbuktu. The *Tarikh al-sudan* mainly concerns the history of the Songhay Empire from the mid-15th century to the Moroccan invasion in 1591 and then from that date down to 1655. The early chapters are devoted to brief histories of earlier Songhay dynasties, of imperial Mali and of the Tuareg, and to biographies of the scholars and saints of both Timbuktu and Djenne. Al-Sadi relies mainly on personal knowledge supported by notes and on records of the Moroccan Arma administration. He is not without bias: his approach to history reflects his training as a member of the scholarly class. What benefits this

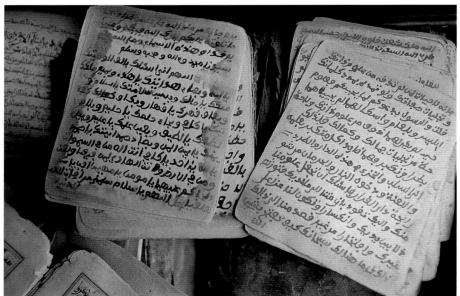

ABOVE Ismael Diadié Haïdara, descendant of Mahmud Kati and Director of the Fondo Kati, together with his wife Hawah Touré.

group meets with his approval; what is to their detriment is deplored. This is most clearly seen in his denigration of Sonni Ali, who sacked the city of Timbuktu, and his highly flattering portrait of the more benign Askiya Muhammad. While he looks back with some nostalgia to the era of the Songhay Empire, he is careful not to present any outright criticism of the Moroccan invasion, or of the Arma regime by which he was employed. Rather than condemning the Moroccans for their overthrow of the Askiya dynasty, he attributes this change of fortune to the decadence of the 'Songhay folk', representing it as just divine retribution.[15] Little is known about al-Sadi's life, but perhaps this information is another hidden treasure that will one day be rediscovered.

Mahmud Kati (d. 1593)

Another celebrated historian was Mahmud Kati, principal author of the *Tarikh al-fattash*. Mahmud Kati's father was Ali bin Ziyad al-Quti, *quti* meaning Visigoth, the Germanic people who settled in France and Spain after invading the Roman Empire in the 4th century CE. Ali bin Ziyad migrated from Toledo in Spain towards West Africa in the mid-1460s. We know this from a note he made on the final, blank page of the first volume of a copy of the *Kitab al-Shifa* by Qadi Iyad, where he records purchasing the book in the oasis of Tuwat in 1468 on his way to the 'land of the blacks': 'I bought this illuminated book called *al-Shifa* by the Qadi Iyad from its first owner Muhammad b. Umar in a [legally] valid sale, for the sum of 45 mithqal of gold cash paid in its entirety to the one from whom it was purchased with the witness of our companions. This took place two months after our arrival in Tuwat coming from our land (*bilad*) of Toledo, capital of the Goths. And we are now on our way to the *Bilad al-sudan*, asking of God Most High that He should grant us repose there.'[16]

Toledo had effectively come under Christian rule in 1085, but some Muslims continued to live there, at least until 1502, when a royal decree

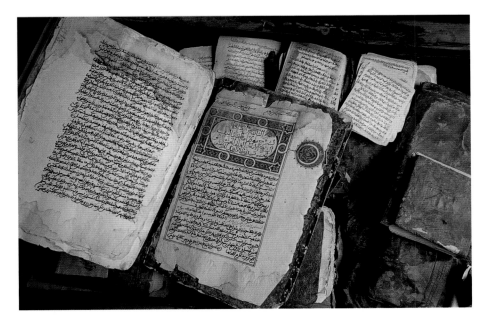

gave them the option of Christian baptism or exile. However, pressure was likely mounting on Muslims not only in Toledo but throughout Spain in the decades preceding that decree. Thus it is no surprise that Ali bin Ziyad should have decided to emigrate, presumably not very long before 1468. Why he should have decided to head for the *Bilad al-sudan* is unclear. Indeed, we do not know whether Ali bin Ziyad's decision to go to sub-Saharan Africa was taken before he and his companions left Toledo, or after they arrived in Tuwat, where they might have learned something about Timbuktu as a city of commerce and Islamic learning. However, they settled in West Africa and married local Songhay women.[17]

The Kounta (18th and 19th centuries)

Today the Kounta in Mali live predominantly along the River Niger east of Timbuktu. Some are in the city of Timbuktu, where they have mixed with the local population. Since the drought in 1984, many have moved to Bamako or dispersed throughout the region where one finds them in Mauritania, Senegal, Mali, Niger and Nigeria.[18]

The Kounta have been associated with religious learning for a number of centuries, with the result that many have become renowned saints or *wali*, in the Sufi tradition. One of the best known of the Kounta in the region was Shaykh Sidi al-Mukhtar al-Kabir al-Kounti who lived in the 18th century. The position of spiritual leader in the Kounta tradition is transmitted from father to son, and eventually the leadership was passed on to Ahmad al-Bakkay al-Kounti, who was a man of many abilities. Not only was he a great scholar, a poet, and the leader of the Qadiriyya, he was also a politician and a military man (see pages 58–60).

Partly thanks to their nomadic lifestyle, the Kounta are the people in northern Mali who have been best able to protect their manuscripts despite political and climatic turbulence. Each time there was an invasion or a drought, the Kounta moved with all their manuscripts, or entrusted

RIGHT Abdoul Wahid Haïdara, Director of the Mohamed Tahar Library, examines a manuscript from the collection recently inherited from his father, one of the great scholars and teachers of Timbuktu in modern times.

them to other members of their clan. Today they are doing everything in their power to protect this substantial patrimony.[19]

Shaykh Sidiyya al-Kabir (1775–1868)

One of the most illustrious disciples of Sidi al-Mukhtar al-Kabir was Sidiyya al-Kabir from Boutilimit in Mauritania, who spent a year with al-Mukhtar before he died, then twelve years with his son, Sidi Muhammad al-Kounti. While with the Kounta he rose to a role similar to that of a chancellor, keeping careful copies of all their correspondence, as well as building his own library of manuscript books. Soon after his return to southern Mauritania in 1825 he set off for Morocco, where he purchased over two hundred books and book-fragments, carefully recording each acquisition and its source. This became the foundation of his own library. During his life he attempted, with some success, to replicate the religious and mediatory influence wielded by the Kounta in his own region of south-western Mauritania. One indication of the influence he achieved was that the first president of independent Mauritania hailed from his clan. Shaykh Sidiyya's library, and that of his son and grandson, was reconstituted in the 1960s by a great-grandson and bibliophile, Haroun, and its 2,000-odd volumes stand as testimony to the legacy of Kounta (and Timbuktu) influence across the Sahel at dozens of similar sites where library collections comparable to those in Timbuktu were built.[20]

Ahmad Boularaf (1864–1955)

One of the most significant migrants to Timbuktu in the 20th century was known as Boularaf. He came from the town of Gulimim in Darfia in southern Morocco, and moved to Timbuktu in 1907. Although not a professional scholar, he was a man of independent wealth, acquired through trade, a bibliophile and a patron of the learned. His love of books brought him to collect a large number of manuscripts after his arrival in Timbuktu. He

LEFT Abdoul Wahid Haïdara consults
manuscripts with his wife and a neighbour.

enriched his collection through trade with other libraries and publishing
houses including eleven libraries in the Timbuktu region, two in Bamako,
and others in Mauritania, Niger and Nigeria. He also had relations with
publishing houses in Algeria, Morocco, Tunisia, Libya and Egypt.

Boularaf is perhaps best known for his revival of the book arts in
Timbuktu, where he established a workshop for manuscript production.
This appears to have been very well organized, employing a group of trained
copyists and copy editors, as well as individuals responsible for preparing
the paper and making covers. He not only reproduced manuscript books
but also used his influence to promote and publish contemporary scholar-
ship. He himself wrote approximately forty works, most of which were
versifications or abridgments of texts by others, but which included an
important original work entitled *Izalat al-Rayb* that contains biographies of
scholars of the Middle Niger. Similar to Ahmed Baba's *Nayl al-Ibtihaj*
written about three hundred years earlier, this book covers the lives of
scholars who lived during that long intervening period.[21]

Boularaf's publishing house no longer exists and his collection is
largely dispersed. However, after he died, his library was inherited by one of
his sons, and around 1970 most of his manuscripts were donated to the
newly founded Ahmed Baba Institute, where they are to be found today.

Ahmad Baber al-Arawani (d. 1997)

Among the eminent scholars of the second half of the 20th century was
Ahmad Baber al-Arawani, who was born in Arawan, a trading town about
125 miles (200 km) north of Timbuktu. He studied under another Arawani
scholar and went on to become one of the leading teachers of Timbuktu,
renowned as a historian, an exegete, a *muhaddith* (transmitter of the *Hadith*)
and a recognized expert in matters of inheritance. He was also imam of a
zawiya and *qadi* of the people of Arawan resident in Timbuktu. He is buried
close to the mausoleum of Muhammad Aqit, just north of the city.

ABOVE Book covers bearing the logo of
Ahmad Boularaf, who not only collected
manuscripts in the early 20th century, but
also commissioned new copies to be made.
He would order three copies of each work:
two to sell and one for his library, which
by 1945 contained 2,000 manuscripts and
6,000 printed volumes. Sadly much of this
material has since been dispersed.

ABOVE RIGHT Abdoul Wahid Haïdara
reading from a work copied by his father,
Mohamed Tahar.

Ahmad Baber wrote about fifteen original works, among them
biographies of scholars of Timbuktu and historical works, including the
Tarikh Azawad, a chronicle of the Azawad region. This is an edited version
with footnotes of a history of the Barabish of Azawad by Mahmud b.
Dahman, written in 1948.

Mohamed Tahar (d. 1969)

One of the great scholars and teachers of Timbuktu in modern times,
Mohamed Tahar was born in Arawan, where he studied with several schol-
ars. When Mohamed Tahar migrated to Timbuktu he established Koranic
schools both in the city and the surrounding rural areas. He had students
throughout the region, and any number of students came to study with him
each morning. He was also a copyist at Ahmad Boularaf's library, and was
known to be the best copyist in the Azawad in his time. Often other schol-
ars would send him their texts to correct. His annotations can be found in
the margins of many manuscripts from the area. His own house contained
the fruits of his labour. He had five closets full of books including manu-
scripts treating the subjects of Sufism, law, comments on the Koran, and on
grammar. There are also fragments on traditional medicine, poems and
documents on the history of Arawan.[22]

Mahamane Mahamoudou (known as Hamou) (b. 1955)

Born in Timbuktu in 1955, Hamou studied under several teachers, includ-
ing Muhammad Boularaf (son of Ahmad) and Mohamed Tahar, from
whom he obtained certificates (*ijaza*) to teach the *Hadith* and other Islamic
sciences. Hamou's father and Mohamed Tahar were very close friends. As a
child, Hamou was often at Tahar's house and would be treated like a son. In
the evening he would go there to borrow books. He would not be allowed to
take a new book before he had read and understood the previous one. Then
sometimes, before setting out on an expedition, Tahar would give him

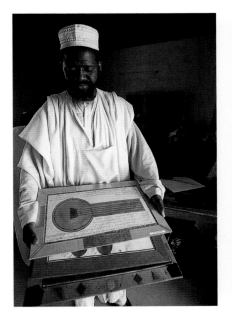
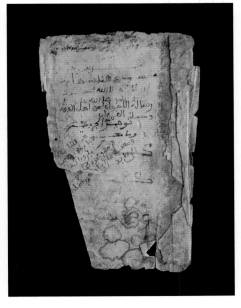
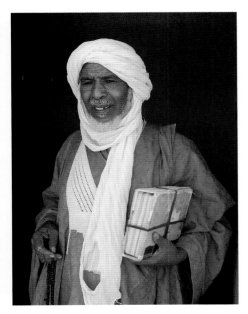

thirty or forty manuscripts at once. Upon his return, he would ask Hamou what he had learned and would tell him to make his own copies by hand.

After Mohamed Tahar's death, Hamou studied under a succession of other teachers. He later set up a Koranic school and today has his own teaching circle which meets at his house. He also obtained a certificate in calligraphy and continues to copy manuscripts. He is today one of the experts in the field of Arabic manuscripts of Timbuktu and has been assistant to several researchers as well as prospector and curator at the Ahmed Baba Institute.[23]

THE LIBRARIES OF TIMBUKTU TODAY

Foremost among the collections in Timbuktu today are those of the national Ahmed Baba Institute (IHERIAB)[24] and of private libraries including the Mamma Haïdara Library, the Fondo Kati and Al-Wangari Library. There are, however, many other libraries in the city of Timbuktu including the Library of Imam Abdramane ben Essayouti of the Djingereber Mosque, the Maigala/Almoustapha Konaté Library, the Boularaf collection and the Library of Mohamed Tahar. Further afield in the region there is the library in Boujebeha and the library of Shaykh Sidi al-Mukhtar al-Kabir al-Kounti in Gao.[25] Most of these libraries have received funding to construct buildings for their collections, and many have recently opened to the public.

The Ahmed Baba Institute, Timbuktu

The Ahmed Baba Institute (IHERIAB) was established in 1970 through an initiative by UNESCO. It was created to fulfil a need for a national repository and conservation centre for the historic manuscripts of the region. With financing from Saudi Arabia and Kuwait, the building was officially opened in 1973. At the time, the Institute had no manuscripts, and had to borrow them from private collections for its inauguration.[26] Today the Ahmed Baba Institute houses nearly 30,000 manuscripts ranging

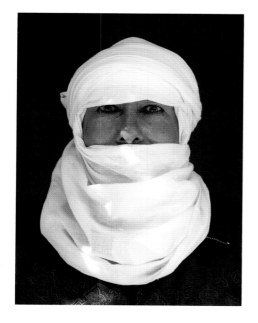
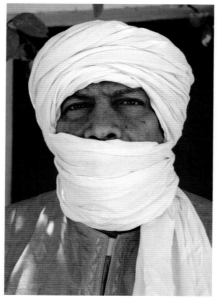
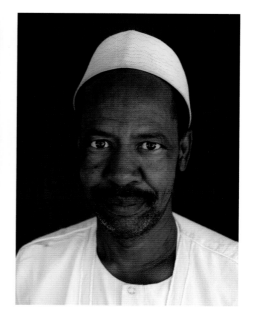

ABOVE Noury Mohamed Alamine al-Ansary, a Researcher at the Ahmed Baba Institute. He is working on *ajami* manuscripts written in the Tamasheq language using Arabic script.

ABOVE CENTRE Sidi Mohamed ould Youbba, Assistant Director of the Ahmed Baba Institute.

ABOVE RIGHT Dr Mohamed Gallah Dicko, Director of the Ahmed Baba Institute.

from one to 400 pages collected from across the region. The Timbuktu Manuscripts project was launched in the year 2000 with funding from the government of Norway channelled through the University of Oslo. In cooperation with UNESCO, with funding from the government of Luxembourg, laboratories have been equipped at the Institute and staff have been trained to carry out research, promotion and conservation. Researchers have been trained to catalogue the collection and to undertake studies of its content. Technicians have been trained to digitize and retrieve manuscripts and create promotional websites. Artisans have mastered restoration techniques and learned how to create a secure environment for the manuscripts, including the fabrication of handcrafted storage boxes. By 2008, over 4,500 manuscripts had been catalogued, 15,000 manuscripts digitized, and more than 12,000 lodged in storage boxes handcrafted at the Institute. Several articles written by researchers at the Institute are ready for publishing. The South African government is constructing a new building for the Ahmed Baba Institute to accommodate the growing collection as well as the level of ambition for preserving it.

Al-Wangari Library

Based on the manuscript collection of Muhammad Baghayogho al-Wangari, Ahmed Baba's teacher, Al-Wangari Library is probably one of the oldest libraries in Timbuktu.

Over one thousand manuscripts have so far been identified as part of the collection; however, as the *Tarikh al-sudan* tells us, Baghayogho would lend his books very freely (see pages 134–35), and as a consequence his manuscripts were dispersed all over the region. Today, one of Baghayogho's descendants, Moctar Sidi Yahia al-Wangari, has taken the initiative to reassemble what survives of the collection from various family members and reconstruct Al-Wangari Library, with assistance from the Ford Foundation, on the site of Baghayogho's former house.[27]

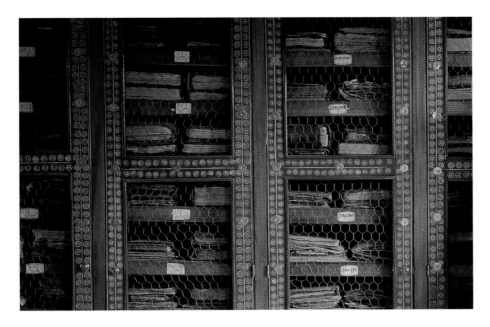

LEFT Cabinets of manuscripts at the Mamma Haïdara Library, constructed in 2000. Although over 500 volumes were pillaged in 1974, and others have been destroyed over the years by fire and floods, there remain over 9,000 manuscripts in the collection today, of which over 4,000 have been sorted, catalogued and shelved.

The Mamma Haïdara Library

One of the largest private libraries of Timbuktu is that of Mamma Haïdara. The collection from which this library partially originated was that of Muhammad al-Mawlud, who came from Bamba, a village about 120 miles (195 km) southeast of Timbuktu. As the collection was passed down from generation to generation, it suffered great losses and damage from pillaging,[28] fire, flooding and termites, and again when the family's house collapsed. Many of the manuscripts still show traces of these disasters and containers of the destroyed manuscripts are still preserved today.

In the late 20th century, the collection was handed down to Mamma Haïdara who invested in the purchase of new manuscripts and reorganized the library. He travelled and studied throughout the region of Timbuktu, including Arawan and Boujebeha, and also went to Mauritania, Sudan and Egypt, from where he brought back many manuscripts that have enriched the original collection. Eventually, he settled in Timbuktu and created a new library, combining purchases with his ancestors' collection and his own copied works. Mamma Haïdara promoted the manuscripts through research, prospecting, exchange, correspondence and copying; all of which he did with great vigour, working together with twenty-five libraries in the region. Now the library created in Timbuktu surpasses the original library in Bamba.

When Mamma Haïdara died in 1981, his son Abdel Kader continued the work of his father in enhancing the collection through the purchase of new manuscripts and assisting other libraries to conserve theirs. Having inherited a love of the written word, he also devoted much of his time to maintaining, cataloguing and organizing the library in Timbuktu. In 1993, he unified the two libraries, bringing the total number of manuscripts to 9,000, of which the oldest is said to date from 1114. With assistance from the Andrew Mellon Foundation and then the Ford Foundation, this library was the first in Timbuktu to be officially opened to the public.

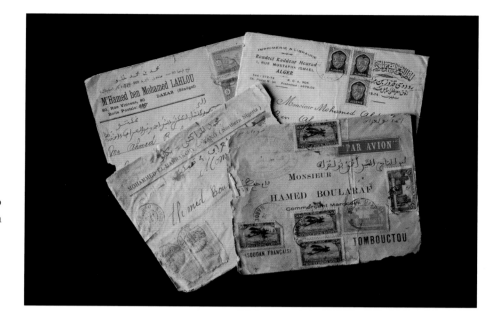

RIGHT AND OPPOSITE Letters from across West and North Africa addressed to Ahmad Boularaf (1864–1955), a Moroccan merchant and bibliophile who settled in Timbuktu in 1907. Boularaf devoted his life to promoting science and culture, and to the collecting and conservation of manuscripts.

The Fondo Kati

According to Ismael Diadié Haïdara, a descendant of Mahmud Kati, the origin of the Fondo Kati is two-fold. The original collection was brought to the region by Ali bin Ziyad who purchased manuscripts during his travels from Spain to the Middle East before he settled in West Africa. His descendants continued to add to the collection. Through close ties to the royal family of the Songhay Empire, they eventually came to acquire the manuscripts of the royal family, making the Fondo Kati a double library. Over subsequent generations, this collection was dispersed among family members, some of whom lived in Goundam, west of Timbuktu. In the 1990s Ismael Diadié Haïdara reassembled manuscripts conserved by his relatives and brought them to Timbuktu. In 2000 he obtained funding from the Junta de Andalusia in Spain to construct a library in Timbuktu.

Today the manuscripts of the Fondo Kati library are organized according to who originally acquired them, often female members of the family. The collection totals 7,026 manuscripts, of which the oldest is a Koran on vellum copied in 1198 in Ceuta and the most recent a manuscript purchased at the end of the 19th century.[29] It includes a copy of *Kitab al-Shifa*, a Koran copied in 1423 with a note in Turkish on the colophon page, as well as perhaps one of the oldest copies of the *Dala'il al-Khayrat*.[30] The collection also features a short treatise written by Alfa Kati Mahmud on the anatomy of the eye, and on various diseases and cures related to eyes, including how to perform a cataract operation.[31]

However, the most significant manuscripts in the Kati collection are those where the margins have been used by various family forebears to write notes recording events, activities, births and deaths from the 15th to the 19th centuries (see pages 94–95). These make the Fondo Kati collection an extraordinary treasure, not only as a record of Islamic culture, but also for its potential for adding a whole new dimension to our understanding of the social and political history of the Timbuktu region. Its 'discovery' is

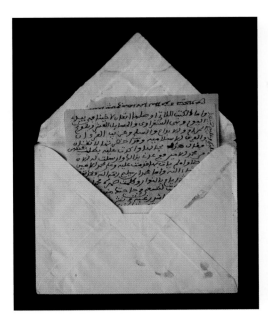
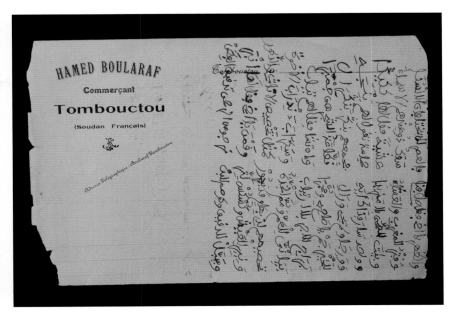

no doubt the most significant event in the history of recovering the intellectual legacy of precolonial Muslim Africa over the past half century. Ismael Diadié Haïdara informs us that work is in progress to publish three volumes of the marginalia and to conserve the collection.

The Boularaf Collection

The fortune Ahmad Boularaf made from buying, copying and selling books was not only beneficial to the caretakers of the manuscripts and those producing books, but also to scholars who were encouraged to write their own original works. In 1945, his library had 2,076 manuscripts and 6,039 printed books. Today, there are no more than 680 manuscripts and 900 printed books. Boularaf was one of the first to open the doors of his library to visitors, researchers and even to public institutions such as the Ahmed Baba Institute, which acquired many of the works from the collection. Most of the original collection is composed of relatively recent works or copies of works concerning the West African Sahel along the river and the surrounding desert. Among some of the most important works from the collection are the *Shifa al-Asqam* of Sidi Ahmad b. Muhammad al-Raqqadi, treating traditional medicine and pharmacopoeia, and the *Fath al-Shakur* of Abu Bakr al-Siddiq al-Bartili, a bibliography of the scholars of Takrur living between 1650 and 1800.[32]

PRESERVING A UNIQUE LEGACY

Great efforts are now being made to preserve the literary heritage of the Sahel and Sahara, beginning with some of the major collections of the city of Timbuktu. This is an urgent mission, since poverty is leading to the sale of some fine items, while climate and insects continue to take their toll on the fragile paper. The dry climate of the Sahel and Sahara regions has been among the most significant factors in the physical survival of the manuscripts to this day. By contrast, the damp, humid conditions along the

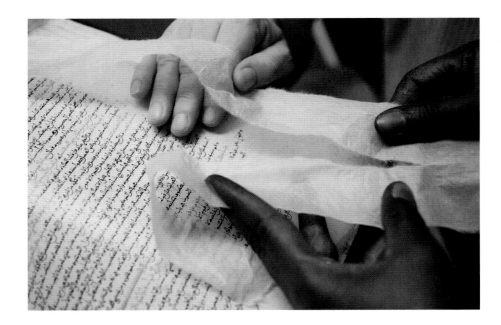

coast of both East and West Africa have meant that few old manuscripts have survived in those areas – the very earliest date from the late 17th century. Nonetheless, unknown numbers of manuscripts have been lost to conflicts, plundering, floods and fires. Forced migration has led many families to hide their manuscripts (sometimes even burying them in the sand), entrust them to friends and relatives, or take the risk of keeping their collections with them. During the period of French colonization, the libraries of the region went underground, only to surface again after the French withdrew in 1960.

Many of the private libraries of Timbuktu today have been passed from generation to generation for centuries, or have been reassembled from collections that had been split between different branches of the same family. For perhaps the greatest protection for the manuscripts are notes found in many collections commanding that they be kept within the family and forbidding their sale. One such note, from the Library of Mohamed Tahar, instructs that the book is 'not to be sold or [pawned] but to remain in the inheritance of Mohamed al-Tahar and his descendants for ever!'[34] (see page 141). That these collections still survive today is due to a strict adherence to family heritage, and a devotion to knowledge and its transmission that has been passed through many generations. The ongoing preservation of these private collections is dependent upon maintaining the close association between the collections and their custodians, so often the direct descendants of the scholars who originally collected, wrote or copied the manuscripts we find today.

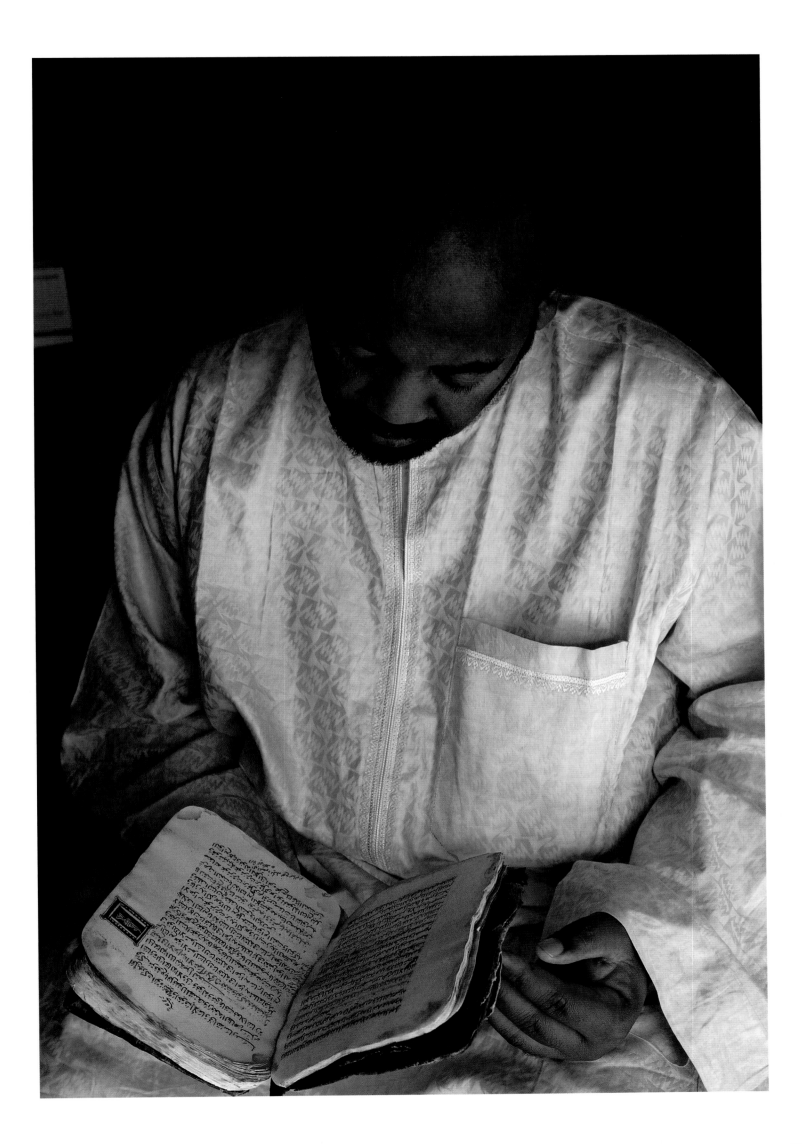

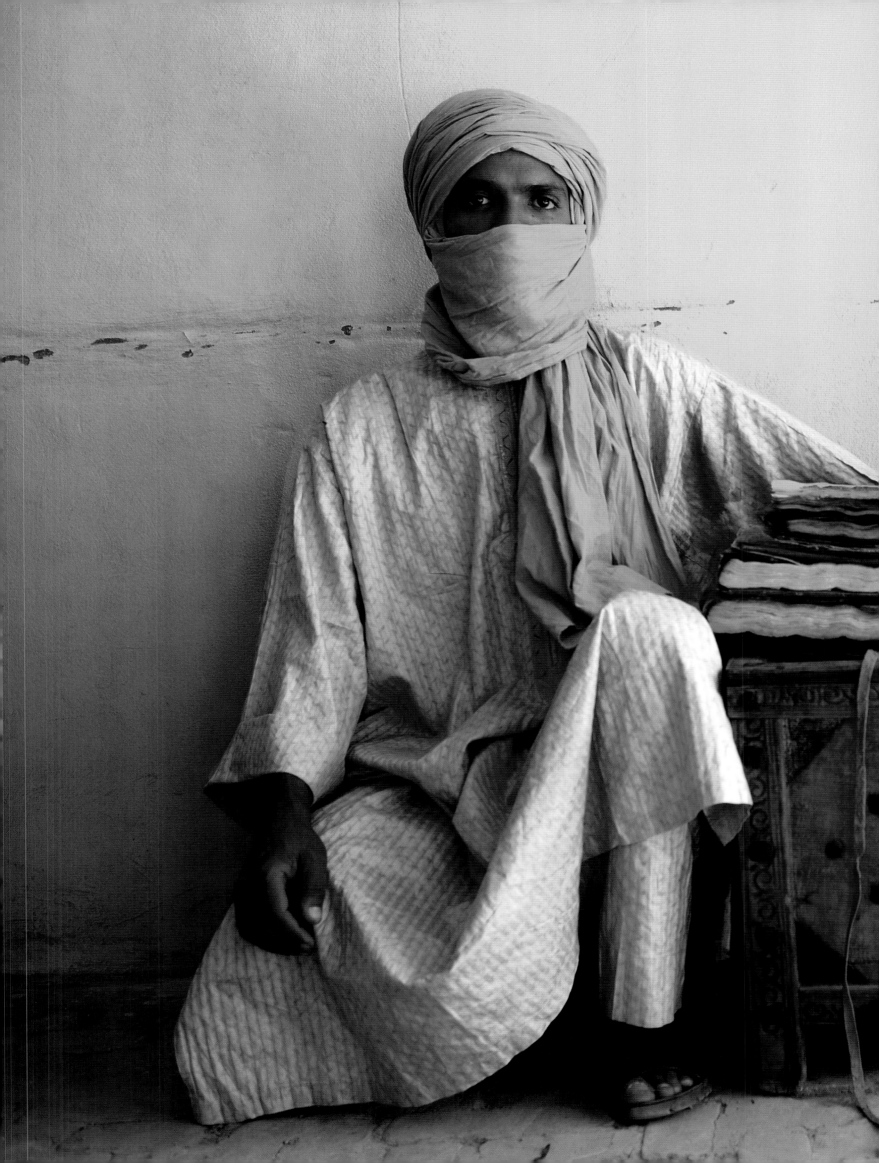

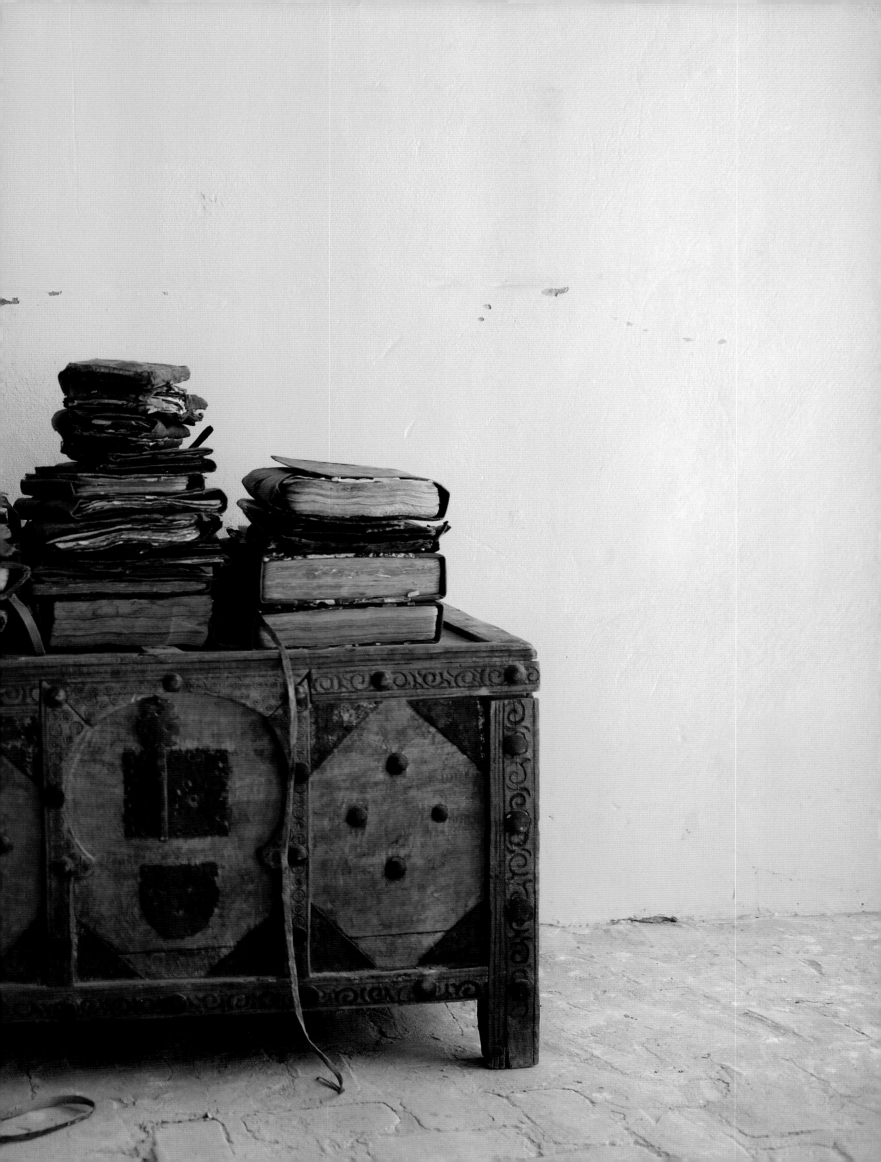

NOTES

This book has been compiled by myself, Alida Jay Boye, drawing primarily, but not entirely, upon the work of Professor John Hunwick: his writings on the Songhay Empire, relations between North Africa and sub-Saharan Africa, the transsaharan slave trade and Islamization in West Africa, not to mention his three special areas of expertise: Timbuktu, Nigeria and Ghana. Extensive use is made of his publications with Brill Academic Publishers, *Timbuktu and the Songhay Empire: Al-Sa'di's Ta'rikh al-sudan down to 1613 and other Contemporary Documents* (1999), and *Arabic Literature of Africa Volume IV – The Writings of Western Sudanic Africa* (2003), as well as his numerous publications with Markus Wiener (see Bibliography).

Translations from the Arabic are drawn principally from two sources: John Hunwick's translation of the *Tarikh al-sudan* in *Timbuktu and the Songhay Empire,* and *Corpus of Early Arabic Sources for West African History* edited and translated by J.F.P. Hopkins and N. Levtzion (Cambridge University Press, 1983; repr. Markus Wiener, 2000). In order to minimize confusion, I have taken the liberty of standardizing spellings in citations in cases where this in no way changes the meaning.

For areas beyond Hunwick's expertise, I have relied heavily on the work of other scholars, in particular descriptions by David Robinson of the Umarian regime, William Allen Brown of Hamdallahi, and Elias Saad of Timbuktu's scholarly traditions. These in turn draw upon previous African scholars, particularly those who have studied the oral traditions such as Amadou Hampâté Ba, Youssouf Tata Cissé and Bintou Sanankoua.

ABBREVIATIONS

ALA IV
Arabic Literature of Africa Volume IV – The Writings of Western Sudanic Africa (2003) compiled by John O. Hunwick with the assistance of Ousmane Kane, Bernard Salvaing, Rüdiger Seesemann, Mark Sey and Ivor Wilks. Leiden: Brill. A guide to the scholarly and literary production of Muslim writers of West Africa, other than Nigeria, including both biographies of scholars and lists of their writings. *Arabic Literature of Africa* series: general editors John O. Hunwick and R.S. O'Fahey; editorial consultants Albrecht Hofheinz, Muhammad Sani Umar and Knut Vikør.

Atelier CNRST
Centre National de la Recherche Scientifique et Technologique (CNRST), 'Atelier sur l'Exploitation Scientifique des Manuscrits de Tombouctou – Rapport Final' 21–23 décembre 2006. Bamako: CNRST.

Barth
Barth, Heinrich (1857–59) *Travels and Discoveries in North and Central Africa, being a Journal of an Expedition undertaken under the auspices of H.B.M.'s Government in the Years 1849–1855.* Repr. (1965) in 3 vols. Volume III. London: Frank Cass.

Caillié
Caillié, René (1829) *Journal d'un Voyage à Tembouctou et à Jenné dans l'Afrique Centrale.* 3 vols. Paris. Repr. (1965) Paris: Editions Anthropos. Trans. (1830) *Travels through Central Africa to Timbuctoo; and across the Great Desert, to Morocco.* London: Henry Colburn & Richard Bentley.

Chemins du Savoir
Chemins du Savoir: Les manuscrits arabes et a'jami dans la région soudano-sahelienne. Colloque International 13–17 juin 2005 – Rabat. (2006) Rabat: Institut des Etudes Africaines.

Corpus
Hopkins, J.F.P. and N. Levtzion ed. and trans. (1983) *Corpus of Early Arabic Sources for West African History.* Cambridge: Cambridge University Press; repr. (2000) Princeton: Markus Wiener.

Saad
Saad, Elias (1983) *Social History of Timbuktu: the Role of Muslim Scholars and Notables.* Cambridge: Cambridge University Press.

TSE
Hunwick, John O. ed. and trans. (1999) *Timbuktu and the Songhay Empire: Al-Sa'di's Ta'rikh al-sudan down to 1613 and other Contemporary Documents.* Leiden: Brill.

TF
Ibn al-Mukhtar/Mahmud Ka'ti b. al-hajj al-Mutawakkil, *Ta'rikh al-fattash.* Ed. and trans. into French by O. Houdas and M. Delafosse, *Tarikh El-Fettach, ou chronique du chercheur pour servir à l'histoire des villes, des armées et des principaux personnages du Tekrour.* Paris: E. Leroux 1913; repr. (1964) Paris: Librairie d'Amérique et d'Orient Adrien-Maisonneuve.

NOTES TO INTRODUCTION
pages 8–16

1 Shamil Jeppie, Senior Lecturer at Cape Town University, South Africa.
2 TF p. 313.
3 N. Levtzion (1973) *Ancient Ghana and Mali.* London: Methuen.
4 The governor of Timbuktu wrote a letter to Sonni Ali, ruler of the Songhay, insulting him, saying he was a bad Muslim. This he interpreted as a declaration of war. Al-Maghili wrote works leading to the persecution of the Jews. The fundamentalist Ahmadu Lobbo, with the assistance of his scribe, sought to legitimize his authority over the Niger Bend, and particularly the servile groups providing river transport, by forging the *Tarikh al-fattash* as well as sending letters to high officials in North Africa proclaiming him as the 12th Caliph. Al-Bakkay al-Kounti of Timbuktu accused the fundamentalist ruler of the Caliphate of Hamdallahi, Ahmadu Ahmadu, of shallow learning, saying he lacked knowledge and instruction to pursue a *jihad.* Umar Tall wrote works legitimizing his *jihads.*
5 See particularly N. Levtzion and R.L. Pouwels eds (2000) *The History of Islam in Africa,* Athens, OH: University of Ohio Press; J.D. Fage (1995) *A History of Africa,* 3rd edition, London and New York: Routledge; as well as numerous works published by the Institut des Etudes Africaines in Rabat, Morocco.
6 For example *The Epic of Askia Muhammad;* or *The Epic of Sunjata,* founder of the Malian Empire. See also Ba, A.H. and J. Daget (1962) *L'Empire Peul du Macina (1818–1853),* Abidjan: Les Nouvelles Editions Africaines.
7 See Roderick J. McIntosh (1998) *The Peoples of the Middle Niger: The Island of Gold,* London: Blackwell Publishers; P.F. de Moraes Farias ed. (2004) *Arabic Medieval Inscriptions from the Republic of Mali: Epigraphy, Chronicles and Songhay-Tuareg History,* Oxford: Oxford University Press. *Vallées du Niger, Musée national des arts et d'Océanie, 12 octobre 1993–10 janvier 1994* (1993) Exhibition catalogue, Paris: Éditions de la Réunion des musées nationaux.
8 This pertains particularly to the Fulani and the Tuareg. Families from several ethnic groups claim descent either from the Prophet Muhammad or from Saudi Arabia/Yemen, making distinctions between Arabs, Berbers, Moors and local groups rather blurred.
9 John O. Hunwick (1973) 'The Mid-Fourteenth Century Capital of Mali', *Journal of African History* 14, 2, pp. 195–206.
10 Volumes I–IV were published between 1993 and 2003. Volumes V–VI are under preparation as of 2008.
11 The Al-Furqan Islamic Heritage Foundation, based in London, has

published several catalogues of manuscript collections from the region. Electronic databases include ADJAB, designed through a collaboration between the University of Oslo and the Institut de recherche et d'histoire des textes (IRHT) in Paris; the Arabic Manuscript Management System (AAMM) based in Chicago; and the database of the West African Arabic manuscripts collection at Northwestern University, Evanston.

12 Leo Africanus, *Della Discrittione dell'Africa* (1526) TSE p. 282.

NOTES TO CHAPTER 1
Timbuktu: Where the Camel Meets the Canoe, pages 32–62

1 Barth (1965) p. 685.

2 These are only averages; annual and seasonal variation is considerable.

3 'Tin' in the Tamasheq language means 'well'. Benjaminsen, Tor Arve and Gunnvor Berge (2004) *Une histoire de Tombouctou*, trans. from Norwegian into French by Yves Boutroue. Arles: Actes Sud, p. 87. Al-Sadi in the *Tarikh al-Sudan* gives a different explanation: that the slave woman was called 'Tinbuktu, which in their language [Songhay] means [the one having a] "lump".' TSE p. 29.

4 According to al-Sadi in the *Tarikh al-Sudan*, 'Timbuktu was founded by the Maghsharan Tuareg towards the end of the fifth century of the hijra [c. 1100]. They would come there in summer to graze their herds on the banks of the river at the village of Amadia where they encamped. Then in the rainy season they would return northward by stages to Arawan their farthest point in the upper lands, and encamp there. Thus did they choose the location of this virtuous, pure, undefiled and proud city, blessed with divine favour, a healthy climate, and [commercial] activity which is my birth-place and my heart's desire. It is a city unsullied by the worship of idols, where none has prostrated save to God the Compassionate, a refuge of scholarly and righteous folk, a haunt of saints and ascetics, and a meeting place of caravans and boats.' TSE p. 29. Al-Sadi defines the 'Tuareg' as 'the Massufa, who trace their descent from Sanhaja' TSE p. 35.

5 Ibn Battuta (1355) 'The Journey' *Corpus* p. 303.

6 Leo Africanus' original name in Arabic was al-Hasan b. Muhammad al-Wazzan al-Zayyati.

7 In much of the literature, including the *Tarikh al-Sudan*, the various Berber groups are referred to as Tuareg. The name 'Tuareg' (or 'Tawäriq' in Arabic) is a term used by foreigners or outsiders.

8 Ibn Battuta (1355) *Corpus* p. 301.

9 Zouber, Mahmoud (2006) 'Le patrimoine écrit au Mali' *Chemins du Savoir*.

10 Stewart, Charles (1973) *Islam and Social Order in Mauritania*. Oxford: The Clarendon Press, pp. 35–53.

11 The language of the Fulani is Fulfulde, but the Fulani of Senegal and Guinea call themselves Fulbe and their language Pulaar.

12 A pattern which is still played out today in inter-ethnic social relationships, often referred to as 'joking relationships' or 'plaisanterie'.

13 'Between Tamantit and the frontier of Mali at a place called Ghar is a little-known desert where the tracks and watering-places can be found only by experienced guides drawn from the veil-wearers who nomadize in that wilderness. The merchants hire them as escorts at a high price.' Ibn Khaldun (1374–78) 'The Book of Examples and the Register of Subject and Predicate in the Days of the Arabs, the Persians, and the Berbers' *Corpus* p. 339.

14 Ibn Battuta (1355) *Corpus* p. 283.

15 Interview with Sidi Mohamed ould Youbba (2007). The French explorer René Caillié travelled across the desert in 1828 at about 2 miles per hour with a caravan of about '1,400 camels each bearing a load of 500 pounds and composed of 250 men on foot.' Caillié (1830) pp. 106 and 422. During the heyday of transsaharan trade, caravans were probably much larger, although the accuracy of reported numbers cannot be verified. Ibn Khaldun in his 'Book of Examples' written in the 14th century reports on a caravan of 12,000 camels (Corpus p. 339). The Moroccans were said to have set off to invade Timbuktu in 1591 with as many as 10,000 camels carrying munitions, tents, water and other provisions, according to a Spaniard in Marrakesh gathering intelligence for King Phillip II of Spain. 'An Account of the Sadian Conquest of Songhay by an anonymous Spaniard', TSE p. 319.

16 Ibn Battuta (1355) *Corpus* p. 303.

17 Leo Africanus, *Della discrittione dell'Africa*, TSE p. 282.

18 TF p. 270

19 Al-Umari (1337–38) 'Pathways of Vision in the Realms of the Metropolises' *Corpus* p. 267.

20 Al-Masudi (947) 'The Meadows of Gold and the Mines of Jewels' *Corpus* p. 32. Al-Masudi was probably the first to write about the 'silent trade' in gold.

21 Watson, Andrew (1967) 'Back to Gold and Silver' in *Economic History Review* 20; Nehemia Levtzion (1973) *Ancient Ghana and Mali*. London: Methuen, pp. 131–33.

22 Al-Umari (1337–38) *Corpus* p. 275.

23 A North African traveller provided the Iranian geographer Al-Qazwini who wrote in 1275 with the following description of a city which developed in the vicinity of one of the salt mines in the northern Sahara: 'The ramparts of the city of [Taghaza] were of salt as also all its walls, pillars, and roofs. The doors, too, were made of slabs of salt covered with leather so that the edges might not crack...all the land around that town is a salt pan where salt and alum are mined. If an animal dies there it is thrown into the desert and turns to salt. Salt is very precious in the land of the Sudan... Its inhabitants are the slaves of the Massufa and their job is to collect salt all the year round. The caravan comes once a year.'

24 Al-Qazwini (1275) 'The Marvels of the Created Beings and the Monuments of the Lands' *Corpus* p. 178.

24 Ahmed Baba (1610) *Ayn al-isaba fi hukm taba*, 'On the lawfulness of tobacco usage'. See Mahmoud A. Zouber (1977) *Ahmad BÇbÇ de Tombouctou (1556–1627): sa vie et son oeuvre*. Paris: Maisonneuve et Larose.

25 Leo Africanus (1526) TSE p. 281.

26 Mahmud Kati, through the liberality of Askiya Dawud, purchased a copy of *al-Qamus al-muhit*, the great dictionary by al-Firuzabadi, for 80 mithqal. TF p. 108. This would be equivalent to the price of two horses, according to the sum quoted by Leo Africanus for such a purchase in Gao.

27 Shaykh Sidi al-Mukhtar al-Kabir was known to send someone to meet the caravans in order to have the first bid. Shaykh ben Hamada Kounta (2006) 'Présentation du Centre Sheikh Sidi Al Moukhtar Al Kadir Kounti pour la Recherche et la Documentation à Gao' *Chemins du Savoir* p. 79.

28 Al-Umari (1337–38) *Corpus* p. 271.

29 From Manuscript no. 5777, Ahmed Baba Institute, Timbuktu. Interpretation by Seydou Traoré in 'Relations Commerciales entre Tombouctou et Ghadames du 14è à l'Epoque Coloniale' Atelier CNRST p. 50.

30 Ibn Khaldun (1374–78) *Corpus* p. 335.

31 TSE p. 148.

32 Al-Idrisi (1154) *Corpus* p. 109.

33 Al-Bakri (1068) 'The Book of Routes and Realms' *Corpus* p. 68.

34 John O. Hunwick and Fatima Harrak ed. and trans. (2000) *Mi'raj al-Su'ud: Ahmad Baba's Replies on Slavery, Arabic text and English translation*. Rabat: Institut des Etudes Africaines.

35 Khalil ibn Ishaq, *al-Mukhtasar*, trans. G.H. Bousquet (1956) *Abrégé de la loi musulmane selon le rite de l'Imâm Mâlik*. Algiers.

36 Manuscript no. 5785, Ahmed Baba Institute, Timbuktu. Interpretation by Seydou Traoré in 'Relations Commerciales entre Tombouctou et Ghadames du 14è à l'Epoque Coloniale', Atelier CNRST p. 52.

37 Ibn Hawqal (10th century) 'The Picture of the Earth' *Corpus* p. 49.

38 Al-Istakhri (10th century) 'The Book of Routes and Realms' *Corpus* p. 41.

39 Al-Idrisi (1154) *Corpus* p. 110.

40 Ibn Khaldun (1374–78) *Corpus* p. 333.

41 Al-Umari (1337–38) *Corpus* p. 262.

42 Ibn al-Dawadari (1335) 'The Treasure of Pearls and the Assemblage of Choice Objects' *Corpus* p. 250.

43 TSE p. 9.

44 Al-Umari *Corpus* pp. 270–71.

45 Ibn Battuta *Corpus* pp. 295–97.

46 TSE p. 12.

47 Ibid. p. 12.

48 Ibid. p. 93.

49 TF p. 114.

50 TF p.131, also TSE p. 105.

51 See John O. Hunwick (2006) *Jews of a Saharan Oasis*. Princeton: Markus Wiener.

52 G.R. Crone, ed. and trans. (1937) *The Voyages of Cadamosto and other Documents on Western Africa in the Second Half of the Fifteenth Century*. London: Hakluyt Society, p. 86.

53 'The Replies of al-Maghili to the Questions of Askia al-Hajj Muhammad' trans. in John O. Hunwick (1985) *Shari'a in Songhay*. Oxford: Oxford University Press.

54 Mungo Park (1799). Repr. (1983) *Travels into the Interior of Africa*. London: Eland. Vol. I, p. 211.

55 TF p. 119.

56 TSE p. 187.

57 Ibid. p. 198.

58 Letter from Mulay Ahmad al-Mansur to Kanta Dawud of Kebbi. Undated. TSE p. 304.

59 Ibid. p. 221.

60 Ibid. Footnote no. 30 p. 221.

61 Ibid. p. 318. 'An Account of the Sadian Conquest of Songhay by an anonymous Spaniard.'

62 Ibid. p. 256.

63 Al-Mukhtar issued several *fatwas* against Lobbo's 'Proclamation' prohibiting contact between men and women who were not married or closely related. Al-Mukhtar, *Ajwiba*, fos 219r. Saad p. 217, footnote no. 181 p. 295. See also Vikør, Knut S. (2000) 'Sufi Brotherhoods in Africa', in *The History of Islam in Africa*, ed. N. Levtzion and R.L. Pouwels. Athens, OH: Ohio University Press.

64 TF p. 315, Saad pp. 86–87.

65 Genevière, J. (1950) 'Les Kountas et leurs activités commerciales', *Bull. IFAN* XII pp. 1111–27.

66 Barth p. 299. Hamdallahi took revenge by blockading Timbuktu's port, Kabara, and cutting off the city's food supply.

67 Ibid. p. 395.

68 Ibid. p. 430.

69 Caillié, René (1830) Vol. 2 p. 49.

70 Barth (1853). Appendix XIV 'Al-Bakkay's letter of Recommendation' trans. by Dr. Nicholson. p. 764.

71 Benjaminsen, Tor Arve and Gunnvor Berge (2004), *Une histoire de Tombouctou*, translated from Norwegian into French by Yves Boutroue. Arles: Actes Sud, p. 70.

72 Ibid. p. 83.

NOTES TO CHAPTER 2
Timbuktu: A Sanctuary for Scholars, pp. 80–100

Page 81 Leo Africanus (1526) TSE p. 281.

1 'People came there from all directions, and over time it became a commercial emporium. The most frequent traders there were the people of Wagadu, followed by others from that general area. The previous centre of commerce had been the town of Biru, to which caravans came from all directions. The cream of scholars and holymen, and the wealthy from every tribe and land settled there – men from Egypt, Awjila, Fezzan, Ghadames, Tuwat, Dar'a, Tafilalt, Fez, Sus, Bitu, etc. Little by little, together with [representatives of] all the branches of the Sanhaja, they moved to Timbuktu until they filled it to overflowing. Timbuktu's growth brought about the ruin of Walata, for its development, as regards both religion and commerce, came entirely from the west.' TSE p. 30.

2 TSE p. 91.

3 Ibid. p. 158

4 Ibid. p. 223.

5 The Moroccans were, however, very impressed by Ahmed Baba's works and set him up to teach during his stay (see page 133).

6 Three copies of the *Tarikh al-fattash* have been found to date. These each differ either because pages have been lost or because the work has been forged or manipulated to legitimize later claims. In editing and translating the text in 1913, Houdas and Delafosse included passages found only in one of these copies of the manuscript, so that the currently available text published in Arabic (and translated into French) is an amalgam of original 16th- and 17th-century material and 19th-century forgery.

7 See John O. Hunwick (1996) 'Fez and West Africa in the fifteenth and sixteenth centuries: scholarly and sharifian networks', in *Fès et l'Afrique: Relations économiques, culturelles et spirituelles*, Rabat: Institut des Etudes Africaines, pp. 57–71.

8 The Malians built a *madrasa* in Cairo where their entourage stayed during pilgrimages to Mecca. Al-Umari *Corpus* p. 261.

9 The 'chain' of transmission of Islamic knowledge or authority, particularly the transmission of spiritual allegiance and mystical knowledge, is a *silsila*. An *isnad* is a document listing scholars through whom authority has been transmitted. The *isnad* of a particular scholar will thus show both where his knowledge originated and how it might have been transformed.

10 Reichmuth, Stefan (2000) 'Islamic Education and Scholarship in Sub-Saharan Africa', in N. Levtzion and R.L. Pouwels eds (2000) *The History of Islam in Africa*, Athens, OH: University of Ohio Press, p. 424.

11 Ahmed Baba gave an *ijaza* to a scholar giving him permission to transmit everything for which he himself had received a license whenever he wished and in any words he wished on the condition that it be free of corruption and inaccuracy. Such *ijazas* provide us with a fuller picture of Ahmed Baba's mentors and the sources from which the preceding generations of Timbuktu scholars received at least part of their education. Hunwick, John O. (1966) 'Further Light on Ahmad Baba al-Tinbukti'. *Research Bulletin, Centre of Arabic Documentation*, ii/1, pp. 20–21.

12 Wilks, Ivor (1968) 'The Transmission of Islamic Learning in the Western Sudan' in J. Goody, ed., *Literacy in Traditional Societies*. Cambridge: Cambridge University Press, p. 171.

13 Estimations of the population of Timbuktu in the 15th and 16th centuries have ranged widely, from 25,000 to 100,000. R. Mauny (1961), in *Tableau géographique de l'ouest africain au moyen âge*, Dakar: IFAN [Mém. de l'IFAN, 61), estimated that Timbuktu had a total of only about 25,000 inhabitants. Local historians in Timbuktu tell of a population of 100,000 of which every fourth inhabitant was a student (interview with Salem ould el Hadje in 2007). In the *Tarikh al-fattash* it is reported that there were 26 workshops in the tailoring industry, where many students worked, each with 50–100 apprentices (TF p. 315). Elias Saad estimates about 200–300 scholars during this period (Saad p. 82). When René Caillié visited Timbuktu in 1828, he estimated Timbuktu's population at 10–12,000 (Caillié p. 56) while Heinrich Barth reported 13,000 inhabitants with an additional 'floating population' of as many as 10,000 (Barth p. 326). Timbuktu's population today is said to be about 30,000, greatly increasing when there is an event such as a festival in town.

14 TSE pp. 73–74.

15 From an interpretation by Mohamed Baye of various manuscripts from the Ahmed Baba Institute presented in 'Science de l'Education à travers les manuscrits de l'IHERIAB', Atelier CNRST p. 46.

16 Ibn Battuta *Corpus* p. 300.

17 Barth p. 372.

18 In 1992, John Hunwick came across nearly 200 documents at the Ahmed Baba Institute relating to the purchase, sale, inheritance and endowment of slaves as well as claims to free status. One document records how a woman who gained a quarter-share of a slave through inheritance gave it away as a charitable donation in expiation of her sins. Another is a *fatwa* concerning whether a master should pay his slave's taxes during the colonial period. Hunwick, John O. (1992) 'CEDRAB: the Centre de Documentation et de Recherches Ahmad Baba at Timbuktu'. *Sudanic Africa* 3, pp. 173–81.

19 When WWI broke out, many scholars of West Africa wrote letters of support for the French, but while most wrote very brief letters, the scholars of Timbuktu 'drew up an elaborate jurisprudential treatise in which they almost surveyed the whole history of their city.' Saad p. 221.

20 Number 218, Ismael Diadié Haïdara (2006) 'Marginalia' *Chemins du Savoir* p. 59.

21 Berge, G., D. Diallo and B. Hveem (2005) *Les plantes sauvages du Sahel malien: les stratégies d'adaptation à la sécheressse des Sahéliens*. Paris: Editions Karthala, p. 135.

22 Salvaing, Bernard (2006) 'La question des manuscrits au Fuuta Jaloo (Guinée)' *Chemins du Savoir* p. 108.

23 Diagayeté, Mohamed (2006) 'Présentation de quelques manuscrits des auteurs peul du Mali à l'IHERI-AB', Atelier CNRST p. 36.

24 Arabic script generally only represents the consonants and the long vowels and eliminates the short vowels. Vocalization is the process of adding the short vowels. The text of the Koran is always vocalized, but so too are also some canonical texts on grammar or law when precise

pronunciation and/or comprehension needs to be ensured. The work of vocalizing may have been done by the proofreader. See also Glossary.

25 Abdel Kader Haïdara (2006) 'Bibliothèque Mamma Haïdara de Tombouctou' *Chemins du Savoir* p. 49. *Mohamed Maghraoui (2005) Guide de l'Exposition sur les manuscrits de Tombouctou: Patrimoine Partagé, Rabat 13–17 juin 2005. Bibliothèque Nationale du Royaume du Maroc*, Institut des Etudes Africaines, p. 24; *Bruno Marty 'Histoire de l'Ecriture'* in Abdelhamid, Arab et al. (2005) *Les Trésors Manuscrits de la Méditerranée* p. 62. Special thanks to Philippe Roisse, Centre de Documentation et de Recherches Arabes Chrétiennes (CEDRAC), University of St Joseph, Beirut, and Mohamed Maghraoui, Université Mohamed V–Agdal, Rabat, for providing clarifications to this description of styles of calligraphy used in West Africa.

26 Bloom, Jonathan (2001) *Paper Before Print: The History and Impact of Paper in the Islamic World*. New Haven: Yale University Press, pp. 86–87.

27 Barth p. 475.

NOTES TO CHAPTER 3
Timbuktu: Scholars and Libraries Past and Present, pp. 126–49

1 'Al-Ifrani's account of the Sadian conquest' TSE p. 315.

2 Saad p. 62 and Appendix 12 p. 247.

3 These biographies are extracted from ALA IV unless otherwise indicated.

4 Marking nuts are similar to cashews, but when untreated can be very toxic. (Thanks to Dr Berit Smestad Paulsen, Department of Pharmacy, University of Oslo.)

5 Saad p. 60.

6 TSE p. 72.

7 TSE p. 54.

8 Ibid pp. 40–42. See also Saad p. 43.

9 Saad p. 75.

10 Ahmed Baba (1596) *Nayl al-ibtihaj bi-tatriz al-dibaj*, on margins of Ibn Farhun, *al-Dibaj al-mudhahhab fi ma'rifat a'yan'ulama' al-madhhab*. Cairo 1351/1932–33.

11 Since war could not be fought against other Muslims, only 'unbelievers' could be captured and held as slaves. No consideration was ever given in Islamic teachings to what colour of skin made people enslaveable. According to Muhammad al-Sanusi al-Jarimi (*Tanbih ahl al-tuhghyan 'ala hurriyyat al-sudan*, MS 1575, IHERIAB, Timbuktu) the Prophet Muhammad said that 'The Arab has no virtue over the non-Arab, nor has the non-Arab over the Arab, nor has the White over the Black, or the Black over the White, except in terms of devotion to God. Surely, the noblest of you in God's sight is the most devout.' See also Drissa Diakité's review of medieval Arab authors writing about black Africa: 'Le "pays des noirs" dans le récit des auteurs arabes anciens', *Notre Librairie*, 95 (octobre–décembre 1988), pp. 16–25.

12 'Al-Ifrani's account of the Sadian conquest' TSE p. 316.

13 Baghayogho was also a kind of father or uncle to Ahmed Baba. When Ahmed Baba lost his father, Baghayogho married his mother.

14 Ahmed Baba (1596) Op cit p. 341. A similar description can be found in the *Tarikh al-sudan*, TSE p. 62.

15 TSE pp. lxiii–lxv.

16 This manuscript is preserved in Timbuktu nowadays in a private library under the direction of Ismael Diadié Haïdara, who gave John O. Hunwick permission to publish this page of sale and translate it; see Hunwick (2001) *Sudanic Africa*, xii pp. 111–14.

17 According to the historian and descendant of Ali ben Ziyad, Ismael Diadié Haïdara, Ali ben Ziyad al-Quti al-Tulaytuli al-Andalusi left Castille and found himself in Tuwat, on the northern edges of the Sahara, in 1468. En route he had passed through Ceuta, Fez and finally Sijilmasa, where he stayed for six months. From Tuwat, he went to Mecca before taking the road to the 'land of the blacks' (*bilad al-sudan*). He stayed four months in Walata and then settled down in Gumbu, a Soninke region. Here he married Princess Kadija bint Abubakr Sylla, niece of Songhay ruler Sunni Ali Ber, and older sister of the future ruler, Askiya Muhammad. Summarized from Ismael Diadié Haïdara (2006) 'Marginalia' in *Chemins du Savoir* p. 57. See also Albrecht Hofheinz (2004) 'Goths in the Lands of the Blacks: A Preliminary Survey of the Ka'ti Library in Timbuktu' in *The Transmission of Learning in Islamic Africa*, ed. Scott Reese. Leiden: Brill, pp. 154–83.

18 Based on an interview with Salem ould el Hadje (2007).

19 Ibid.

20 Stewart, Charles (1973) *Islam and Social Order in Mauritania*. Oxford: Clarendon Press, pp. 35–53.

21 Sidi Mohamed ould Youbba (2006) 'Bibliothèque de Bula'raf' in *Chemins du Savoir*. See also ALA IV pp. 53–54.

22 Based on an interview with the Timbuktu scholar Mahamane Mahamoudou (known as Hamou) (2006).

23 Ibid. See also ALA IV p. 64.

24 The Ahmed Baba Institute for Higher Education and Islamic Studies (IHERIAB), formerly the Ahmed Baba Centre for Documentation and Research (CEDRAB).

25 Abdel Kader Haïdara (2002) 'Bibliothèques du Désert: Difficultés et Perspectives' in *Les Bibliothèques du désert: recherches et études sur un millénaire d'écrits*, ed. Attilio Gaudio. Paris: L'Harmattan, pp. 187–203.

26 Based on an interview with Imam Mahmoud Baba Hasseye (2007), who was responsible for organizing the inauguration of the Ahmed Baba Institute.

27 Based on an interview with Moctar Sidi Yahia al-Wangari (2005) and a resumé of his presentation at the *Chemins du Savoir* Conference in 2005 in Rabat.

28 In 1974 an estimated 500 volumes were pillaged, apparently by unknown intruders

from a neighbouring country. For a description of the library see Abdel Kader Haïdara (2006) 'Bibliothèque Mamma Haïdara de Tombouctou' in *Chemins du Savoir* pp. 41–56.

29 Ismael Diadié Haïdara (2006) 'Marginalia' in *Chemins du Savoir* pp. 57–64.

30 Mohamed Maghraoui (2005) *Guide de l'Exposition sur les manuscrits de Tombouctou: Patrimoine Partagé, Rabat 13–17 juin 2005. Bibliothèque Nationale du Royaume du Maroc*. Rabat: Institut des Etudes Africaines, p. 13.

31 Ismael Diadié Haïdara (2006) 'Marginalia' in *Chemins du Savoir* p. 60.

32 Sidi Mohamed ould Youbba (2006) 'La Bibliothèque de Bula'raf' in *Chemins du Savoir* pp. 67–72.

33 Based on an interview with Mahmoud A. Zouber, first director of the Ahmed Baba Institute, who worked closely with Mamma Haïdara to create access to the manuscript heritage of Timbuktu.

34 Interpretation by Michael Carter, Senior Lecturer in Arabic, Centre for Middle Eastern Studies, University of Sydney, Australia.

GLOSSARY OF TERMS, PEOPLE AND PLACES

Arabic words, proper nouns and titles in the main text have been written in the most accessible form possible, without diacritics, and following the Oxford English Dictionary when applicable. This glossary also includes various alternative spellings as found in the literature; these are in brackets after the main entry. Arabic transliterations provided here generally follow standards presented in *Arabic Literature of Africa* compiled by John Hunwick; however, diacritics are omitted, with the exception of some *ayns* and *hamzas* which are preserved for purposes of pronunciation. The Arabic definite article 'al-' is ignored in alphabetization.

The names of historical individuals who have living relatives follows modern Malian (often French) usage rather than academic norms for transliterating Arabic into English. Thus the French 'Kounta' is maintained rather than the English standard 'Kunta'. People of the past are presented using the more academically accepted spelling 'Muhammad', while 'Mohamed' is maintained for those who use this spelling today. Place names also follow current usage in Mali (with the exception of Timbuktu, which in Mali is called Tombouctou). Dates throughout the text refer to the Common Era (CE, equivalent to AD) rather than the *Hijri* or Islamic calendar. Places are also located on the map (p. 8).

Special thanks to Albrecht Hofheinz, Knut Vikør, Charles Stewart and Gunnvor Berge for assistance with this glossary.

Abu al-Hasan known as the 'King of the Maghreb', r. 1331–51
Sultan of Morocco who for a brief period united much of North Africa, capturing the strategic city of Tlemcen in 1337.

Abu Ishaq Ibrahim al-Sahili, *c.* 1290–1346
Architect-poet from al-Andalus who contributed to the development of the Sudanese architectural style of West Africa when he returned from Mecca with Mansa Musa in 1324 and supervised, among other royal projects, the construction of the Djingereber Mosque in Timbuktu.

ag Tamasheq, 'son of'

Ahmad al-Bakkay al-Kounti
Ahmad al-Bakka'i b. Muhammad b. al-Mukhtar al-Kunti al-Wafi, *c.* 1803–65
Grandson of al-Mukhtar al-Kabir al-Kounti, al-Bakkay was the effective civil power in Timbuktu in the mid-19th century and the host and protector of the German explorer Heinrich Barth.

Ahmad Boularaf (Ahmad Bularaf, Bou'l-Araf, Abu'l-A'raf)
Ahmad b. Mubarak b. Barka b. Muhammad al-Musa-u-Ali al-Takani al-Wadnuni al-Susi al-Tinbukti, 1864–1955
Moroccan merchant and bibliophile who settled in Timbuktu in the early 20th century

and established a library and a professional workshop for manuscript copying and production.

Ahmadu Ahmadu (Ahmadu III)
Ahmad b. Ahmad b. Ahmad b. Muhammad Lobbo, r. 1853–62
Succeeded his father Seku Ahmadu (Ahmadu II) as third and last ruler of Hamdallahi, the Islamic state of Masina, but was defeated and put to death by Umar Tall in 1862 after being declared an 'unbeliever' for supporting the ruler of Segu, whom he claimed to have converted to Islam.

Ahmadu Lobbo
Ahmad b. Muhammad Bubu b. Abi Bakr b. Sa'id al-Fullani, r. 1818–45
Fulani fundamentalist of the Qadiriyya Sufi order who founded the Islamic state of Masina, known as the Caliphate (or Diina) of Hamdallahi, in *c.* 1818, which he ruled until his death.

Ahmed Baba (Ahmad Baba)
Ahmad Baba b. Ahmad b. al-hajj Ahmad b. Umar b. Muhammad Aqit al-Tinbukti, al-Sudani, al-Musufi, al-Sanhaji, 1556–1627
One of Timbuktu's greatest scholars, Ahmed Baba was active during the last years of the Songhay Empire, and was then deported to Marrakesh following the Moroccan invasion in 1591. His teaching in Morocco as well as his extensive work *Nayl al-Ibtihaj* detailing the biographies of Maliki scholars brought much prestige to Timbuktu scholarship. The Ahmed Baba Institute (IHERIAB) in Timbuktu is named after him.

ajami Ar., 'foreign, non-Arab'
Refers to the use of Arabic script for writing languages other than Arabic, such as Persian. In Sahelian West Africa and the Sahara, manuscripts written in local languages using Arabic script include among others Songhay, Tamasheq, Fulfulde, Hausa and Wolof. *Ajami* educational texts and poetry in Fulfulde and Hausa flourished in the region particularly during the 19th century.

Ali bin Ziyad al-Quti
Ali b. Ziyad al-Quti al-Tulaytuli al-Andalusi, active mid-15th century
Visigoth who fled Toledo in southern Spain and settled in Timbuktu. His descendant, Mahmud Kati, was the primary author of the great Timbuktu chronicle the *Tarikh al-fattash*.

Almoravids from Ar., *al-Murabitun*
Militant Islamic movement of Sanhaja nomads which originated in Western Sahara, destabilized ancient Ghana, then conquered and unified Morocco and al-Andalus during the second half of the 11th century.

al-Andalus (Andalusia)
Refers to those parts of the Iberian Peninsula dominated by Muslims or Moors between 711 and 1492. Al-Andalus gave its name to

the modern-day province of Andalusia in southern Spain, but at its height extended over an area far greater than this, reaching all the way from modern Portugal in the west to the southern borders of modern France.

Aqit
Family of scholars prominent in Timbuktu until the Moroccan invasion in 1591, after which they were deported to Morocco. Their most acclaimed member was Ahmed Baba.

Arabs
Arabic-speaking peoples who originated in the Arabian Peninsula. In West Africa, this would include Hassaniyya Arabs, speakers of a dialect of Arabic who live in an area stretching north and westwards from the Niger Bend to the Atlantic and southern Morocco.

Arawan (Arouane)
Small town 260 km (160 miles) north of Timbuktu on the route from Timbuktu to the Taghaza salt mines and the trading entrepot of Tuwat. Arawan was founded by a Sufi shaykh of the Kel al-Suq in the late 16th century. It is the capital of the Azawad region.

Arma (Ruma, *al-Rumat*) from Ar. *al-ruma*, 'musketeers'
An army composed of Spanish, Berber and Arab mercenary soldiers who participated in the Moroccan conquest of Timbuktu in 1591. They settled in the city and intermarried with the local elites, becoming the ruling caste.

Askiya (Askia)
Title of the dynasty of rulers of the Songhay Empire which reigned from 1493 to 1608.

Askiya Dawud (Daoud) r. 1549–83
Ruler of the Songhay Empire during the Askiya dynasty who is known to have established public libraries during his reign.

Askiya Muhammad Askiya *al-hajj*
Muhammad Ture, r. 1493–1529
'Commander of the Faithful' and founder of the Askiya Dynasty of the Songhay Empire. A Soninke, he led a successful coup d'état against previous Songhay ruler Sonni Ali. Askiya Muhammad is one of the heroes of the Timbuktu chronicles, while Sonni Ali was condemned by them as a bad Muslim and a tyrant. Apart from the change of dynasty, this owes much to the fact that Sonni Ali drew his legitimacy from local Songhay traditions while Askiya Muhammad based his legitimacy on Islam and provided support to the scholarly class. Under Askiya Muhammad, the Songhay Empire expanded beyond the core riverine territories established by Sonni Ali as far north as the salt pans of Taghaza with tributaries as far as Agades. Attempts were also made to control areas as far west as the Senegal Valley.

Awdaghast (Tegdaoust)
Town west of Timbuktu in what is today southern Mauritania. Founded in the early Middle Ages, Awdaghast was a centre for the gold trade in the times of ancient Ghana. Its conquest by the Almoravids in the late 11th century put an end to the golden age of ancient Ghana. Al-Bakri described the town in 1068, telling us about the early development of Islam in the area: 'In Awdaghust there is one cathedral mosque and many smaller ones, all well attended. In all the mosques there are teachers of the Koran.' ('The Book of Routes and Realms' translated in *Corpus* p. 68.)

Azawad
Desert territories of northern Mali stretching from the River Niger to the salt mines at Taghaza, and northeast of Timbuktu to the present-day border with Mauritania.

al-Azhar Mosque Ar., *al-azhar* 'the most flourishing and resplendent'
Al-Azhar Mosque was founded in Cairo in the year 972 CE. The university attached to the mosque is known as the cradle of Islamic learning, and scholars from Timbuktu often stopped at al-Azhar during their pilgrimages to Mecca.

al-Bakri
Abu Ubayd Abd Allah b. Abd al-Aziz al-Bakri, d. 1094
One of the most important sources for the history of the Western Sudan, al-Bakri lived in al-Andalus and compiled information from Andalusian and North African merchants who had travelled across the Sahara through what is now Mauritania. His writings include the *Kitab al-masalik wa-'l-mamalik*, 'The Book of Routes and Realms' (1068), featuring a rare description of ancient Ghana.

Bamako
Capital of the modern Republic of Mali.

Barabish
Arabic speakers of the Hassaniyya dialect in the area of modern-day Mauritania, these peoples are often referred to as simply Arabs or Moors.

baraka Ar., 'blessing, blessedness'
Quality of divine grace or spiritual power that may inhere in a person or an object, enabling unusual or 'miraculous' things to occur.

bin (*ibn* or *b.*) Ar. 'son [of]'

Berber
Native peoples of North Africa. Also defined as speakers of various Berber dialects, including the Sanhaja, Massufa and Tuareg.

Bilad al-sudan Ar., 'Land of the Blacks'
Africa south of the Sahara. In Arabic the *Bilad al-sudan* is primarily a historic term referring to lands adjacent to those inhabited by the lighter-skinned Berber and Arab populations of Saharan Africa, the *Dar al-islam* ('Lands of Islam'). Through trade and Islamization, by the 12th and 13th centuries the domains of the Sahara and the *Bilad al-sudan* had become the melting pot of the Niger Bend,

and cities such as Timbuktu had a mixed Muslim population of Berbers, Arabs and black Africans which has been maintained to this day.

Boujebeha (Bou Djebiha, Bousbehay, Boûdjbéha, BuJbayhah)
Village in the desert 220 km (140 miles) north-northeast of Timbuktu and 100 km (60 miles) southwest of Arawan.

Bozo
Fisherfolk inhabiting the northern section of the River Niger. Although not ethnically Malinke, they speak Manding, the language of the Malinke, a sub-group of the Mande.

Caliph from Ar. *khalifa*, 'successor, representative'
The highest political leader of a community of Muslims; the Prophet's successor in his earthly role.

colophon
An inscription at the end of a manuscript book giving the title of the work, the name of the copyist, and the date (or at least the year) of completion. Sometimes the colophon includes the name of the person for whom it was copied. This information is often displayed on the page in triangular form, the lines becoming narrower towards the end.

Dala'il al-Khayrat
Dala'il al-Khayrat wa Shawariq al-Anwar fi Dhikr al-Salat ala al-Nabi al-Mukhtar, by Imam Muhammad b. Sulayman al-Jazuli, d. 1465
'The Guide to Blessings and the Advent of Light in Blessing the Chosen Prophet'. Written in Morocco in the 15th century, this devotional work – a prayer to the Prophet – is among the most popular of its genre. It was quickly disseminated throughout the Muslim world and is still read across West Africa today.

Djenne (Jenne)
City located south of Timbuktu on a branch of the River Niger. Djenne was one of the great centres of Islamic learning and trade, and a sister city to Timbuktu. Today, it is famous for its magnificent mosque, the largest adobe structure in the world, which was constructed in 1907 during French colonial rule.

Djingereber (Jingere Ber, Jingeregir) Songhay, 'Great Mosque'
The 'Great Mosque' of Timbuktu built in 1325 on the order of Malian Emperor Mansa Musa by Abu Ishaq Ibrahim al-Sahili, an Andalusian architect and poet who accompanied the emperor on his return from pilgrimage to Mecca.

Dogon
Pagan people who life along the the Bandiagara cliffs (also known as Dogon Country) about 200 km (125 miles) south of Timbuktu.

fatwa Ar., 'formal ruling or opinion on a point of Islamic law'
A fatwa would be given by a legal counsellor or *mufti*.

Fez (Fr., Fès; Ar., Fas)
City in Morocco and centre of the Moroccan book trade into the 19th century.

fiqh Ar., 'Islamic jurisprudence'
The academic discipline providing understanding of the *Sharia*, the Islamic law.

Fulani (Fulbe, Peul, Pulaar)
Semi-nomadic cattle breeders and herders from central Mali who have also spread over much of modern Sahelian Africa from Sudan in the east to Senegal in the west.

Fulfulde
The language of the Fulani (Fulbe, Peul), also used in Guinea and Senegal where it is known as Pulaar.

Futa Jallon (Fouta-Djalon, Fuuta Jaloo)
Highland area in Guinea serving as the principal source of the Niger, Senegal and Gambia Rivers. An area which historically attracted Fulani cattle breeders.

Futa Toro (Fouta-Toro, Fuuta Tooro)
Area in the middle Senegal River valley in what is now northern Senegal, bordering the desert of southern Mauritania.

Gao
City on the left bank of the Niger River, southeast of Timbuktu. The former capital of the Songhay Empire.

geomancy
Divination through numbers or lines drawn in the sand.

Ghadames (Ghadamis)
City in western Libya on the border with Algeria. Historically, Ghadames was a gateway to Tripoli and for routes leading to Egypt, while to the south it also established commercial ties with Kano in northern Nigeria. Traders from Ghadames played an important role in the commercial life of Timbuktu from the 15th to 19th centuries. Al-Bakri described the town in 1068: 'The inhabitants are Muslim Berbers... Between Ghadamis and Jabal Nafusa takes seven days' travelling through the desert. From Nafusa to the city of Tripoli is three days.' ('The Book of Routes and Realms' translated in *Corpus* p. 86.)

Ghana, ancient Empire of
Located in areas of what today are southern Mauritania and western Mali, and including the cities of Awdaghast and Walata, ancient Ghana (also known as Wagadu) was the northernmost territory of the Soninke people. The capital lay most likely somewhere between the Niger and the Senegal Rivers, though its precise location is not established. The Empire probably developed in the 8th century and reached its height in the 10th century, maintaining considerable power in the region until it was weakened by Almoravid attacks in 1076. Modern Ghana takes its name from the ancient Empire of Ghana, despite its different location.

Gordon Laing 1793–1826
Scotsman Laing was the first European explorer to reach Timbuktu. He was killed on his return journey across the desert in 1826.

Hadith Ar., 'saying, report'
Oral traditions relating to the sayings and deeds of the Prophet Muhammad. The corpus of *Hadith* is one of the major sources of Islamic law.

hajj Ar., 'pilgrim, pilgrimage'
Honorary title accorded to one who has made the Greater Pilgrimage to Mecca (*Hajj*).

Hamdallahi
The Caliphate (or Diina) of Hamdallahi was an Islamic state in Masina. The capital, also Hamdallahi (meaning 'Praise be to God'), lay 80 km (50 miles) northeast of Djenne. It was founded in *c.* 1818 by the Fulani Ahmadu Lobbo, who was succeeded in 1845 by his son Seku Ahmadu (Ahmadu II, not to be confused with the son of Umar Tall with the same name) and then by his grandson Ahmadu Ahmadu (Ahmadu III). Hamdallahi ruled over much of the Inland Delta of the Niger in the first half of the 19th century, making several attacks on Timbuktu and gaining hegemony for a period. The Caliphate of Hamdallahi was defeated by Umar Tall in 1862.

Hassaniyya Arabs
Speakers of a dialect of Arabic who live largely in modern-day Mauritania in an area stretching north and westwards from the Niger Bend to the Atlantic and southern Morocco. Often referred to as Arabs or Barabish.

Hausa (Fr. Haoussa)
Language and people of southern Niger and northern Nigeria.

Heinrich Barth 1821–65
German explorer who provided one of the most well-researched accounts of life and politics in Sahelian West Africa in the mid-19th century in his famous work *Travels and Discoveries in North and Central Africa, being a Journal of an Expedition undertaken under the auspices of H.B.M.'s Government in the Years 1849–1855*. This included an account of his seven-month stay in Timbuktu in 1853.

Hijra (*Hegira*) Ar., 'relocation, emigration'
Applied especially to the Prophet Muhammad's move from Mecca to Medina in 622 CE, which marks the beginning of the Islamic calendar.

Ibn (*bin* or *b.*) Ar. 'son of'

Ibn Battuta
Shams al Din Abu Abd Allah Muhammad, 1304–72
One of the great travellers of the 14th century, Ibn Battuta was born in Tangier, Morocco. Between 1325 and 1353 he visited most of the Muslim world of his day and then ventured on to East Africa, India, Ceylon, Sumatra as well as possibly China. His West African journey was his last, beginning in February 1352 and ending in December 1353. He stayed six months with Mansa Sulayman, ruler of the Malian Empire, and visited Timbuktu, providing us with what is most likely the earliest first-hand account of the city. His travels were recorded in his *Rihla* or 'Journey' which was edited by his secretary Ibn Juzayy.

Ibn Khaldun
Abu Zayd Abd al-Rahman Ibn Khaldun, d. 1406
North African philosopher and historian who included a brief dynastic history of the Malian Empire from information recorded in 1393–94 in his general history of Islamic civilization, the *Kitab al-'Ibar* or 'The Days of the Arabs, the Persians and the Berbers'.

al-Idrisi
Abu Abd Allah Muhammad *al-sharif* al-Idrisi, 1100–*c.* 1165
A descendant of the Banu Hammud dynasty which had ruled Malaga until 1055, al-Idrisi also claimed to be descended from the Prophet Muhammad; hence the *al-sharif* in his *nisba*. Geographer, cartographer and traveller, in 1154 he wrote the book *Nuzhat al-mushtaq fi ikhtiraq al-afaq*, 'The Pleasure of Him who Longs to Cross the Horizons', often referred to as the *Book of Roger* since it was written for Roger II, Norman King of Sicily. This provides us with an account of areas of West Africa from what is today Senegal to Lake Chad. Al-Idrisi is known particularly for his maps.

Ibn Sina (Avicenna) 980–1037
Persian Muslim polymath, especially renowned as a physician and philosopher. Avicenna is the Latinized version of his name.

ijaza Ar., 'authorization, license'
Certificate or authorization, usually written, specifying the works studied and completed by a student, as well as the level at which they were studied, and providing licence to teach that material to others.

imam Ar., literally 'person in front'
Refers to the prayer leader in a mosque, particularly the Friday prayer. The term is also used of great scholars with their leadership functions; and of political leaders of a community of Muslims, equivalent to caliph.

ineslemen
Tuareg Muslim scholars.

jihad Ar., 'struggle'
Military struggle to preserve and expand the realm of Islam. Also refers to spiritual struggle against the evil within oneself. The former is considered the 'minor' jihad, while the 'major' effort is the struggle against the lower instincts of one's soul.

Kabara
Port of Timbuktu on the River Niger, *c.* 20 km (12 miles) from Timbuktu.

Kano and Katsina
Rival religious, commercial and political centres in Hausaland, in what is now northern Nigeria. Katsina was the site of a major 19th-century jihad.

Kel al-Suq (Kel Essouk)
Tuareg group held in esteem for their sanctity and learning, and with a reputation as mediators rather than participants in conflicts.

Kitab al-Mudhish by Ibn al-Jawzi
A handbook for preachers containing instruction for and examples of sermons, as well as much material taken from Koranic studies, language, Prophetic tradition and history which may be used to 'astonish' the audience (the literal meaning of the title). Ibn al-Jawzi of Baghdad (1126–1200) was a jurist, historian, preacher and prolific writer.

Kitab al-shifa by Qadi Iyad
A work of piety centred on the Prophet Muhammad, his qualities and the reverence due to him, written by the Almoravid Qadi Iyad (d. 1149).

Kounta (Kunta, al-Kunti)
A clan of desert nomads, most likely of Berber origin, who became great spiritual leaders in the 18th and 19th centuries through promotion of the Qadiriyya Sufi order. The Kounta are now dispersed throughout West Africa.

Leo Africanus
al-Hasan b. Muhammad al-Wazzan al-Zayyati al-Gharnati al-Andalusi, *c.* 1488–1554
Writer and explorer Leo Africanus was a Muslim of Spanish origin whose parents moved to Fez. He travelled throughout North Africa and twice through West Africa in the early 16th century. In 1518, he was captured by Sicilian corsairs who presented him to Pope Leo X as a slave. Within a year, the Pope had baptised him as Johannis Leo de Medicis, after which he became known as Leo Africanus. He remained in Rome for some years, and in 1550 published the book *Discrittione dell'Africa* (Description of Africa), which includes an invaluable description of Timbuktu under the Songhay Empire.

madrasa Ar., 'place of study'
Islamic school of a type found throughout the Muslim world, often organized by an individual teacher.

al-Maghili
Muhammad b. Abd al-Karim al-Maghili al-Tilimsani, 1440–*c.* 1505
Muslim scholar from North Africa who advised the Songhay rulers and wrote a treatise on the Jews. It was on his advice that Jews were officially expelled from the Songhay Empire.

Maghreb (Maghrib) Ar., 'place of the setting sun'
Generally applied to North Africa from Morocco to Libya.

Mahmud Kati
Mahmud Kati b. *al-hajj* al-Mutawakkil Kati al-Kurmini al-Tinbukti al-Wa'kuri, d. 1593
Principal author of the *Tarikh al-fattash*, one of the great chronicles of Timbuktu.

Maliki school
One of the four schools of Islamic law.

Originating in the work of Malik ibn Anas (715–95), it is the dominant school of law practised in North Africa, though not to the exclusion of others. Works on Maliki law such as the *Risala* by Ibn Abi Zayd (d. 922) from Qayrawan, and the *Mukhtasar* by Khalil ibn Ishaq written in the 14th century were widely diffused throughout the region, legitimizing the authority of legal scholars who studied and interpreted them.

Mande
Ethnic and linguistic group of the Sahel which includes the Soninke, Malinke, Bambara and Wangara (Dyula).

Mansa Bambara, 'ruler' or 'king'

Mansa Musa (Mansa Moussa, Kankan Musa) r. 1312–37
Ruler of the Malian Empire known for his famous pilgrimage to Mecca in 1325. On arrival in Egypt, his gifts and purchases in gold were so prodigious that they caused a lasting collapse in the price of gold.

Mansa Sulayman r. 1341–60
Ruler of the Malian Empire at the time of Ibn Battuta's visit to West Africa in 1352–53. Reported by Ibn Battuta in his *Rihla* or 'Journey' to be an unpopular king on account of his avarice, in contrast with his predecessor Mansa Musa who was generous and virtuous. Sulayman may have been less generous out of necessity because Mansa Musa had emptied the treasury and run the country into debt.

al-Mansur
Sultan Mulay Ahmad al-Mansur al-Dhahabi, r. 1578–1602
Moroccan Sultan who ordered the invasion of Timbuktu in 1591. He had visions of 'capturing' the gold trade, hence his nickname 'al-Dhahabi', 'the Golden'.

marginalia
Annotations written in the margins of a book or manuscript.

Marrakesh
Southern Moroccan city that was the capital of Morocco from the 12th–17th centuries. The Timbuktu scholar Ahmed Baba was held captive there for 14 years.

Masina (Macina)
Area south of Timbuktu, in the Inland Delta of the Niger River; location of the town of Hamdallahi, capital of a major 19th-century Islamic reform movement and state.

Massufa (Masufa)
Known as the 'people of the Sahara', the Massufa were originally a sub-group of the Sanhaja. Timbuktu was founded in *c.* 1100 by some Massufa who had migrated eastward from the western Sahara. They were influenced by Almoravid ideology, but not necessarily active propagators of it. Ibn Battuta found Massufa in both Walata and Timbuktu in 1352–53, and they remained an important element of the population of Timbuktu down to the

Moroccan conquest. The leading scholarly family of 16th-century Timbuktu, the Aqit, were Massufa.

mithqal Ar., unit of weight
Weight varying from 3.5 to 5 grams according to the customs of different times and places. Also applied to a gold coin of this weight called a dinar. A slave in 16th-century Timbuktu was worth 80 mithqal (see page 43).

Mossi
Non-Muslim people from southern Mali who briefly conquered Timbuktu in *c.* 1400.

muezzin Ar. *mu'adhdhin*
Caller to prayer at the mosque.

mufti Ar., 'one who delivers judicial opinions (*fatwas*)'
A legal counsellor or scholar who gives formal legal opinions or *fatwas*, as opposed to the judge (*qadi*) who passes legally binding verdicts.

muhaddith Ar., 'scholar, traditionalist, transmitter of the *Hadith*'

Muhammad Baghayogho
Muhammad b. Ahmad b. Mahmud b. Abi Bakr Baghayogho al-Wangari, d. 1594
Renowned scholar of Timbuktu from the clan of the Wangari, long-distance traders of West Africa. Muhammad Baghayogho was Ahmed Baba's teacher.

al-Mukhtar al-Kabir al-Kounti
al-Mukhtar b. Ahmad b. Abi Bakr al-Kunti al-Wafi, Abu Zayn al-Abidin, 1729–1811
Great leader of the Kounta, renowned for his qualities of learnedness and sanctity, political astuteness and commercial acumen. He founded a *zawiya* in Azawad, some 400 km (250 miles) northeast of Timbuktu, from where he exercised his intercessory powers in various inter-tribal disputes, especially those between his own tribe and the Barabish. His descendants maintained a wide range of contacts with other Islamic leaders across a region extending from southern Mauritania to Bornu and southwards to the forest zones of Ivory Coast and Guinea, and including Ahmadu Lobbo of Masina.

Mukhtasar by Khalil ibn Ishaq
Written in Cairo in the 14th century, this book sums up the general rules of Maliki law. It was a popular text for teaching and study in Timbuktu. According to the 16th-century Timbuktu scholar Ahmed Baba, over sixty commentaries upon the *Mukhtasar* had been written by scholars from across the Muslim world, seven of them from Timbuktu.

Mungo Park 1771–1806
British explorer who made an extraordinary attempt to reach Timbuktu in 1805. He got as far as Timbuktu's port of Kabara but was killed further downstream. Nonetheless Park discovered (for the Europeans) the route of the River Niger.

Niger Bend (*La Boucle du Niger*, Fr.)
The Niger Bend is the northern part of the great curve of the Niger River. Kabara, the port of Timbuktu, is located at the northernmost bend of the river, rendering the city of Timbuktu an ideal meeting place for caravan and river traffic, whilst its proximity to the flood plains of the Inland Delta assured its supply of grain.

Niger River (*Aqafa* in Arabic, *Djoliba* in Mande, *Issa Ber* in Songhay)
At 4,160 km (2,585 miles) in length, the Niger is the third-longest river in Africa. After descending from the highlands of Guinea, and being joined by other smaller rivers, it flows into its Inland Delta in central Mali, a network of lakes and waterways that overflow their banks each year following the heavy annual rains. From there it flows south to the Bight of Benin and the Atlantic Ocean.

nisba Ar.
In Arab cultures, part of a person's name indicating family, ethnic or geographic origins. For example, the *nisba* of Ahmed Baba is 'al-Sanhaji (of the Sanhaja), al-Masnawi (from Masina), al-Takruri (from Takrur), al-Tinbukti (from Timbuktu)'.

Pasha Ar., *basha*
Turkish title, used also by Moroccans for a military rank of the first order. The area of the Niger Bend conquered by Morocco in 1591 was designated a Pashalik and was ruled from Timbuktu by a Pasha appointed from Marrakesh until 1612 when the local Arma administration appointed its own Pasha and gained autonomy.

The Prophet Muhammad
The Prophet Muhammad, the founder of Islam, was born in Mecca in 570 CE and as an adult would go to a hill north of the city to offer prayer to God. There he had contact with the angel Gabriel, and through him received messages from God. These revelations, which Muhammad continued to receive throughout his life, form the verses of the Koran. By the time of the Prophet's death in 632 CE, most of Arabia had converted to Islam.

qadi Ar., 'arbiter, judge'
According to the Maliki school of law, the *qadi* is a supreme judicial post with authority over the entire population of a city for settling disputes. The *qadi* hears cases brought before him and has the sole power to make a decision, which cannot be appealed. The *qadi* of Timbuktu was selected by the scholars of the city.

Qadiriyya
Sufi brotherhood or order originating in 12th-century Baghdad in the teachings of Abd al-Qadir al-Jilani (d. 1166) and later adopted by North African and Saharan tribes such as the Kounta, who diffused the Qadiriyya throughout West Africa.

Qayrawan (Qairawan, Kairouan, Cairouan)
City in Tunisia and a major centre of Muslim pilgrimage.

Quti Ar., 'of the Goths or Visigoths'
The Visigoths (a sub-group of the Goths) were one of the Germanic peoples who settled in France and Spain after invading the Roman Empire in the 4th century CE.

René Caillié 1799–1838
French explorer who in 1828 successfully disguised himself as an Arab and became the first European explorer to reach Timbuktu and return alive.

risala Ar., 'treatise, written report, epistle'
The *Risala* by Ibn Abi Zayd al-Qayrawani (b. 922), a treatise providing a synthesis of Islamic law of the Maliki school, was widely diffused throughout the region.

al-Sadi
Abd al-Rahman b. Abd Allah b. Imran b. Amir al-Sa'di, 1596–1655
Author of the *Tarikh al-sudan*, one of the great chronicles of Timbuktu.

Sahara from Ar. *sahra*, 'desert'

Sahel from Ar. *sahil*, 'shore, coast'
The Arabs conceived of the Sahara as a great ocean, with the Sahel as its shore. This belt of land running the width of the African continent lies between the Sahara to the north and the more fertile lands to the south. It is a semi-arid region with average annual rainfall ranging from 100 to 600 mm (4 to 24 in.).

Sanhaja
The Sanhaja, who claim their remote ancestors came from Yemen and spread over the western Sahara, were the main pastoral group in the Sahara around the year 1000. Often confused with the Tuareg, in the Azawad region north of the Middle Niger the Sanhaja had by 1600 mixed with and been overtaken by the Tuareg, becoming culturally and linguistically completely assimilated. Given their very similar cultural traits – both are camel nomads, wear the face veil, and speak dialects of Berber – this metamorphosis cannot have been very great. Al-Sadi in the *Tarikh al-sudan* conflates the Sanhaja with the Tuareg. The Massufa, the first settlers of Timbuktu from whom were descended the great Aqit family of scholars, are a sub-group of the Sanhaja.

Sankore Mosque
Mosque in the Sankore Quarter of Timbuktu, the district where many of the city's scholars lived and assembled. It was built in the 14th century.

Segu (Ségou)
Town southwest of Timbuktu on the banks of the River Niger. It was the seat of power for the Bambara kingdoms until conquered by Umar Tall in 1861.

Sharia Ar., 'path'
The laws and regulations of Islam, as derived from the Koran and the Sunna and formulated by Islamic legal scholars.

sharif Ar., 'noble'
Honorific title accorded to those claiming descent from the Prophet Muhammad or his family.

shaykh (sheikh) Ar., 'elder'
Honorific term applied to exalted religious personalities and communal or tribal leaders. It may also be used of a teacher at an Islamic institution of higher learning, the spiritual master of a Sufi aspirant, or the spiritual leader in a Sufi brotherhood. 'My shaykh' would signify 'my chief mentor'.

Sidi from Ar. *sayyidi*, 'my master'
Term of respect given to a man of religion.

Sidi Yahia al-Tadallisi
Sidi Yahya b. Abd al-Rahim b. Abd al-Rahman al-Tha'alibi al-Tadallisi, d. 1461
A Sufi shaykh who claimed descent from the Prophet Muhammad, Sidi Yahia al-Tadallisi arrived in Timbuktu in the middle of the Tuareg rule in *c.* 1450 from North Africa near Algiers. He became imam of the Sidi Yahia Mosque, which was built in his honour, and eventually the patron saint of Timbuktu.

Sidi Yahia Mosque (Sidi Yahya, Sidi Yehiya, Sidi Yehyia)
Mosque built in Timbuktu in honour of Sidi Yahia al-Tadallisi. Although it has been rebuilt several times, the mosque still stands in the middle of the old city.

Songhay (Songhai, Songhoï, Songhoy)
People and language of a primarily agriculturalist ethnic group living along the northern bend of the River Niger. Known as 'Masters of the soil'.

Songhay Empire
In the early 15th century, the Songhay took over the territories of the former Malian Empire, including Timbuktu, and reaching as far as the Hausa states of Kano and Katsina in present-day Nigeria and the Aïr Mountains in present-day Niger. The Songhay capital was Gao, an ancient city east of Timbuktu along the River Niger. The Songhay were defeated in the Moroccan invasion of 1591.

Soninke
The northernmost of the Mande peoples, the Soninke were rulers of Ancient Ghana, some of whom were among the earliest West African converts to Islam following contact with Berber and Arab traders from North Africa. The Soninke inhabited the territory stretching from the banks of the Senegal River (the area of the goldfields) to the banks of the River Niger, thereby controlling an important link in the gold trade.

Sonni Ali Ber r. 1464–92
Songhay ruler who rapidly conquered an extensive swathe of territory around the Niger Bend, including Timbuktu. The *Tarikh al-sudan* portrays him as a wicked tyrant: 'A man of great strength and colossal energy, a tyrant, a miscreant, an aggressor, a despot, and a butcher who killed so many human beings that only God Most High could count them. He tyrannized the scholars and holymen, killing them, insulting them, and humiliating them.' (TSE p. 91).

Sorko
Songhay-speaking fishermen and hippopotamus hunters who live along the banks of the River Niger and lakes upstream from Timbuktu. Known as 'Masters of the water'.

Sudanic Africa
A term generally referring to the Sahelian region, known in medieval Arabic as the *Bilad al-sudan* or 'land of the blacks', but which may also include the whole of black Africa.

Sufi
A Muslim mystic, often a member of one of the Sufi orders or brotherhoods.

Sufism
Islamic mysticism, an aspect of popular Islam practised all over the Muslim world either under an individual master or shaykh, or as part of an organized brotherhood or order. Sufis seek to achieve a personal experience of God through prayers, rituals involving rhythmic motion or music, seclusion, or similar. Sufi lodges often have strong local foundations in rural or urban life, and can have social functions in addition to their religious ones. Among the most notable international orders are the Qadiriyya, the Shadhiliyya and the Naqshbandiyya. The Tijaniyya order, established in the early 19th century, has undergone tremendous growth particularly in West Africa in the 20th century.

Sultan
Secular title of a sovereign ruler in the Islamic world.

Sunna Ar. 'habit, custom'
The body of accepted practices derived from the distillation of the words and deeds of the Prophet Muhammad as mostly laid down in the *Hadith*. The Sunna forms a code of behaviour for Muslims, an exemplary model guiding many details of their lives.

al-Suyuti
Jalal al-Din Abd al-Rahman b. Abi Bakr al-Suyuti, d. 1505
Celebrated Egyptian polymath who taught a number of West African scholars and advised rulers, including Askiya Muhammad of the Songhay Empire, who studied with al-Suyuti during a brief stay in Cairo while making a pilgrimage to Mecca.

Tadmekka
Town in the southern Sahara, 400 km (250 miles) northeast of Timbuktu, settled by the Tuareg group the Kel al-Suq. Its name means 'this is Mecca' because of all the towns in the world, it was said to be the one that most resembles Mecca.

Taghaza (Taghaza, Teghazza)
Village located near salt deposits 725 km (450 miles) north of Timbuktu. Ibn Battuta described Taghaza in his *Rihla* or 'Journey' from 1355: 'This is a village with nothing good about it. One of its marvels is that its houses and mosque are of rock salt and its roofs of camel skins. It has no trees, but is nothing but sand with a salt mine... Nobody lives there

except the slaves of the Massufa who dig for the salt. The Sudan (people from the 'land of the blacks') come to them from their land and carry the salt away.'

Takrur (Tarkrur, Tekrur)
Name of a state on the bank of the River Senegal which flourished around the same period as the ancient Empire of Ghana and was eventually subsumed by the Malian Empire. Arabs used the term to describe the whole lands of Muslim West Africa from the Senegal River to the Aïr Mountains to Hausaland and west of Lake Chad.

Tamasheq (Tamashek, Tamacheq, Temajegh; Ar., Tawariq)
Dialect of the Berber language spoken by the Tuareg, who call themselves 'Kel Tamasheq' or 'those who speak Tamasheq'.

Taoudenite (Taoudeni, Tadeni, Tawdani)
Location of rock salt deposits in the central Sahara, now in northern Mali.

tarikh Ar., 'date, dating, chronology, history'

Tarikh al-fattash
Tarikh al-fattash fi akhbar al-buldan wa-'l-juyush wa-akabir al-nas wa-dhikr waqa'l' al-Takrur wa-aza'im al-umur wa-tafriq ansab al-abid min al-ahrar
'The Seeker's Chronicle', a history of Timbuktu written by Mahmud Kati and completed by his descendants in 1655. This chronicle covers the period of the Songhay Empire from the reign of Sonni Ali (r. 1464–92) down to the Moroccan conquest of 1591, and sketches the earlier empires of Ghana and Mali. Part of its purpose was to rationalize a social hierarchy based on a dichotomy between slave and free, this latter category also essentially embracing the servile groups.

Tarikh al-sudan
'History of the Blacks' by Abd al-Rahman al-Sadi. This covers the Middle Niger region from the founding of Timbuktu in c. 1100 to the Moroccan occupation in 1591, including specifically the history of the Songhay Empire from the mid-15th century until 1591, and the history of the Pashalik of the Arma of Timbuktu from that date down to 1655.

tariqa Ar., 'way' or 'path'
The system of practices of a particular Sufi tradition, often organized as a brotherhood or order.

tifinagh
The written alphabet of the Tuareg, which derives partly from the ancient Libyan script.

Tijaniyya
Sufi brotherhood or order founded by Ahmad al-Tijani (1737–1815), born in Ayn Madi in Algeria. His followers believe al-Tijani received his word directly from the Prophet, and therefore that their *tariqa* is the most authentic and divinely blessed. Similarly, al-Tijani is considered the most exalted of 'saints' from whom all others before and after derive their inspiration. Such claims were a source of conflict with other Sufi groups,

but were also a powerful factor in attracting followers. The Tijaniyya spread from Senegal and Mali in particular in the time of Umar Tall, and is now one of the largest *tariqas* in West Africa.

Timbuktu (Fr. Tombouctou)
City on the River Niger founded in the early 12th century and which reached its height in the 15th and 16th centuries. Timbuktu is known as the 'City of 333 Saints' because it is surrounded by cemeteries of mystic saints (*wali*) who protect the city.

Tlemcen (Ar. Tilimsan)
City near the Mediterranean in present-day Algeria. Strategically located along the land route between Morocco and the east, Tlemcen was significant for trade relations between the Mediterranean and West Africa.

Tuareg (Fr. Touareg)
Nomadic tribe of the Sahara and Sahel who inhabit the massifs of the Adrar-n-Iforas in Mali, the Aïr in Niger, and the Hoggar in Algeria. The Tuareg call themselves 'Kel Tamasheq' or 'those who speak the Tamasheq language'; the name 'Tuareg' is a term used by outsiders. Known as 'Masters of the desert', they were originally a Berber people whose traditional economy was based on raising cattle, camels and goats, and providing security to the great trading caravans passing through the desert. They are Muslim, but unlike in many Muslim communities, it is Tuareg men not women who traditionally veil their faces.

Tukulor (Toucouleur)
Semi-nomadic herders who were most likely driven south to the province of Futa Toro by the expansion of the Berber, as well as the desert, from what is today southern Mauritania. The most famous Tukulor is Umar Tall, who through his jihads in the mid-19th century gained control over large areas of West Africa including Timbuktu. Ethnically and culturally the Tukulor are very close to the Fulani.

Tuwat (Touat, Tuwat, Tuwait)
Oasis town and entrepot in the northern Sahara, with trade routes radiating out to Fez, Algiers and Tunis in the north, and Gao, Agades and Katsina in the south. Slaves were assembled here before being taken to North Africa and Europe.

ulama Ar., 'learned men'
Scholar-jurists of Islam.

Umar Tall (*al-hajj* Umar)
Umar b. Sa'id b. Uthman b. Mukhtar b. Ali b. Mukhtar al-Futi al-Turi al-Gidiwi al Tijani, c. 1794–1864
A Tukulor Fulani born in the province of Futa Toro in the central Senegal River valley, Umar Tall was initiated into the Tijaniyya Sufi order in his youth. In c. 1826 he left his homeland to undertake a pilgrimage to Mecca. Much of the rest of his life is a story of conflict and conquest. He was the founder of a short-lived but extensive empire covering much of what is now Guinea, Senegal and

Mali. He conquered Segu in 1861 and took Hamdallahi in 1862, putting to death Ahmadu III. His attempts to impose the more ascetic and militant Tijaniyya order on the Qadiriyya adherants of Timbuktu and the Niger Bend led the Kounta chief Ahmad al-Bakkay to join forces with other opponents of Umar Tall and besiege Hamdallahi, sending Umar Tall to his mysterious death in 1864.

al-Umari
Shihab al-Din Abu 'l-Abbas Ahmad b. Yahya b. Fadl Allah al-Adawi, known as Ibn Fadl Allah al-Umari, 1301–49
Syrian historian who wrote in the early 14th century the *Masalik al-absar fi mamalik al-amsar*, 'Pathways of Vision in the Realms of the Metropolises', an encyclopedia for bureaucrats which included a description of the Malian Empire.

Visigoth
Branch of the Goths who settled in France and Spain after invading the Roman Empire in the 4th century CE.

vocalization
The process of adding short vowels to what normally is unvocalized Arabic text. Arabic script generally only represents the consonants and the long vowels, but not the short ones. Short vowels are typically only added where precise pronunciation and/or comprehension needs to be ensured; especially in manuscripts of the Koran, but also in some canonical texts on for example grammar or law.

Wahhabiyya
Conservative branch of Islam based on the teachings of Muhammad b. Abd al-Wahhab (1703–72), a radically fundamentalist Muslim reformer born in the Arabian Peninsula. It is the official doctrine of the modern state of Saudi Arabia.

Walata (Oualata, Iwalatan)
Oasis town in the southwestern Sahara, in present-day Mauritania, founded in the 11th century.

wali Ar. 'saint'
Muslim mystic, usually a scholar, who has achieved such closeness to God as to possess special powers or *baraka*.

al-Wangari (al-Ouangari, Dyula)
Famous scholarly and merchant family of West Africa from which Timbuktu scholar Muhammad Baghayogho al-Wangari (d. 1594) was descended.

zawiya Ar., 'lodge'
Sufi lodge used for the study and teaching of Islam and sometimes used by religious leaders for spreading their message. In the southern Sahara, tribal groups who specialized in learning were identified as *zawiya* people.

CHRONOLOGY

DATE	TIMBUKTU	DATE	GENERAL
		622	The *Hijra*, the Prophet Muhammad's flight from Mecca to Medina, which marks the beginning of the Islamic calendar.
c.400s–1000s	The ancient Empire of Ghana, located in what is now southern Mauritania and northwestern Mali, flourishes.	mid-to-late 600s	Muslim Arabs conquer coastal North Africa all the way from the Red Sea to the Atlantic.
1000s	Almoravids expand from Western Sahara to conquer land and occupy trade routes from Ancient Ghana to Spain.	c.1000	Vikings reach America.
c.1100	Founding of Timbuktu, originally a seasonal camp for nomads	1095	The First Crusade.
c.1200s to mid-1400s	The Malian Empire flourishes, extending at its height from the Atlantic Ocean to Gao.	1215	The Magna Carta is signed, limiting the powers of the King of England.
1325	Malian Emperor Mansa Musa visits Timbuktu on his return from Mecca and orders the construction of the Great Mosque, the Djingereber.	1325	The Egyptian economy is seriously upset by Mansa Musa's liberal distribution of gold during his visit to Cairo.
1343	The pagan Mossi tribe sacks Timbuktu, but the Malians recover and continue to rule the city for a further hundred years.	1337	The Sultan of Morocco Abu al-Hasan captures Tlemcen and unifies North Africa.
1352	The great Moroccan traveller Ibn Battuta visits Timbuktu during the reign of Mansa Sulayman.	1340–1400	The Black Death kills an estimated 25 million people in Europe.
1438	The Malian Empire disintegrates and the Tuareg seize Timbuktu, controlling the city for thirty years.	1415–1600	Portuguese exploration and trade along the West African coast lead to a gradual shift away from the traditional transsaharan trade routes, eventually gravely undermining the power of the Songhay Empire.
1450	Sidi Yahia al-Tadallisi arrives in Timbuktu from North Africa, near Algiers; he serves as Imam of the Sidi Yahia Mosque, which is built in his honour, and eventually becomes patron saint of Timbuktu.	c.1450–1850	At least 12 million Africans are forcibly transported to the Americas through the transatlantic slave trade.
c.1468	Ali bin Ziyad al-Kuti, father of Mahmud Kati (principal author of the *Tarikh al-fattash*), flees Andalusia to find refuge in the Sahara and eventually Timbuktu.	1478	The Spanish Inquisition is established; it is not officially abolished until 1834.
1464–92	Reign of the Songhay Emperor Sonni Ali, who sacks Timbuktu and in 1468 purges its scholars.	1492	Jews banished from Spain.
1493–1591	Reign of the Askiya dynasty of the Songhay Empire, a Golden Age for the scholars of Timbuktu.	1492	Christopher Columbus reaches the Americas.
1506	Spanish-born Muslim traveller and writer Leo Africanus visits Timbuktu.	1502	Muslim Moors banished from Spain.
1591	Moroccan Arma forces invade and occupy Timbuktu. Songhay authority evaporates and the Moroccan Pashalik is established.	1517	Ottoman Turks occupy Egypt.
1593	Timbuktu scholars including Ahmed Baba are exiled to Morocco.	1551	Ottomans take Tlemcen and Tuwat, in present-day Algeria.
1608	Ahmed Baba returns to Timbuktu, where he dies in 1627.		
1612	The Arma administration of Timbuktu appoints its own Pasha and breaks away from Moroccan rule.	1616	William Shakespeare and Miguel de Cervantes die.

1655	Timbuktu chronicle the *Tarikh al-sudan* is completed by Abd al-Rahman al-Sadi.	1642	Tuscan scientist Galileo Galilei dies under house arrest after being persecuted by the Catholic Church for his defence of Copernicus's theory that the earth circumnavigates the sun.
1665	Timbuktu chronicle the *Tarikh al-fattash* is completed by descendants of its principal author Mahmud Kati, who died in 1593.		
1737	The Tuareg occupy Timbuktu.	1700s	Rise of the Wahhabiyya, a conservative branch of Islam, in the Arabian Peninsula.
1766	The Bambara from Segu occupy Timbuktu.	1807	Britain outlaws the slave trade.
1770	The Tuareg besiege Timbuktu.	1798–1801	Napoleon Bonaparte invades Egypt. The discoveries made by the group of scientists who accompany him stimulate huge popular interest in Europe in Africa's antiquities and culture.
1810	The Kounta take control of Timbuktu.	early 1800s	Muhammad Ali builds a powerful Egyptian Empire, penetrating the Nile Valley and fighting against the Wahhabi of Arabia.
c.1818	Muslim fundamentalist Ahmadu Lobbo leads a Fulani rebellion and establishes the Islamic Caliphate of Hamdallahi in Masina, the area of the Inland Delta of the Niger.		
1826	Hamdallahi gains hegemony over Timbuktu. Major Gordon Laing, the first European explorer to reach Timbuktu, is ordered out of town and meets his death in the desert.		
1828	Frenchman René Caillié is the first European explorer to visit Timbuktu and return alive.	1830	The full course of the River Niger is drawn on European maps for the first time.
1845	Ahmadu Lobbo dies, prompting a revolt in Timbuktu. Hamdallahi blockades the city, starving it into submission.		
1853	Heinrich Barth, a German explorer and scholar sent on behalf of the British government, visits Timbuktu during the rule of Ahmadu Ahmadu, grandson of Ahmadu Lobbo; he receives protection from the Kounta.	1859	Charles Darwin publishes *On the Origin of Species*.
1862	Umar Tall launches a *jihad* against the descendants of Ahmadu Lobbo; his forces reach Timbuktu.		
1864–80	The Kounta mobilize and defeat Umar Tall, maintaining leadership over Masina from 1864 to 1880.	1869	The Suez Canal is opened.
1880	The Tuareg take control of Timbuktu.	1880s–1914	The European 'Scramble for Africa'.
1880–92	The French gradually consolidate and extend control over a huge swathe of West African territories, which in 1892 are renamed the French Sudan.	1884–85	The Berlin Conference divides the continent of Africa between competing European powers.
1894	The French gain control of Timbuktu, but do not finally defeat the Tuareg in the northern regions until 1916.	1914–18	The First World War.
		1939–45	The Second World War.
1960	The Republic of Mali gains independence.	1950s–70s	Countries across Africa achieve independence from European colonial rule.
1960–68	Modibo Keita serves as the first President of independent Mali.		
1968–91	Military dictatorship in Mali under General Moussa Traoré.	1989	Collapse of the Soviet Empire.
1992–2002	Alpha Oumar Konaré serves as the first democratically elected Malian President.	2001	September 11 terrorist attacks on the United States.
2002–	Amadou Toumani Touré succeeds as President of Mali.	2003	US forces invade Iraq.

BIBLIOGRAPHY

SELECTED WORKS BY JOHN O. HUNWICK

—(2006) *West Africa, Islam, and the Arab World*. Princeton: Markus Wiener.

—(2006) *Jews of a Saharan Oasis: The Elimination of the Tamantit Community*. Princeton: Markus Wiener.

—(2001) 'Studies in Ta'rikh al-fattash, III: Ka'ti origins'. *Sudanic Africa* 12, pp. 111–14.

—(2000) 'Ahmad Baba on slavery'. *Sudanic Africa* 11, pp. 131–39.

—(2000) *Mi'raj al-Su'ud: Ahmad Baba's Replies on Slavery*, ed. and trans. with Fatima Harrak. Rabat: Institut des Etudes Africaines.

—(1999) *Timbuktu and the Songhay Empire: Al-Sa'di's Ta'rikh al-Sudan down to 1613, and other Contemporary Documents,* ed. and trans. Leiden: Brill.

—(1999) 'Les manuscrits du Centre Ahmad Baba (CEDRAB) de Tombouctou'. *Revue Anthropologique*/Actes du VII^e Colloque eurafricain du CIRSS. Paris: Institut International d'Anthropologie, pp. 49–63.

—(1997) 'Towards a history of the Islamic intellectual tradition in West Africa down to the nineteenth century'. *Journal for Islamic Studies* (Cape Town) 17, pp. 4–27.

—(1997) 'Sub-Saharan Africa and the wider world of Islam: historical and contemporary perspectives'. *Journal of Religion in Africa* 26/iii, pp. 230–57; also published in *African Islam and Islam in Africa: Encounters between Sufis and Islamists*, ed. Eva Evers Rosander and David Westerlund, London: Hurst and Co./Athens, OH: Ohio University Press, pp. 28–54.

—(1996) 'Fez and West Africa in the Fifteenth and Sixteenth Centuries: Scholarly and Sharifian Networks'. In: *Fès et l'Afrique: relations économiques, culturelles et spirituelles*. Rabat: Institut des Etudes Africaines, pp. 57–71.

—(1996) 'Secular Power and Religious Authority in Islam: the Case of Songhay'. *Journal of African History* 37, 2, pp. 175–94.

—(1996) 'The Arabic qasida in West Africa: forms, themes, and contexts'. In: S. Sperl and C. Shackle, *Qasida Poetry in Islamic Asia and Africa*. Leiden: Brill, I, pp. 83–98, II, pp. 22–25.

—(1996) 'Back to West African Zanj again: a document of sale from Timbuktu'. *Sudanic Africa* 7, pp. 53–60.

—(1994) 'Sufism and the study of Islam in West Africa: the case of al-Hajj Umar'. *Der Islam* 71/ii, pp. 308–28.

—(1994) 'Gao and the Almoravids revisited: ethnicity, political change and the limits of interpretation'. *Journal of African History* 35, 2, pp. 251–73.

—(1992) 'Studies in the *Ta'rikh al-fattash*, II: An Alleged Charter of Privilege Issued by Askiya al-hajj Muhammad to the Descendants of Mori Hawgaro'. *Sudanic Africa* 3, pp. 133–46.

—(1992) 'CEDRAB: the Centre de Documentation et de Recherches Ahmad Baba at Timbuktu'. *SAJHS* 3, pp. 173–81.

—(1991) *Les Rapports intellectuels entre le Maroc et l'Afrique sub-Saharienne à travers les âges*. Rabat: Institut des Etudes Africaines.

—(1990) 'A Contribution to the Study of Islamic Teaching Traditions in West Africa: the Career of Muhammad Baghayogho, 930/1523-24–1001/1594'. *ISSS* iv, pp. 149–63.

—(1990) 'An Andalusian in Mali: A Contribution to the Biography of Abu Ishaq al-Sahili, c. 1290–1346'. *Paideuma* xxxvi, pp. 59–66.

—(1989) *The African Diaspora in the Mediterranean Lands of Islam* with Eve Troutt Powell. 2nd edition (2002), Princeton: Markus Wiener.

—(1985) *Shar'ia in Songhay: The Replies of al-Maghili to the Questions of Askia al-Hajj Muhammad*. Ed. and trans. with an introduction and commentary. Oxford: Oxford University Press.

—(1973) 'The Mid-Fourteenth Century Capital of Mali'. *Journal of African History* 14, 2, pp. 195–206.

—(1971) 'Songhay, Bornu and Hausaland in the Sixteenth Century'. In: J.F.A. Ajayi and M. Crowder eds, *History of West Africa*. 2nd edition (1976), London: Longman. Vol. I, pp. 202–39.

—(1970) 'Arabic Sources for African History'. In: J.D. Fage ed., *Africa Discovers Her Past*. Oxford: Oxford University Press.

—(1966) 'Further Light on Ahmad Baba al-Tinbukti'. *Research Bulletin, Centre of Arabic Documentation*, ii/1, pp. 19–31.

—(1962) 'Ahmad Baba and the Moroccan Invasion of the Sudan (1591)'. *Journal of the Historical Society of Nigeria*, ii, 3, pp. 311–28.

CATALOGUES AND OVERVIEWS OF MANUSCRIPTS OF WEST AFRICA

Arabic Literature of Africa, general eds John O. Hunwick and R.S. O'Fahey; editorial consultants Albrecht Hofheinz, Muhammad Sani Umar and Knut Vikør. Leiden: Brill.
—*Volume II: The Writing of Central Sudanic Africa* (1995), compiled by John O. Hunwick with the assistance of Razaq Abubakre, Hamidu Bobboyi, Roman Loimeier, Stefan Reichmuth, and Muhammad Sani Umar.

—*Volume IV: The Writings of Western Sudanic Africa* (2003), compiled by John O. Hunwick with the assistance of Ousmane Kane, Bernard Salvaing, Rüdiger Seesemann, Mark Sey and Ivor Wilks.

Catalogue of Manuscripts in Mamma Haïdara Library, Volumes I–IV (2000), compiled by Abdelkader Mamma Haidara, ed. by Ayman Fuad Sayyid. London: Al-Furqan Islamic Heritage Foundation.

Handlist of Manuscripts in the Centre de Documentation et de Recherches Historiques Ahmed Baba, Timbuktu, Mali, Volumes I–V (1995). Compiled by Sidi Amar Ould Ely, ed. by Julian Johansen. London: Al-Furqan Islamic Heritage Foundation.

Cuoq, Joseph (1985) *Recueil des sources arabes concernant l'Afrique occidentale du VIII^e au XVI^e siècle (Bilad al-Sudan)*. Paris: Editions du Centre National de la Recherche Scientifique.

Hopkins, J.F.P. and N. Levtzion ed. and trans. (1983) *Corpus of Early Arabic Sources for West African History*. Cambridge: Cambridge University Press; repr. (2000) Princeton: Markus Wiener.

PROCEEDINGS

Centre National de la Recherche Scientifique et Technologique (CNRST). 'Atelier sur l'Exploitation Scientifique des Manuscrits de Tombouctou – Rapport Final' 21–23 décembre 2006. Bamako: CNRST.

Chemins du Savoir: Les manuscrits arabes et a'jami dans la région soudano-sahelienne. Colloque International 13–17 juin 2005 – Rabat. (2006) Rabat: Institut des Etudes Africaines.

Le Maroc et l'Afrique subsaharienne aux débuts des temps modernes. Les Sa'diens et l'empire songhay. Actes du Colloque International organisé par l'Institut des Etudes Africaines Université Mohammed V–Souissi. Marrakech, 23–25 octobre 1992. (1995) Rabat: Institut des Etudes Africaines.

Temimi, Abdeljelil ed. (1997) *Actes du colloque international tenu à Tombouctou sur la culture arabo-islamique en Afrique au sud du Sahara: cas de l'Afrique de l'Ouest.* Zaghouan: Fondation Temimi pour la recherche et l'information.

FURTHER READING

Abdelhamid, Arab et al. (2005) *Les Trésors Manuscrits de la Méditerranée*. Dijon: Editions Faton.

Abitbol, Michel (1979) *Tombouctou et les Arma: De la conquête marocaine du Soudan nigérien en 1591 à l'hégémonie de l'empire peul du Maçina en 1853*. Paris: Maisonneuve et Larose.

Ba, A. Konaré (1977) *Sonni Ali Ber*. Niamey: Institut de Recherches en Sciences Humaines – Etudes Nigériennes, 40.

Barth, H. (1857–59) *Travels and Discoveries in North and Central Africa, being a Journal of an Expedition undertaken under the auspices of H.B.M.'s Government in the Years 1849–1855*. Repr. (1965) in 3 vols. London: Frank Cass.

Batran, Aziz A. (2001) *The Qadiryya Brotherhood in West Africa and the Western Sahara* (Recherche et Etudes 10). Rabat: Institut des Etudes Africaines.

Benítez, Cristobál (1987) *Viage a Tombuctú*. Madrid: Laertés.

Benjaminsen, Tor Arve and Gunnvor Berge (2004) *Une histoire de Tombouctou*, trans. from Norwegian into French by Yves Boutroue. Arles: Actes Sud.

Beraud-Villar, J. (1942) *L'Empire de Gao, un État soudanais aux XV^e et XVI^e siècles*. Paris: Librairie Plon.

Berge, Gunnvor (1999) *In Defence of Pastoralism: Form and Flux among Tuaregs in Northern Mali*. Ph.D thesis. Department of Social Anthropology, Centre for Development and the Environment, University of Oslo.

Bloom, Jonathan M. (2001) *Paper before Print: The History and Impact of Paper in the Islamic World*. New Haven: Yale University Press.

Bovill, E.W. (1995) *The Golden Trade of the Moors*. Princeton: Markus Wiener.

Brown, William Allen (1969) *The Caliphate of Hamdullahi ca. 1818–1864: A Study in African History and Tradition*. Ph.D thesis. University of Wisconsin.

Bonnier, General G. (1926) *Occupation de Tombouctou*. Paris: Editions du Monde Moderne.

Caillié, René (1829) *Journal d'un Voyage à Temboctou et à Jenné dans l'Afrique Centrale*. 3 vols. Repr. (1965) Paris: Editions Anthropos. Trans. (1830) *Travels through Central Africa to Timbuctoo; and across the Great Desert, to Morocco*. London: Henry Colburn & Richard Bentley.

Caron, E. (1891) *De Saint-Louis au Port de Tombouctou. Voyage d'une canonnière française suivi d'un vocabulaire sonraï*. Paris: Augustin Challamel, Editeur Librairie Coloniale.

Chouki El Hamel (2002) *La vie intellectuelle islamique dans le Sahel Ouest-African (XVI^e–XIX^e siècles): Une étude sociale de l'enseignement islamique en Mauritanie et au Nord du Mali (XVI^e–XIX^e siècles) et traduction annotée de Fath ash-shakur d'al-Bartili al-Walati (mort en 1805)*. Paris: L'Harmattan (Collection Sociétés Africaines & Diaspora).

Cissoko, S.M. (1975) *Tombouctou et l'empire songhay*. Dakar: Les Nouvelles Editions Africaines.

Crone, G.R. ed. and trans. (1937) *The Voyages of Cadamosto and other Documents on Western Africa in the Second Half of the XVth Century*. London: Hakluyt Society.

Davidson, Basil (1959) *The Lost Cities of Africa*. Boston/Toronto: Little, Brown & Co.

Delafosse, M. (1912) *Haut-Sénégal-Niger: Les Pays, les peuples, les langues, l'histoire, les civilisations*. 3 vols. Paris.

Demaison, André (1935) *Le Pacha de Tombouctou* (roman). Paris: J. Ferenczi et fils (Le Livre moderne illustré).

Diagayeté, Mohamed (2001) *La Ville de Tombouctou, son histoire, ses hommes et sa contribution à la civilisation islamique pendant les XV^e–XVI^e siècles*, Mémoire pour l'obtention de diplôme d'études approfondies (DEA) Filière Civilisation Islamique. Institut Supérieur de Théologie, Université Ez-zeïtouna, Tunisia.
—(2007) *Les Peul du Mali et leur contribution à la civilisation islamique pendant les 18^e–19^e siècles*. Thèse pour l'obtention de doctorat. Institut Supérieur de Théologie, Université Ez-zeïtouna, Tunisia.

Diawara, Mamadou, P.F. de Moraes Farias and Gerd Spittler (eds) (2006) *Heinrich Barth et l'Afrique*. Cologne: Ruediger Koeppe.

Dramani-Issifou, Zakari (1982) *L'Afrique noire dans les relations internationales au XIVe siècle*. Paris: Karthala.

Dubois, Félix (1896) *Tombouctou la mystérieuse*. Paris. Trans. (1897) *Timbuctoo the Mysterious*. London.

Dupuis-Yacouba F. (1921) *Industries et principales professions des habitants de la région de Tombouctou*. Paris: E. Larose.

Dunn, Ross E. (1989) *The Adventures of Ibn Battuta: a Muslim Traveler of the 14th Century*. London: Croom Helm. New edition (2005) Berkeley, Calif., and London: University of California Press.

Farias, Moraes P.F. ed. (2004) *Arabic Medieval Inscriptions from the Republic of Mali: epigraphy, chronicles and Songhay-Tuareg history*. Oxford: Oxford University Press.

Frèrejean, Louis (1996) *Objectif Tombouctou: Combats entre les Toucouleurs et les Touareg*. Paris: L'Harmattan.

Grevoz, Daniel (1992) *Les Cannonières de Tombouctou. Les Français à la conquête de la cité mythique, 1870–1894*. Paris: L'Harmattan.

Haardt, Georges-Marie and Louis Audouin-Dubreuil (1924) *Le Raid Citroën: la première traversée du Sahara en automobile de Touggourt à Tombouctou par l'Atlantide*. Paris: Librairie Plon.

Haïdara, Ismaël Diadié (2004) *Los Otros Españoles: Los manuscritos de Tombuctú: andalusíes en el Níger*, with Manuel Pimentel. Madrid: Ediciones Martínez Roca.
—(1999) *Les Juifs à Tombouctou: Recueil des sources écrites relatives au commerce juif à Tombouctou au XIX^e siècle*. Bamako: Editions Donniya.

—(1997) *L'Espagne musulmane et l'Afrique subsaharienne*. Bamako: Editions Donniya.
—(2003) *Los últimos visigodos: La biblioteca de Tombuctú*. Seville: RD Editores.
—(1996) 'Marginalia', in *Chemins du Savoir: Les manuscrits arabes et a'jami dans la région soudano-sahelienne. Colloque International 13–17 juin 2005 – Rabat*. (2006) Rabat: Institut des Etudes Africaines.
—(1993) *El Bajá Yawdar y la conquista saadí del Songhay (1591–1599)*. Almeria: Instituto de Estudios Almerienses. (1996) *Jawdar Pasha et La Conquête Saâdienne du Songhay (1591–1599)*. Rabat: Institut des Etudes Africaines.

Hamdun, Said and Noël King (1994) *Ibn Battuta in Black Africa*. Princeton: Markus Wiener.

Hanson, John H. (1996) *Migration, Jihad, and Muslim Authority in West Africa: The Futanke Colonies in Karta*. Bloomington: Indiana University Press.

Harrison, Christopher (1988) *France and Islam in West Africa, 1860–1960*. Cambridge: Cambridge University Press.

Heath, Jeffrey (1999) *A Grammar of Koyra Chiini: the Songhay of Timbuktu*. Berlin and New York: Mouton de Gruyter.

Hodgkin, Elizabeth (1987) *Social and Political Relations in the Niger Bend in the Seventeenth Century*. Ph.D. thesis, University of Birmingham.

Hourst, Émile Auguste Léon [Lieutenant de Vaisseau] (1898) *Sur le Niger et au Pays des Touaregs: la Mission Hourst*. Paris: Librairie Plon.

Ibish, Yusuf (1999) *Editing Islamic Manuscripts on Science: Proceedings of the Fourth Conference of Al-Furqan Islamic Heritage Foundation, London, 29–30 November 1997*, London: Al-Furqan Islamic Heritage Foundation.

Ibn Battuta, *Tuhfat al-nuzzar fi ghara'ib al-amsar wa-'aja'ib al-asfar*. (1854) Ed. and trans. by C. Défrémery and B.R. Sanguinetti, *Voyages d'Ibn Battûta*. Paris. Reprinted (1969) with preface and notes by Vincent Monteil. 4 vols. Paris: Éditions Anthopos. Trans. (1994) H.A.R. Gibb, *The Travels of Ibn Battuta A.D. 1325–1354*. Vol. IV, translation completed with annotations by C.F. Beckingham. London: The Hakluyt Society.

Ibn al-Mukhtar/Mahmud Ka'ti b. al-hajj al-Mutawakkil, *Ta'rikh al-fattash*. (1964) Ed. and trans. O. Houdas and M. Delafosse, *Tarikh El-Fettach, ou chronique du chercheur pour servir à l'histoire des villes, des armées et des principaux personnages du Tekrour*. Paris: E. Leroux [1910–11] 1913; repr. Paris: Librairie d'Amérique et d'Orient Adrien-Maisonneuve.

al-Ifrani, Muhammad al-Saghir b. al-hajj 'Abd Allah, *Nuzhat al-hadi fi akhbar al-qarn al-hadi*. (1888–89) Ed. and trans. O. Houdas, *Histoire de la dynastie saadienne au Maroc (1511–1670)* Paris: Ernest Leroux.

Jackson, James Earl Grey (1820) *An Account of Timbuctoo and Housa*. London:

Jenkins, Mark (1997) *To Timbuktu*. New York: W. Morrow.

Jeppie, Shamil and Suleymane Bachir (2008) *Meanings of Timbuktu*. Cape Town: HSRC Press.

Joffre, Joseph-Jacques-César (1915) *My March to Timbuctoo*, with intro. by Ernest Dimnet. London: Chatto & Windus.

Le Jean, Yannick (1986) *Médecine Traditionnelle en Milieu Nomade dans la Région de Tombouctou*. Ph.D thesis, Faculté de Médecine de Paris-Sud.

Lenz, Oskar (1886) *Timbouctou: Voyage au Maroc, au Sahara, et au Soudan*, trans. from German by Pierre Lehautcourt. 2 vols. Paris: Librairie Hachette.

Leo Africanus [al-Hasan b. al-Wazzan al-Zayyati], *Della discrittione dell'Africa* per Giovan Leoni Africano, Settima Parte, in G.B. Ramusio (1550) *Delle navigationi e viaggi*. Venice. I, ff. 78–81r. (1956) *Description de l'Afrique*, trans. A. Epaulard et al. 2 vols. Paris: Adrien-Maisonneuve.

Levtzion, N. and Jay Spauling (2003) *Medieval West Africa: Views from Arab Scholars and Merchants*. Princeton: Markus Wiener.

Levtzion, N. and R.L. Pouwels, eds (2000) *The History of Islam in Africa*. Athens, OH: University of Ohio Press.

Levtzion, N. (1973) *Ancient Ghana and Mali*. London: Methuen.

Ly Tall, M. (1977) *Contribution à l'histoire de l'empire du Mali (XIIIᵉ–XVIᵉ siècles)*. Dakar: Les Nouvelles Editions Africaines.

McIntosh, Roderick J. (1998) *The Peoples of the Middle Niger: The Island of Gold*. London: Blackwell Publishers.

Monod, Théodore (1977) *De Tripoli à Tombouctou: Le dernier voyage de Laing, 1825–1826*. Paris: Société française d'histoire d'outre-mer (Bibliothèque d'histoire d'outre-mer, Nouvelle série, Travaux, 2).

Norris, H.T. (1982) *The Berbers in Arabic Literature*. London: Longman.

Park, Mungo (1799) *Travels in the Interior Districts of Africa*. Repr. (1983) *Travels into the Interior of Africa*. London: Eland.

Poulton, Robin-Edward and Ibrahim ag Youssouf (1998) *A Peace of Timbuktu: democratic governance, development and African peacemaking*, with a Preface by Kofi Annan. Geneva: United Nations. (1999)

La Paix de Tombouctou: gestion démocratique, développement et construction africaine de la paix. 2nd updated edition. Geneva: United Nations.

Richer, R. (1924) *Les Touareg du Niger (Région de Tombouctou-Gao)*. Paris.

Riley, James (1817) *Loss of the Brig Commerce, wrecked on the Western Coast of Africa in the Month of August 1815*. See 'Sidi Hamet's Narrative of a Journey from Widnoon across the Great Desert to Tombouctoo, and back again to Widnoon', pp. 348–90. London: John Murray.

Roberts, Richard L. (1987) *Warriors, Merchants and Slaves: The State and the Economy in the Middle Niger Valley, 1700–1914*. Stanford: Stanford University Press.

Robinson, David (2004) *Muslim Societies in African History*. Cambridge: Cambridge University Press.
—(1985) *The Holy War of Umar Tal: The Western Sudan in the Mid-Nineteenth Century*. Oxford: Clarendon Press.

Saad, Elias (1983) *Social History of Timbuktu: the Role of Muslim Scholars and Notables 1400–1900*. Cambridge: Cambridge University Press.

al-Sa'di, 'Abd al-Rahman b. 'Abd Allah, *Ta'rikh al-sudan*. Ed. and trans. into French by O. Houdas, *Tarikh as-Soudan*. Paris: Publications de l'École des langues orientales vivantes 1898–1900; repr. (1964) Paris: Librairie d'Amérique et d'Orient Adrien-Maisonneuve. Trans. into English by John O. Hunwick in *Timbuktu and the Songhay Empire* (1999) pp. 1–270.

Sanankoua, Bintou and Louis Brenner, eds. (1991) *L'Enseignment islamique au Mali*. Bamako, Mali: Jamana and London: School of Oriental and African Studies (distributor).

Sanankoua, Bintou (1990) *Un Empire peul au XIXᵉ siècle: La Diina du Maasina*. Paris: Karthala.

Stewart, Charles (1973) *Islam and Social Order in Mauritania*. Oxford: Clarendon Press.

Thiriet, E. (1932) *Au Soudan français. Souvenirs, 1892–1894, Macina–Tombouctou*, Paris: Impr. A. Lesot.

Tymowski, M. (1974) *Le Développement et la régression chez les peuples de la boucle du Niger à l'époque précoloniale*. Warsaw: Wydawnictwa Uniwersytetu Warszaw-skiego.

Vallées du Niger, Musée national des arts et d'Océanie, 12 octobre 1993–10 janvier 1994 (1993). Exhibition catalogue. Paris: Éditions de la Réunion des musées nationaux.

Vikør, Knut S. (2005) *Between God and the Sultan: A History of Islamic Law*, London: Hurst & Company.

Welch, Galbraith (1939) *The Unveiling of Timbuctoo: the Astounding Adventures of Caillié*. New York: W. Morrow. Repr. (1991) New York: Carroll & Graf.

Willis, John Ralph ed. (1985) *Slaves and Slavery in Muslim Africa*. 2 vols. London: Frank Cass.

Yattara, Almamy Maliki and Bernard Salvaing (2000) *Almamy: Une jeunesse sur les rives du fleuve Niger*. Brinon-sur-Sauldre: Grandvaux.

Yattara, Almamy Maliki and Bernard Salvaing (2003) *Almamy: L'âge d'homme d'un lettré malien*. Brinon-sur-Sauldre: Grandvaux.

Zebadia, Abdel Kader (1974) *The Career and Correspondence of Ahmad al-Bakkay of Timbuktu*. Ph.D. thesis, University of London.

Zouber, Mahmoud A. (1977) *Ahmad Baba de Tombouctou (1556–1627): sa vie et son oeuvre*. Paris: Maisonneuve et Larose.

See also various articles on Timbuktu by, among others, Temimi, A.; Brun, J.P.; Cherbonneau, M.A.; Cissoko, S.M.; Cheykh, H.K.; Cleaveland, T.; Colin, G.S.; Cuoq, J.; Curtin, P.; De Castries, H.; Delafosse, M.; Dupuis-Yacouba, F.; Garrard, T.F.; Genevière, J.; Gomez, E.G.; Gomez, M.A.; Haidara, A.K.; Hofheinz, A.; Insoll, Y.; al-Jamal, S.; Joffre, J.; Kaba, L.; Kaddouri, A.; Knappert, J.; Kodjo, N.G.; Kubbel, L.E.; Lange, D.; de la Roncière, C.; Lévi-Provençal, E.; Laing, G.; Levtzion, N.; Ly Tall, M.; Malfante, A.; Mauny, R.; McIntosh, S.K.; McIntosh R.J.; Monteil, Ch.; Monod, Th.; al-Moudden, A.; Mourgues, G.; Niane, D. T.; Norris, H.T.; Ould Ely, S.A.; Péfontain, Lt.; Person, Y.; de la Porte, I.D.; Radtke, B.; Rejou, Cdt.; Rohlfs, G.; Shoup, J.; Stewart, C.; Tamari, T.; Tamouth, Z.; Zeys, E.; Zouber, M.A.

ACKNOWLEDGMENTS

The authors of this book are most indebted to numerous Timbuktu scholars of today who have devoted their lives to preserving the culture of scholarship in Timbuktu and have extended great hospitality over the years. Mahmoud A. Zouber, the first director of the Ahmed Baba Institute, was the first to make the Timbuktu manuscripts accessible to the public. Mohamed Gallah Dicko has continued his work and further developed the Institute. Special thanks are also due to Djibril Doucouré, who has been the caretaker of the manuscripts at the Ahmed Baba Institute since its establishment. Thanks to Abdel Kader Haïdara, Ismael Diadié Haïdara, Abdoulwahid Haïdara, Moctar Sidi Yahia al-Wangari, Sidi Allimam Maïga, Imam Mahmoud Baba Hasseye of the Sidi Yahia Mosque, and Imam Abdramane ben Essayouti of the Djingereber Mosque, and their families, for preserving their manuscripts, opening their libraries and taking time to show us their hidden treasures. Thanks to Mahamane Mahamoudou (Hamou) and Sidi Mohamed ould Sidi for providing biographical information on writers of the Timbuktu region and Azawad, and to Ali ould Sidi and Salem ould el Hadje for their valuable information on the history of Timbuktu. Thanks to researchers at the Ahmed Baba Institute for help in locating manuscript items and for cataloguing the collection, particularly Mohamed Hamidou Dicko, Moulaye Ismail Haïdara, Sidi Allimam Maïga, Mohamed Diagayété, Namou S. Haïdara and Baba ould Boumama. Thanks also to scholars from the University of Bamako, in particular Drissa Diakité and Samby Khalil Magassouba.

Special thanks to our readers Clover Jebsen Afokpa, Gunnvor Berge, Albrecht Hofheinz, Bernard Salvaing, Charles Stewart and Knut Vikør, as well as (and including) specialists who have reviewed, supplemented and commented on various sections of this book: Gunnvor Berge, social anthropologist at the Department of International Environment and Development Studies at the Norwegian University of Life Sciences, on the people of the Niger Bend and the Tuareg; Albrecht Hofheinz at the Department of Culture Studies and Oriental Languages at the University of Oslo on the Fondo Kati; Bernard Salvaing, Centre for African Studies, University of Paris I on the *ajami* manuscripts; Charles Stewart, Department of History at the University of Illinois on the scholars of the western Sahara; Knut Vikør at the Department of Archaeology, History, Cultural Studies and Religion at the University of Bergen on Sufism; Mohamed Maghraoui at the University Mohamed V–Agdal in Rabat and Philippe Roisse at Centre de Documentation et de Recherches Arabes Chrétiennes (CEDRAC), University of St Joseph, Beirut, Lebanon on calligraphy; Professor Michael Carter, Centre for Middle Eastern Studies, University of Sydney, on Arabic grammar; Christine Amadou at the University of Oslo on classical Greek scholars; and Lutz Eberhard Edzard at the University of Oslo on Hebrew. Many people have provided invaluable assistance in identifying, verifying and describing the content of the manuscripts, including: Abdelaziz Abid, Noury Mohamed Alamine Al-Ansary, Michael Carter, Djibril Doucouré, Abdel Kader Haïdara, Albrecht Hofheinz, Mohamed Maghraoui, Sidi Allimam Maïga, Philippe Roisse, Muhammad Sani Umar, and Sidi Mohamed ould Youbba. Thanks also to Muhammad Sani Umar at Northwestern University for informing us of the Letter of Recommendation from the Kounta scholar Al-Bakkay in Appendix XIV of Barth's work; and to Fatima Harrak at the Institute for African Studies in Rabat for rightly insisting that we include a section on the Jewish communities. Special thanks also to Cynthia Jay for drafting a map of West Africa.

We would like to express thanks to all contributors to the *Arabic Literature of Africa* project, particularly Volume IV on Western Sudanic Africa, who have painstakingly provided information on the scholars of the region and their works: Knut Vikør, Albrecht Hofheinz, Ousmane Kane, Bernard Salvaing, Rüdiger Seesemann, Mark Sey and Ivor Wilks. We are indebted to Koninklijke Brill N.V.l, particularly Trudy Kamperveen who worked on John Hunwick's texts, for allowing us to draw freely on material previously published by Brill Academic Publishers, especially *Timbuktu and the Songhay Empire* (1999) and *Arabic Literature of Africa Volume IV – The Writings of Western Sudanic Africa* (2003). We owe also gratitude to Markus Wiener, who published several of John's earlier works which are drawn from here. Interested readers are strongly encouraged to read these works, and will gain from the rich source material referenced there.

We are most grateful to the Institute for African Studies in Rabat, in particular Fatima Harrak, and Ahmed Toufiq, former director of the National Library of Morocco, and Ahmed Chouqui Binbine at the Royal Library of Morocco for long-term collaboration and access to their facilities and publication services; the Program of African Studies and the Africana Library at Northwestern University for making available valuable bibliographical material which is hard to find elsewhere; and to the staff of the Institute for the Study of Islamic Thought in Africa, particularly Rebecca Shereikis and the current director, Muhammad Sani Umar. Thanks also to various scholars of the interdisciplinary 'Mali group' at the University of Oslo who have been consulted on a host of issues along the way.

Thanks to Professor Rex Sean O'Fahey at the University of Bergen who initiated the Institute for the Study of Islamic Thought in Africa (ISITA) and the Arabic Literature of Africa (ALA) project together with John Hunwick. Thanks to Abdoulaye Idnane Touré (known as Acropole) who took the initiative to start the Club John O. Hunwick in Timbuktu, to Hamma and Ibrahim who have assisted us during our stays in Timbuktu, and to the Hotel Colombe in Timbuktu where the idea came to us to collaborate on this book.

Very special thanks to Ali ould Sidi, head of the Cultural Mission in Timbuktu; Mohamed Gallah Dicko, Director of the Ahmed Baba Institute in Timbuktu (IHERIAB); Modibo Haïdara, Director of the National Research Centre in Bamako (CNRST); and Abdelaziz Abid, responsible for UNESCO's Memory of the World Programme, for encouraging us to pursue this adventure. Thanks also to the Program of African Studies at Northwestern University, which has maintained an emeritus office for John Hunwick during his retirement, and to the Centre for Development and the Environment (SUM) at the University of Oslo, which has been Alida Jay Boye's workplace during this process. We are extremely grateful to the Norwegian Agency for Development Cooperation (Norad), which has funded the Timbuktu Manuscripts Project designed to preserve and promote African literary heritage since its conception in 1999.

John O. Hunwick, Alida Jay Boye and Joseph Hunwick

CREDITS

نسيرنا ومولانا محمد وعلى ال سيدنا محمد امام الحوامل

اللهم صل وسلم على سيدنا ومولانا محمد وعلى ال سيدنا

محمد امام اهل الخلاص صل وسلم على سيدنا ومولانا

وعلى ال سيدنا امام المزيدين اللهم صل وسلم

على سيدنا ومولانا محمد وعلى ال سيدنا محمد امام المسلمين

اللهم صل وسلم على

سيدنا ومولانا محمد وعلى ال

سيدنا محمد امام الزاهدين

اللهم صل وسلم على سيدنا ومولانا محمد

وعلى ال سيدنا محمد امام الجاهدين

اللهم صل وسلم على سيدنا ومولانا

محمد وعلى ال سيدنا ومولانا محمد

أمينه جميل محنته ورأفته اللهم صل وسلم على سيدنا ومولانا

محمد وعلى آل سيدنا محمد الذي حبب الله أمته به وأنالهم

من خير ما آتاه نبيه صلى الله وسلم عليه ثم

باب في الصلاة على أمته

الغلبة لجميع الأمة به صلى الله عليه

وسلم على سيدنا ومولانا وعلى آل سيدنا

محمد أصحاب الأبهة الغلاة اللهم صل وسلم على سيدنا

ومولانا محمد وعلى آل سيدنا أصحاب الأبهة عليهم

الصلاة اللهم صل وسلم على سيدنا ومولانا وعلى آل

آل سيدنا أصحاب الأبهة الأبرار اللهم صل وسلم على

سيدنا ومولانا محمد وصل على آل سيدنا أصحاب

الأخيار اللهم صل وسلم على سيدنا ومولانا محمد وعلى

آل سيدنا أصحاب الأمة الناجية اللهم صل وسلم على

سيدنا ومولانا محمد وعلى آل سيدنا أصحاب أهل

الرتبة العالية اللهم صل وسلم على سيدنا ومولانا محمد

وعلى آل سيدنا أصحاب رسل الله اللهم صل وسلم على

سيده

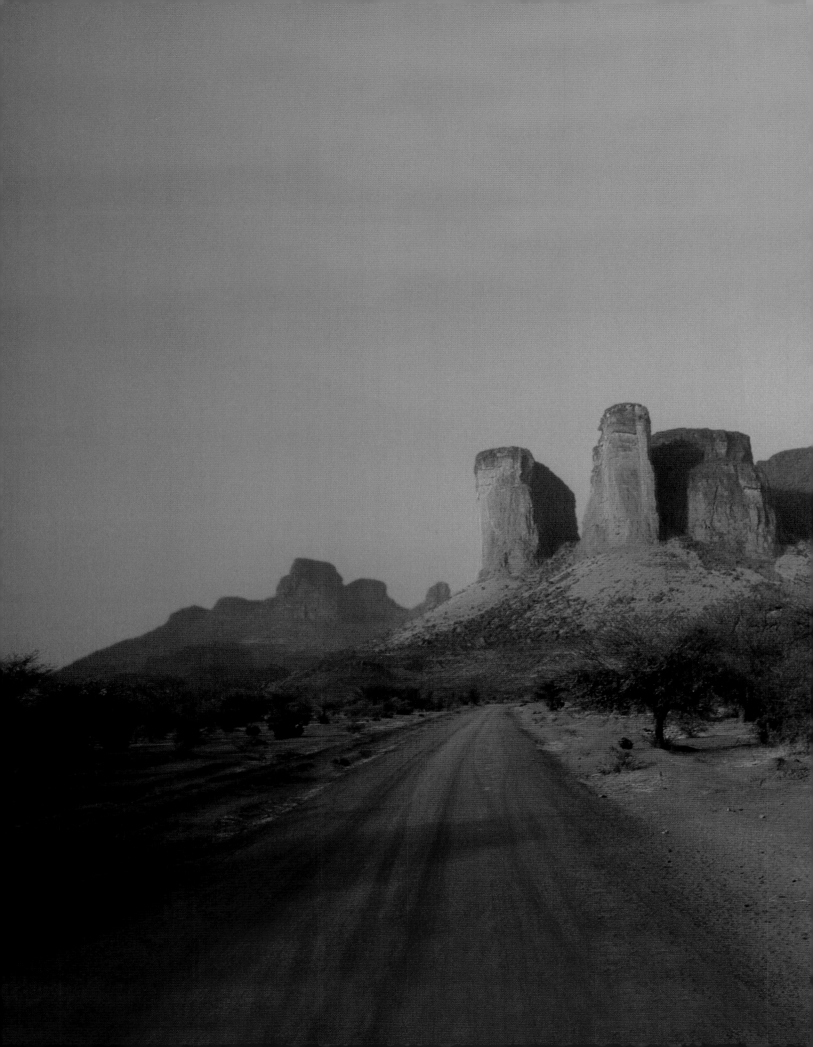

لله رب العالمين

هذا أحد الشكل الثاني

هذا الشكل الثالث

اللهم رب الأرواح والأجساد
البالية ائذن له بكلمة

مع المنقم عليهم

من النسل الشريف

والنشأ والصغير

وسر الملك

رب قار الحم

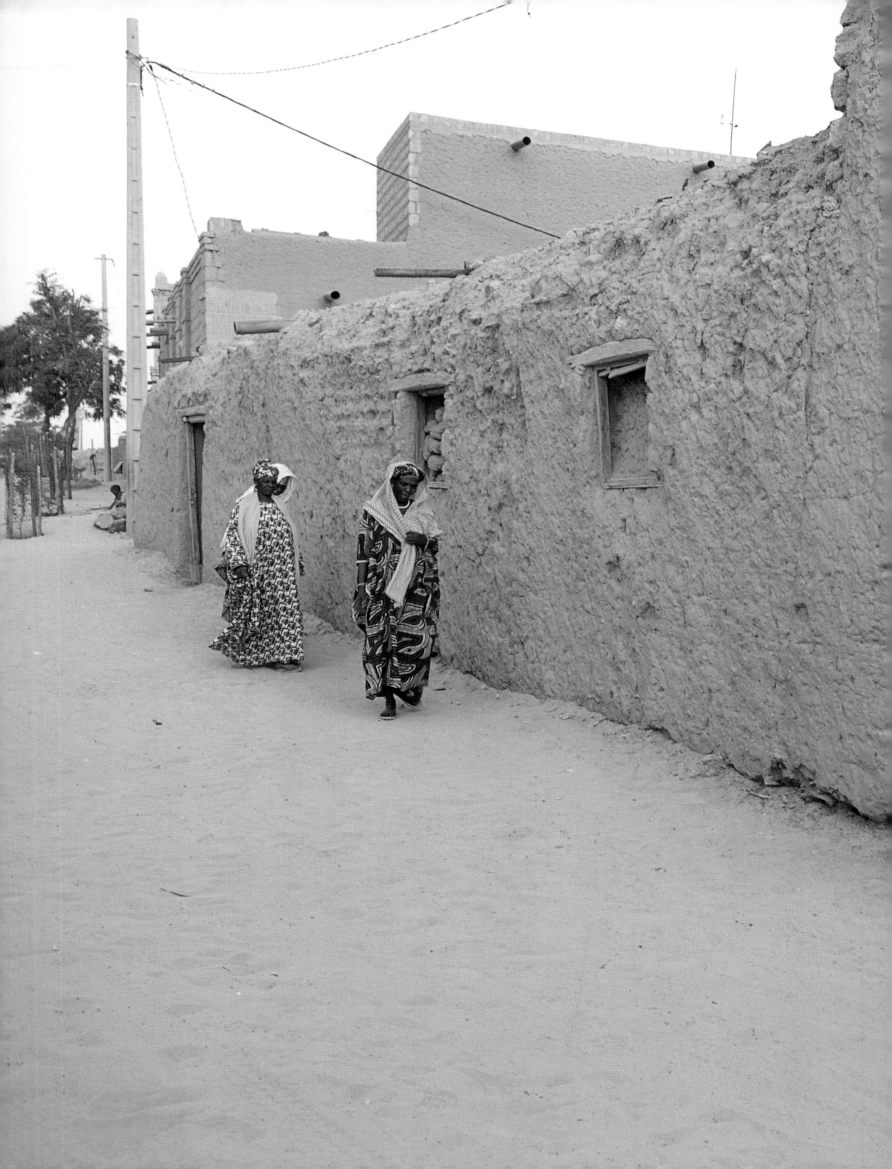

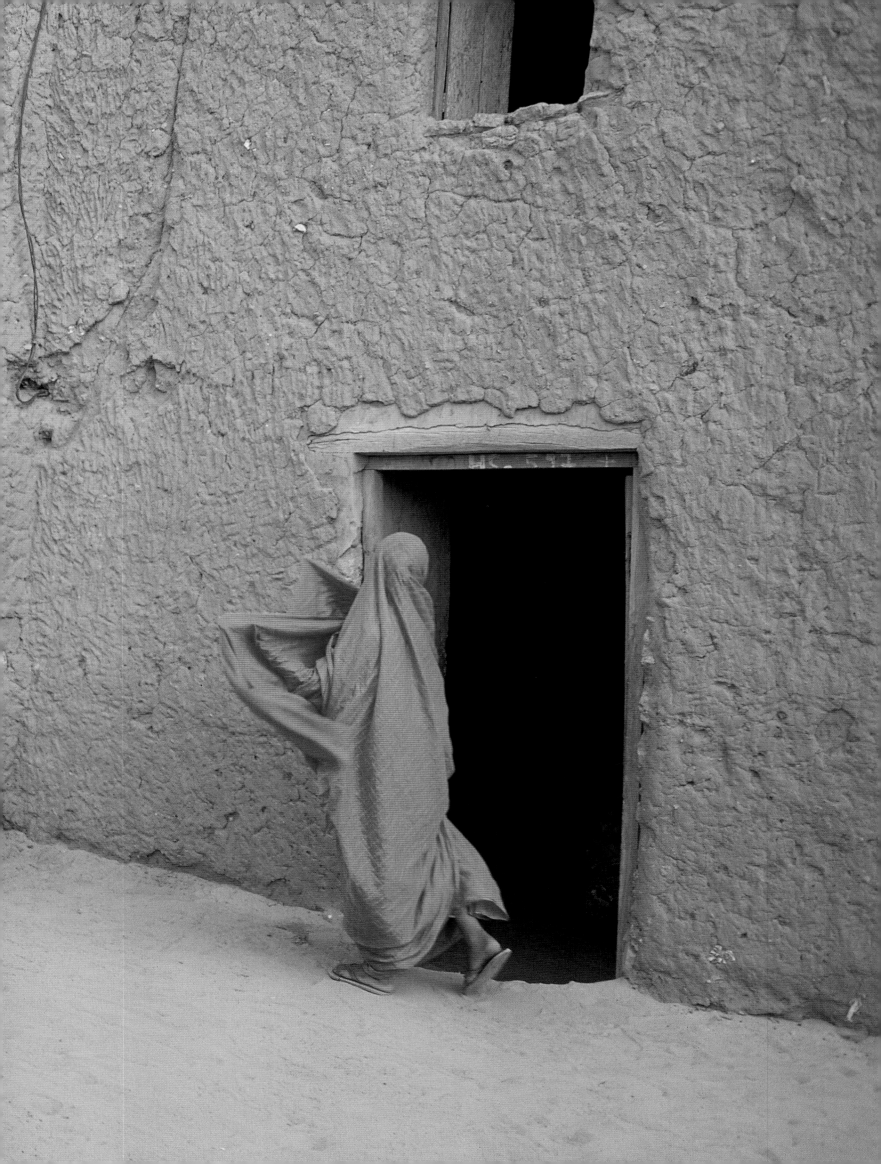

INDEX

Abu al-Hasan 46, 130, 154, 160
Abu Ishaq Ibrahim al-Sahili 24, 51, 129, 130, 155, 158
Ahmad al-Bakkay al-Kounti 58–60, 93, 94, 112, 137, 154, 157
Ahmad Boularaf 138, 140, 145, 154
Ahmadu Ahmadu 4, 154
Ahmadu Lobbo 29, 58, 86, 154, 161
Ahmed Baba 35, 45, 49, 84, 85, 89, 90, 154, 160
Ahmed Baba Institute (IHERIAB, formerly CEDRAB) 15, 62, 78, 84, 85, 86, 87, 89, 90, 175
ajamis 95, 97, 112, 142, 154
Ali bin Ziyad al-Quti 95, 136, 137, 144, 154, 160
Almoravids 41, 49, 50, 89, 131, 154, 155, 160
al-Andalus 36, 154
Aqit family 84, 128, 130, 131, 132, 133, 139, 154
Arabic language and script 11, 12, 14, 40, 41, 55, 62, 86, 87, 89–90, 93, 94, 95–97, 98–99, 112, 125, 142
Arawan 34, 40, 57, 85, 139, 140, 143, 154
Arma 55, 56, 106, 132, 135, 136, 154, 160
Askiyas 42, 53, 56, 99, 136, 154, 160
Askiya Dawud 47, 83, 154
Askiya Muhammad 37, 53, 55, 58, 83, 86, 87, 95, 136, 154
Awdaghast 47, 50, 155
Azawad 34, 57, 140, 155
al-Azhar Mosque 87, 155

Baghayogho al-Wangari *see* Muhammad Baghayogho al-Wangari
al-Bakkay al-Kounti *see* Ahmad al-Bakkay al-Kounti
al-Bakri 36, 47, 155
Bamako 50, 137, 139, 155
Barabish 140, 155
Barth, Heinrich 34, 53, 59–61, 85, 93, 100, 156, 161
Berbers 34, 38, 40, 47, 50, 55, 99, 155
Bilad al-sudan 34, 136, 137, 155
Boujebeha 57, 141, 143, 155
Bozo 39, 155

Caillié, René 60, 61, 158, 161
Caliphs 53, 84, 86, 117, 155
CEDRAB *see* Ahmed Baba Institute

Dala'il al-Khayrat 82, 89, 90, 106, 118, 144, 155, 175

Djenne 14, 29, 34, 43, 57, 82, 85, 86, 134, 135, 155
Djingereber 24, 50, 51, 53, 88, 128, 130, 141, 155, 160
Dogon 60, 155

fatwas 54, 87, 89, 93, 94, 133, 155
Fez 37, 42, 47, 86, 132, 133, 155
fiqh 155
French colonization 10, 11, 14, 61–62, 128, 129, 161
Fulani 39, 40, 45, 49, 58, 59, 60, 61, 70, 95, 97, 99, 131, 155
Fulfulde 95, 97, 112, 117, 155
Futa Jallon 12, 39, 42, 97, 155
Futa Toro 59, 155

Gao 37, 39, 50, 53, 54, 56, 86, 97, 133, 141, 155
geomancy 90, 155
Ghadames 155
Ghana, present-day 9, 40, 43, 155
Ghana, ancient Empire of 34, 36, 40, 41, 49, 50, 155, 160
gold 10, 12, 15, 33, 40, 43–45, 49–51, 53, 54, 56, 98, 118, 159, 160

Hadith 9, 87, 89, 130, 139, 140, 156
Hajj 156; *see also* Mecca
Hamdallahi 4, 58, 59, 86, 117, 156, 161
Hassaniyya Arabs 38, 156
Hausa calligraphy and decoration 89, 90, 99, 106, 118, 175
Hausaland 12, 90, 117
Hausa language 95–97, 112, 156
Hijra 160, 156

Ibn Abi Zayd al-Qayrawani 89, 157
Ibn Battuta 36, 38, 42, 52, 90, 156, 160
Ibn Khaldun 36, 46, 50, 90, 156
al-Idrisi 36, 47, 156
Ibn Sina 93, 156
IHERIAB *see* Ahmed Baba Institute
ijaza 87, 88, 140, 156
ineslemen 38, 156

Jews 54–55, 93
jihad 59, 62, 156

Kabara 33, 43, 44, 46, 156
Kano 37, 53, 156
Kati, Mahmud *see* Mahmud Kati
Katsina 37, 57, 156

Kel al-Suq 57, 86, 99, 129, 156
Khalil ibn Ishaq 49, 89, 132, 156
Kitab al-Mudhish 90, 156
Kitab al-Shifa 89, 125, 132, 136, 144, 156
Kounta 40, 42, 45, 57, 58, 59, 60, 86, 112, 117, 129, 137, 138, 141, 156, 161

Laing, Gordon 61, 156, 161
Leo Africanus 10, 15, 37, 43, 45, 54, 81, 97, 156, 160

madrasa 14, 62, 156
al-Maghili 37, 54, 55, 156
Maghreb 11, 12, 41, 46, 95, 125, 156
Mahmud Kati 85, 129, 136, 144, 156
Maigala/Almoustapha Konaté Library 12, 68, 74, 97, 125, 129, 132, 133, 141
Malian Empire 50–52, 82, 160
Maliki law 9, 12, 51, 89, 133, 156
Mamma Haïdara Library 4, 12, 86, 87, 93, 95, 97, 106, 107, 112, 118, 141, 143, 146
Mande 39, 130, 134, 157
Mansa Musa 24, 82, 129, 157, 160
Mansa Sulayman 36, 47, 157
al-Mansur 55, 84, 157
marginalia 95, 145, 157, 157
Marrakesh 56, 84, 93, 133, 134, 157
Masina 12, 58, 59, 60, 86, 131, 157, 161
Massufa 35, 41, 52, 131, 157
Mecca 18, 24, 37, 49, 51, 53, 59, 83, 86, 129, 133, 155, 156, 157, 158, 159, 160
mithqal 43, 47, 51, 98, 118, 136, 157
Mohamed Taher Library 4, 137, 138, 140
Mossi 52, 62, 157
muezzin 97, 157
mufti 133, 157
muhaddith 139, 157
Muhammad Baghayogho al-Wangari 81, 82, 127, 128, 130, 131, 133, 134, 135, 142, 146, 157, 159
al-Mukhtar al-Kabir al-Kounti, Shaykh Sidi 57, 58, 62, 137, 138, 140, 141, 157
Mukhtasar, *see* Khalil ibn Ishaq

Niger Bend 10, 11, 12, 34, 56, 59, 61, 128, 157
Niger River 10, 18, 43, 55, 90, 157

Park, Mungo 55, 157
The Prophet Muhammad 9, 84, 87, 89, 95, 107, 118, 125, 130, 132, 157, 175

qadi 54, 58, 82, 93, 132, 133, 139, 157
Qadi Iyad 89, 125, 132, 136, 157

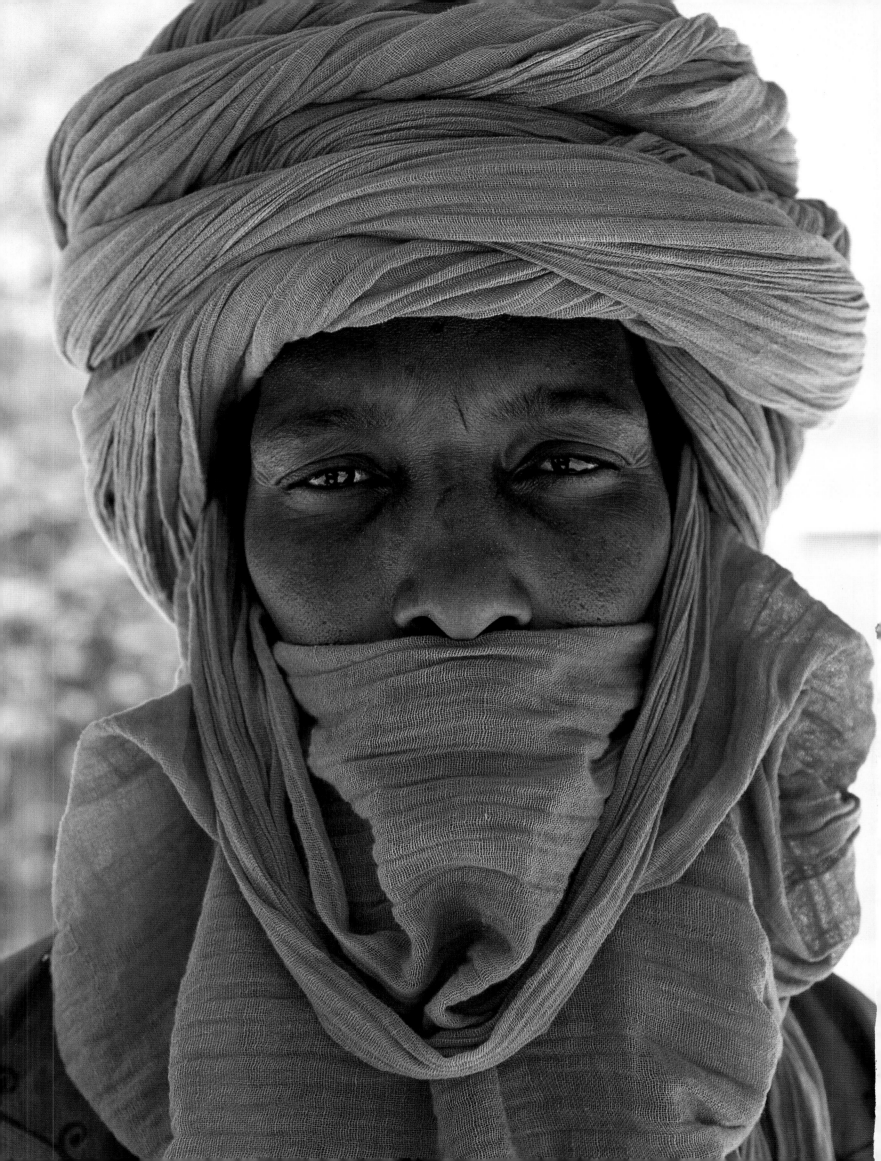